HISTORIC PHOTOS OF
PHILADELPHIA

TEXT AND CAPTIONS BY LAURA E. BEARDSLEY

Turner®
Publishing Company

Nashville, Tennessee • Paducah, Kentucky

The Main Building was the largest building on the Centennial grounds, and is believed to have been the largest building in the world when it was built. More than 13,700 exhibitors were featured, including manufacturers of clothing, furniture, and medical and scientific equipment.

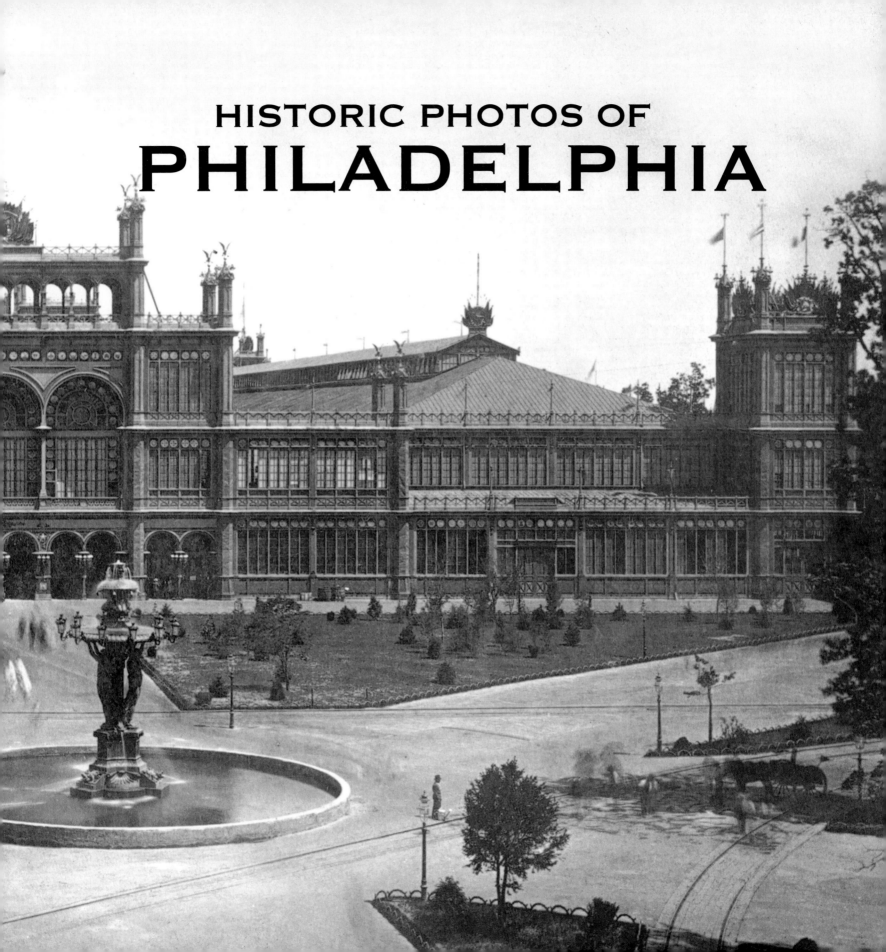

HISTORIC PHOTOS OF
PHILADELPHIA

Turner Publishing Company

200 4th Avenue North • Suite 950 412 Broadway • P.O. Box 3101
Nashville, Tennessee 37219 Paducah, Kentucky 42002-3101
(615) 255-2665 (270) 443-0121

www.turnerpublishing.com

Library of Congress Control Number: 2006933652

ISBN: 1-59652-306-9

Printed in the United States of America

0 9 8 7 6 5 4 3 2 1

CONTENTS

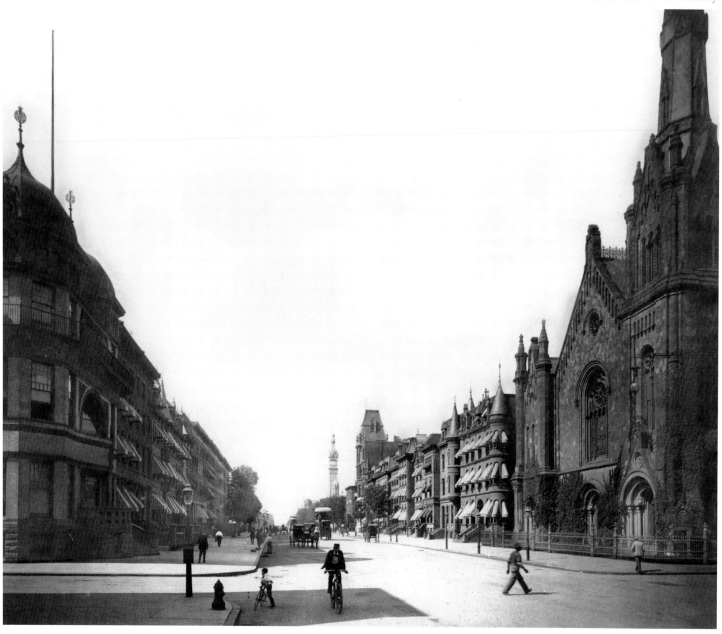

Broad Street looking north from Oxford Street, ca. 1890. To the left is the Columbia Club, one of many men-only social clubs in the city at the turn of the century.

Acknowledgments

This volume, *Historic Photos of Philadelphia,* is the result of the cooperation and efforts of many individuals, organizations, institutions, and corporations. It is with great thanks that we acknowledge the valuable contribution of the following for their generous support:

Historical Society of Pennsylvania
Free Library of Philadelphia
Pennsylvania Historical and Museum Commission

We would also like to thank Laura E. Beardsley, author and editor, Max E. Moeller, Laura's husband and Director of Research Services, Historical Society of Pennsylvania, and R. A. Friedman, Rights and Reproductions Department, Historical Society of Pennsylvania, for valuable contributions and assistance in making this work possible.

PREFACE

Philadelphia has thousands of historic photographs that reside in archives, both locally and nationally. This book began with the observation that, while those photographs are of great interest to many, they are not easily accessible. During a time when Philadelphia is looking ahead and evaluating its future course, many people are asking, "How do we treat the past?" These decisions affect every aspect of the city—architecture, public spaces, commerce, infrastructure—and these, in turn, affect the way that people live their lives. This book seeks to provide easy access to a valuable, objective look into the history of Philadelphia.

The power of photographs is that they are less subjective than words in their treatment of history. Although the photographer can make decisions regarding subject matter and how to capture and present it, photographs do not provide the breadth of interpretation that text does. For this reason, they offer an original, untainted perspective that allows the viewer to interpret and observe.

This project represents countless hours of review and research. The researchers and author have reviewed thousands of photographs in numerous archives. We greatly appreciate the generous assistance of the archivists listed in the acknowledgments of this work, without whom this project could not have been completed.

The goal in publishing this work is to provide broader access to this set of extraordinary photographs that seek to inspire, provide perspective, and evoke insight that might assist people who are responsible for determining Philadelphia's future. In addition, the book seeks to preserve the past with adequate respect and reverence.

With the exception of touching up imperfections caused by the damage of time, no other changes have been made. The focus and clarity of many images is limited to the technology and the ability of the photographer at the time they were taken.

The work is divided into eras. Beginning with some of the earliest known photographs of Philadelphia, the first two

sections record photographs from before the Civil War through the end of the nineteenth century. The third section spans the beginning of the twentieth century through World War I. Section Four moves from World War I to World War II. The last sections cover the World War II era to the recent past.

In each of these sections we have made an effort to capture various aspects of life through our selection of photographs. People, commerce, transportation, infrastructure, religious institutions, and educational institutions have been included to provide a broad perspective.

We encourage readers to reflect as they go walking in Philadelphia, strolling through the city, its parks, and neighborhoods. It is the publisher's hope that in utilizing this work, longtime residents will learn something new and that new residents will gain a perspective on where Philadelphia has been, so that each can contribute to its future.

Todd Bottorff, Publisher

Washington Square is one of five park squares incorporated into Thomas Holmes' original plan for the city. At one time used as a cemetery for the victims of disease and war, the square is now one of Philadelphia's popular neighborhood parks. The town homes at the center of the photo, seen ca. 1870, are still occupied as private residences.

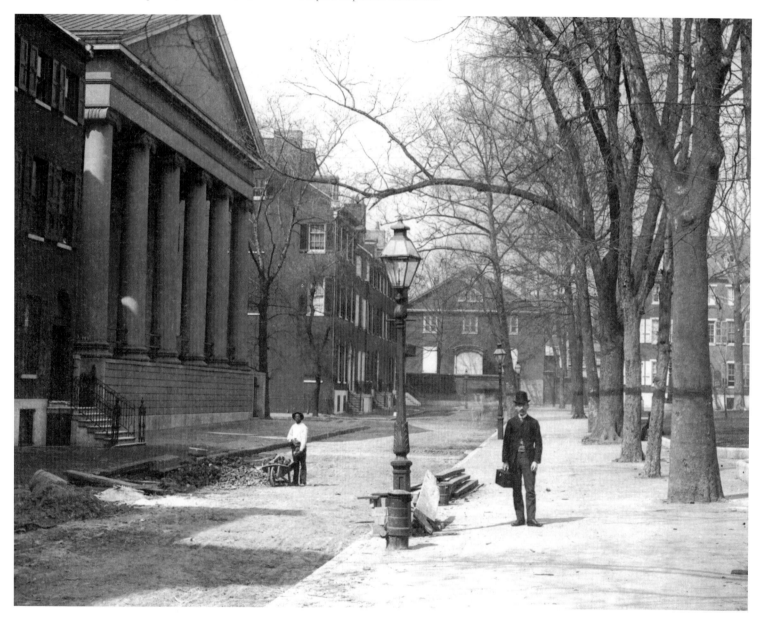

THE CITY OF BROTHERLY LOVE LOOKS FORWARD

1840-1879

As one of America's oldest cities, Philadelphia has enjoyed a long and often successful history. First settled by the Dutch as early as 1609, it was officially established in 1681 by Englishman and Quaker convert William Penn. Founded on the doctrines of the Quaker faith, the city grew quickly due in great part to its reputation for religious freedom and seemingly endless economic possibilities. Its geographical location at the center of the original thirteen colonies in combination with well-established shipping and trade routes along the Delaware River proved to be an advantage to the city.

In 1774 and 1775, Philadelphia served as host to the First and Second Continental Congresses, the colonial assemblies which ultimately led the colonies through the creation of the Declaration of Independence and the trials of the Revolutionary War. In 1787 it was home to the Constitutional Convention, which drafted the United States Constitution, and from 1790 until 1800 the city was the capital city of the newly organized United States of America. By the end of the eighteenth century, Philadelphia was the premier city in the nation, home to leading national politicians, artists, scientists, and an estimated population of more than 67,000 people.

By the mid-1800s the venerable City of Brotherly Love was still revered as the birthplace of the nation but had lost its place as the leading city. In the midst of great tension and change, and increasingly at the mercy of rioting factions, devastatingly regular cholera epidemics, and a growing disparity between the wealthy and the poor, Philadelphia's future seemed bleak. But the city remained a place of great industry, beauty, and culture as reflected in the growth of small businesses, the creation of Fairmount Park (still the largest urban park in the world), and the availability of a wide variety of theaters and museums.

The consolidation of the city in 1854 united independent municipalities of nearly thirty townships and boroughs in the county and created America's newest "great city." The Civil War brought economic opportunity in the form of an increased demand for products such as textiles and ships, both leading industries in Philadelphia. This period of growth culminated in the grand celebration of the 100th anniversary of the Declaration of Independence in 1876. Known formally as the International Exhibition of Arts, Manufactures, and Products of the Soil and Mine, the Centennial Exhibition featured exhibits highlighting the preceding 100 years of American ingenuity and the potential for industrial greatness in the years to come.

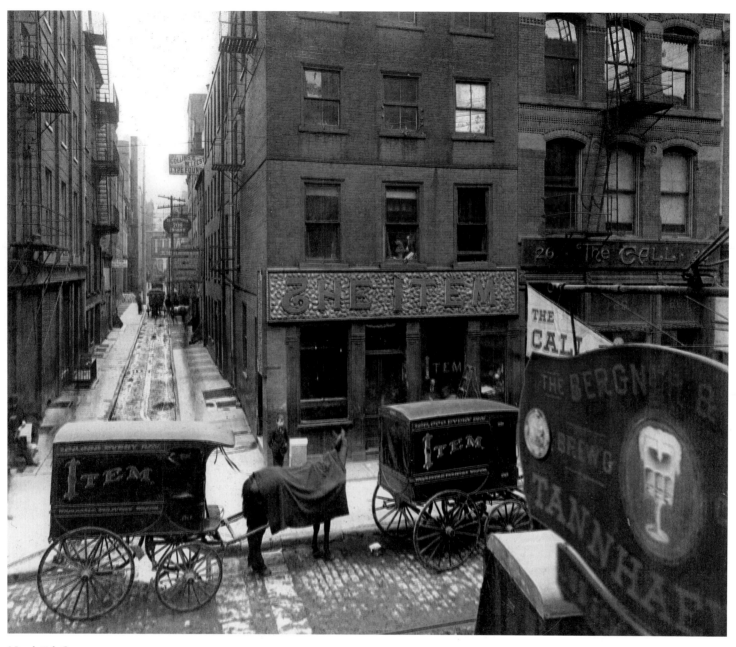

North 7th Street

Bullock and Crenshaw's Drug Store and Chemical Warehouse,
northeast corner of 6th and Arch streets, ca. 1850

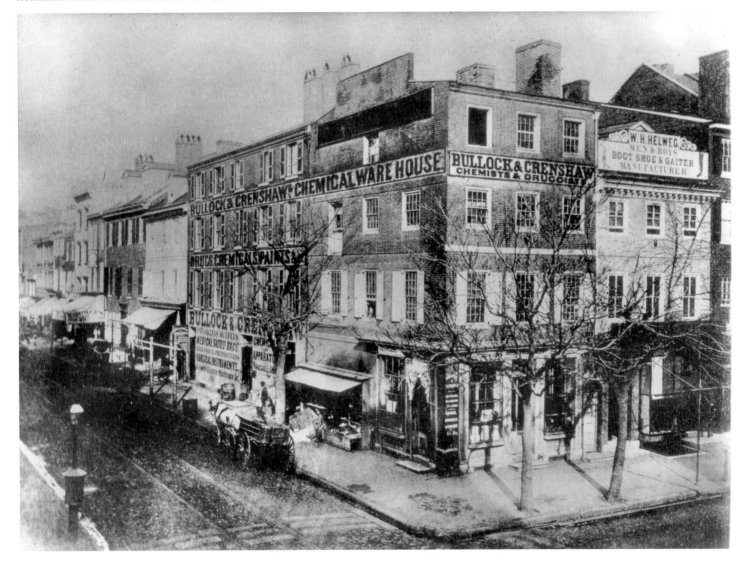

Seen here ca. 1855, the Pennsylvania State House and Congress Hall served as the home of the federal government during the period 1790–1800 when Philadelphia was the nation's capital. The Bill of Rights was ratified by members of Congress in Congress Hall in 1791. The State House became popularly known as Independence Hall as a result of the celebration of the 50th anniversary of the Declaration of Independence during the 1820s.

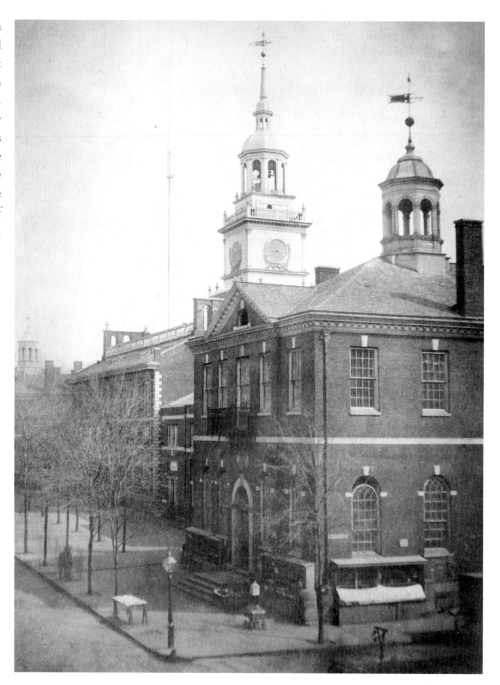

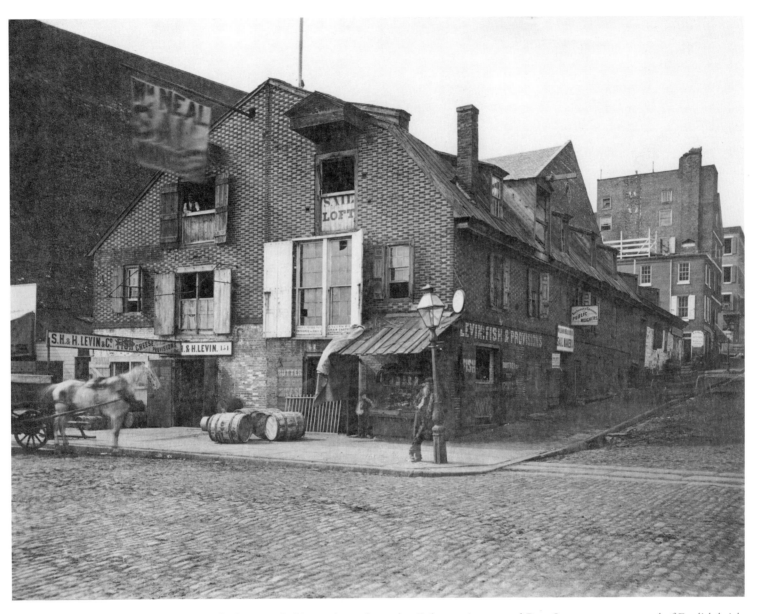

Photographed ca. 1856, this warehouse located at Delaware Avenue and Race Street was constructed of English bricks and timber in 1795. The second floor was used as a sail loft, one of Philadelphia's earliest and most important industries because of the city's status as a major port. Designed with an open plan, a sail loft was used to spread out canvas sails for manufacture and repair. The building was demolished in 1900.

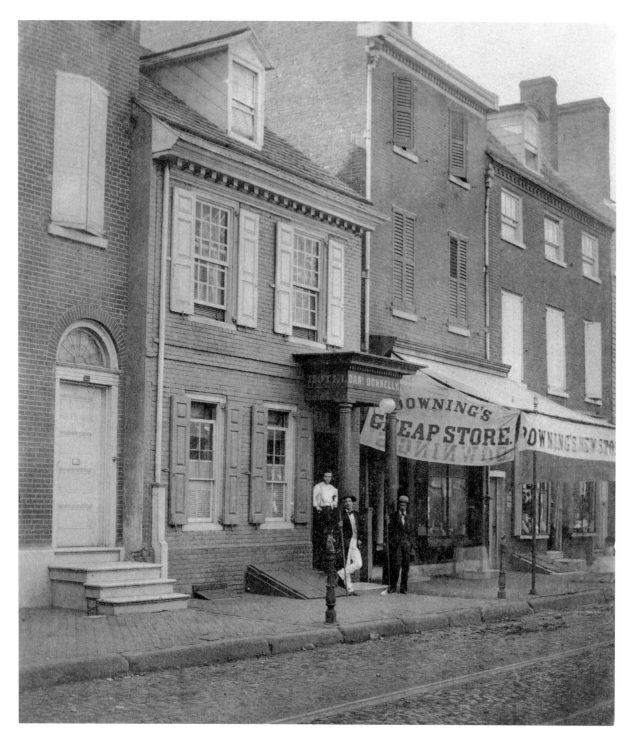

Donnelly's Hotel, 4th
Street at Pine Street,
ca. 1860

Located at the northwest boundary of the city, Chestnut Hill would become one of the premier neighborhoods in the city by the end of the 1800s. Residents enjoyed the country-like views combined with the easy availability of two commuter train lines into the city. This is an early view of the area, ca. 1860.

Arch Street Theater, 6th and Arch
streets, ca. 1860

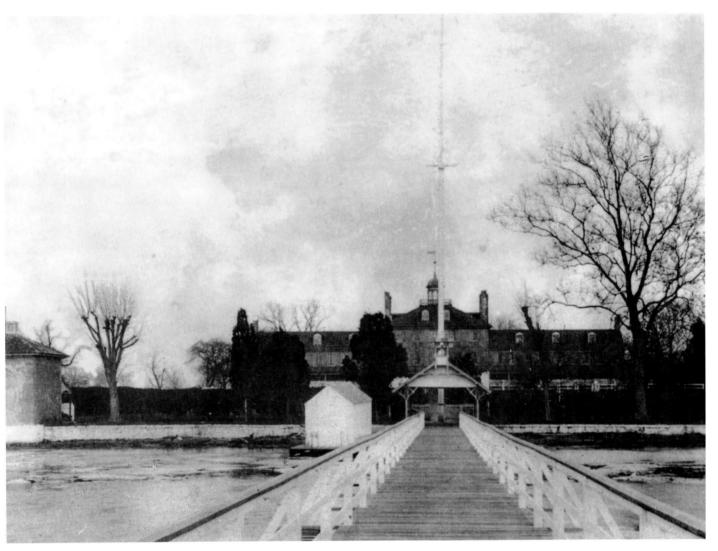

Located on the Delaware River just south of the city, the Lazaretto was originally built in 1799 to serve as a quarantine station during the frequent outbreaks of yellow fever and cholera that struck the city. Through the 1800s, all ships destined for the Port of Philadelphia were detained at the station. In the 1840s, more than 19,000 Irish potato famine refugees passed through its doors. The building still stands today.

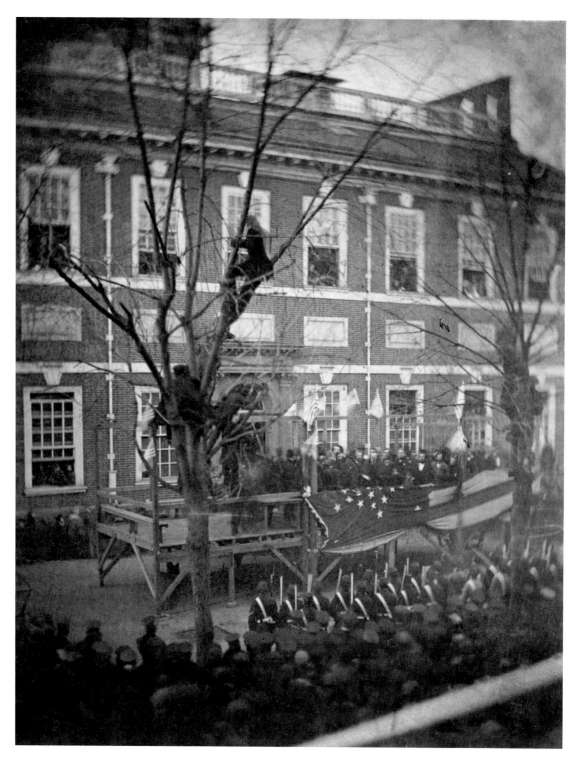

President-elect Abraham Lincoln was in Philadelphia in February 1861 to honor the admission of the state of Kansas to the union. Shown in front of Independence Hall, Lincoln stands holding his hat at the center of the group on stage.

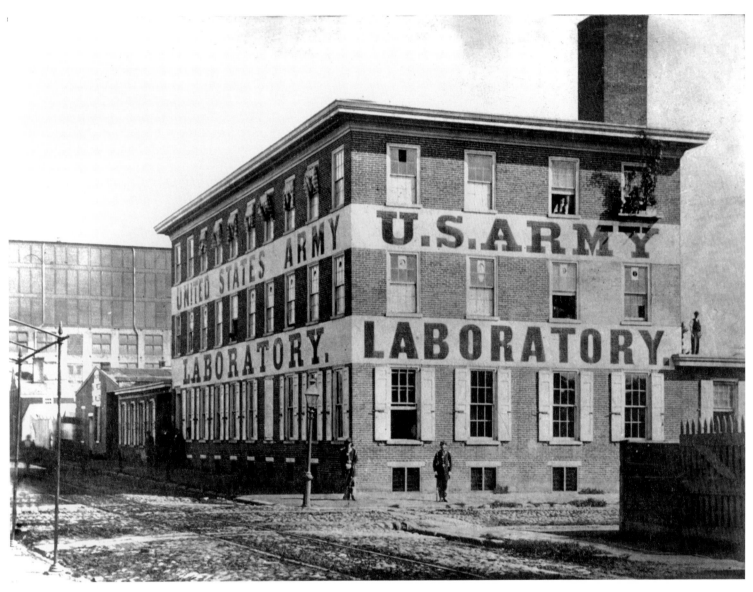

The United States Army Laboratory, located on the northwest corner of 6th and Oxford streets, was one of only two national pharmaceutical laboratories active during the Civil War. The other was located in Astoria, New York.

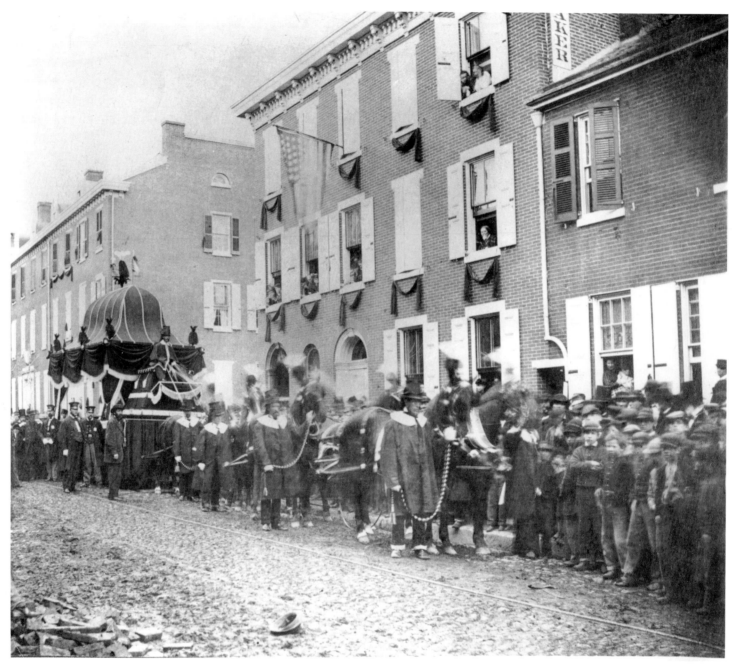

In the days following his assassination on April 14, 1863, Lincoln's body arrived in Philadelphia via train and was transferred to a heavily draped hearse for transport through the streets to Independence Hall, where he was laid in state. It has been estimated that 300,000 people viewed his coffin in Independence Hall on April 23rd, 1865.

Locker's Restaurant, 8th and Vine
streets, ca. 1868

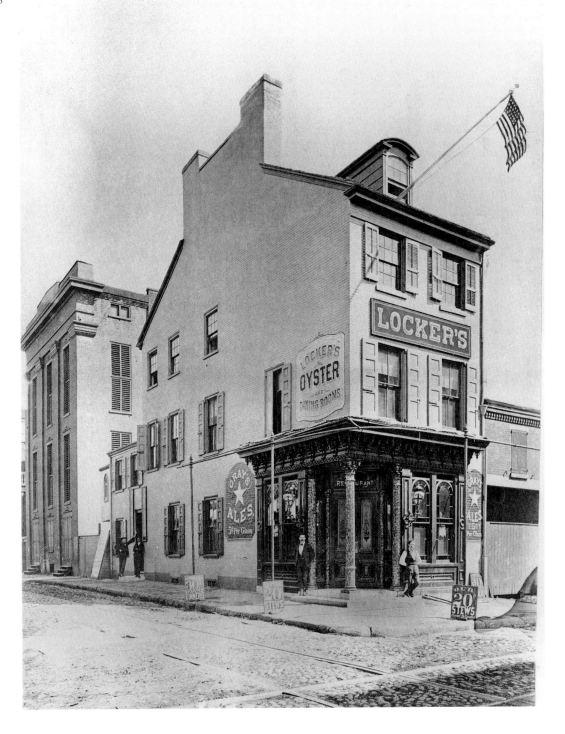

Once considered the largest and finest church in America, Zion Lutheran Church at 4th and Cherry streets is where members of Congress gathered to mourn the death of George Washington in 1799.

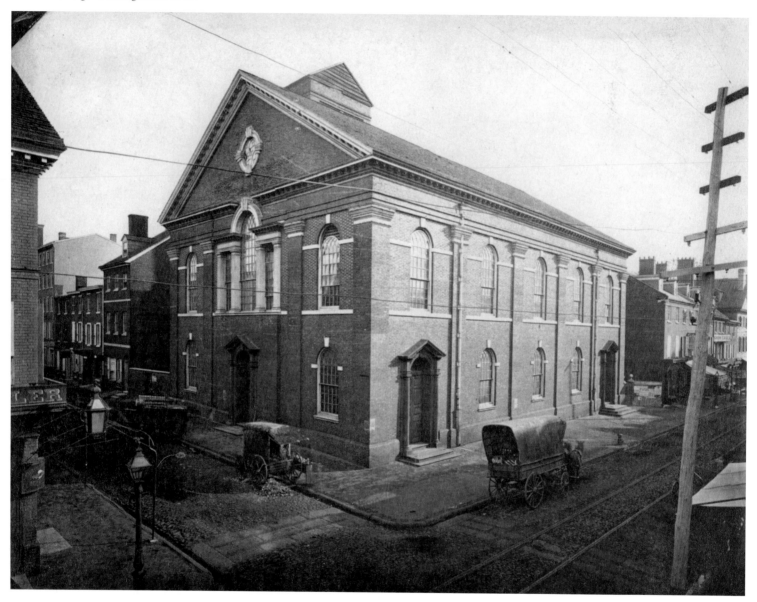

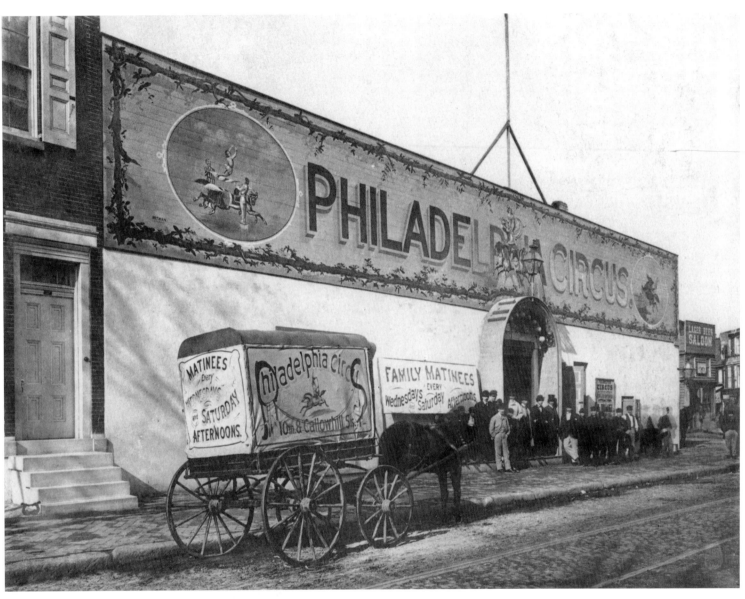

Philadelphia Circus, 10th and
Callowhill streets, ca. 1870

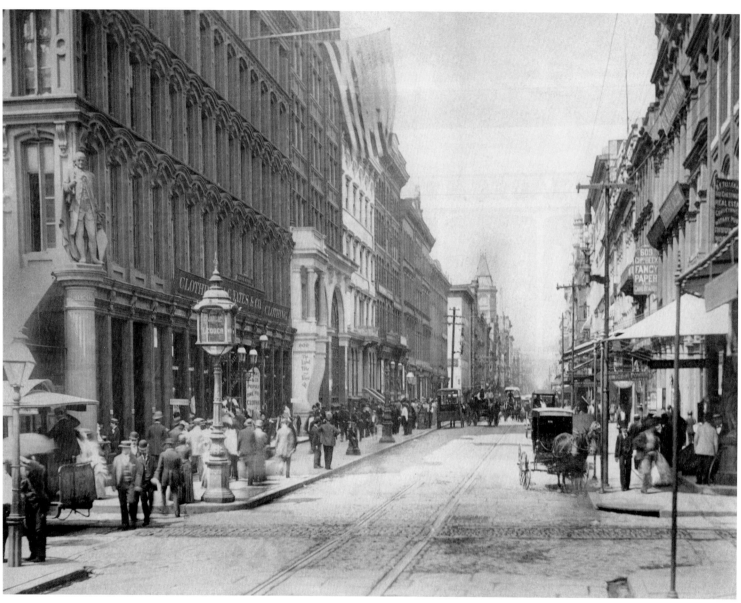

The Public Ledger newspaper, located at 6th and Chestnut streets, was
Philadelphia's most popular newspaper through the second half of the 1800s and
was the first "penny paper" in the country.

The "grand old lady of Broad Street," the Academy of Music was completed in 1857 and remains the oldest continuously running opera and performance house in the country.

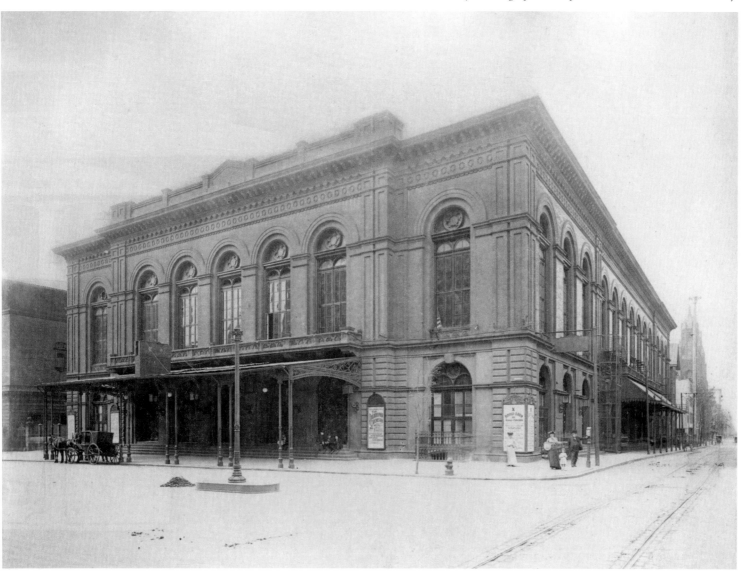

Following Spread: Presided over by President U. S. Grant, the Opening Day Ceremonies for Philadelphia's grand centennial celebration welcomed members of Congress, foreign dignitaries, and over 150,000 visitors to Philadelphia. The Philadelphia Centennial Exhibition was held on a 285-acre section of Fairmount Park overlooking the Schuylkill River from May 10 through November 10, 1876. Several large exhibition pavilions were featured, surrounded by smaller state- and country-sponsored buildings. It is estimated that nearly 9 million people, almost one-fifth of the population of the United States at the time, visited the centennial grounds.

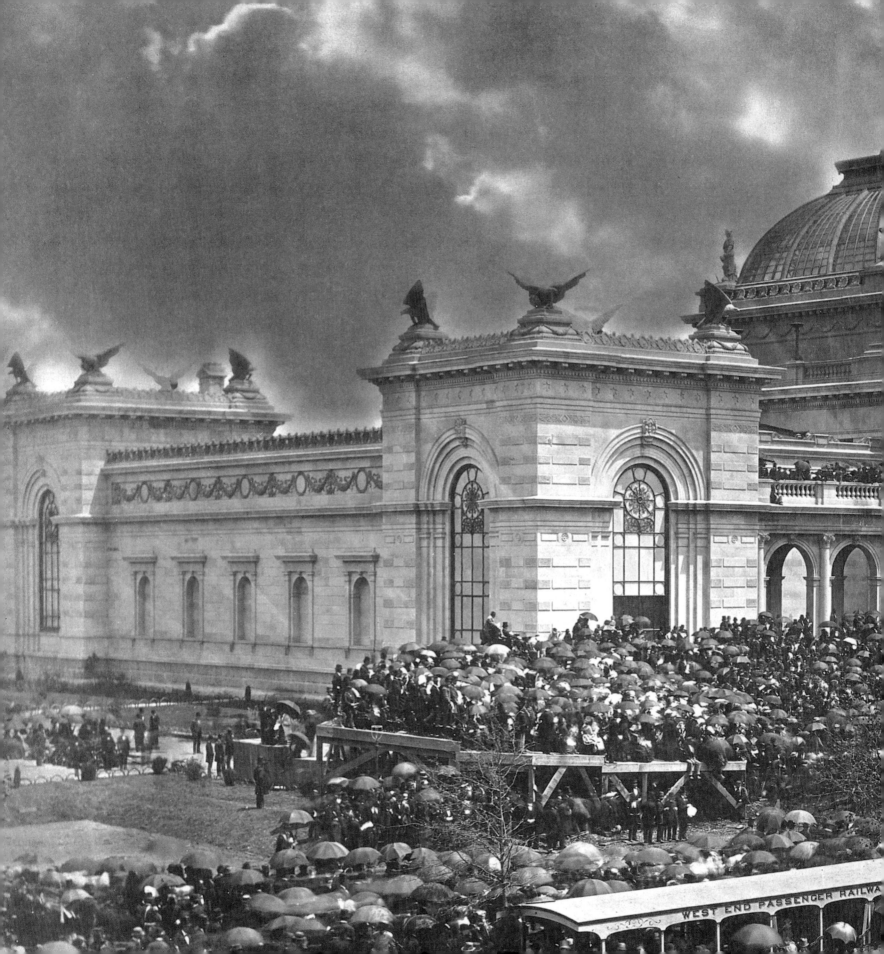

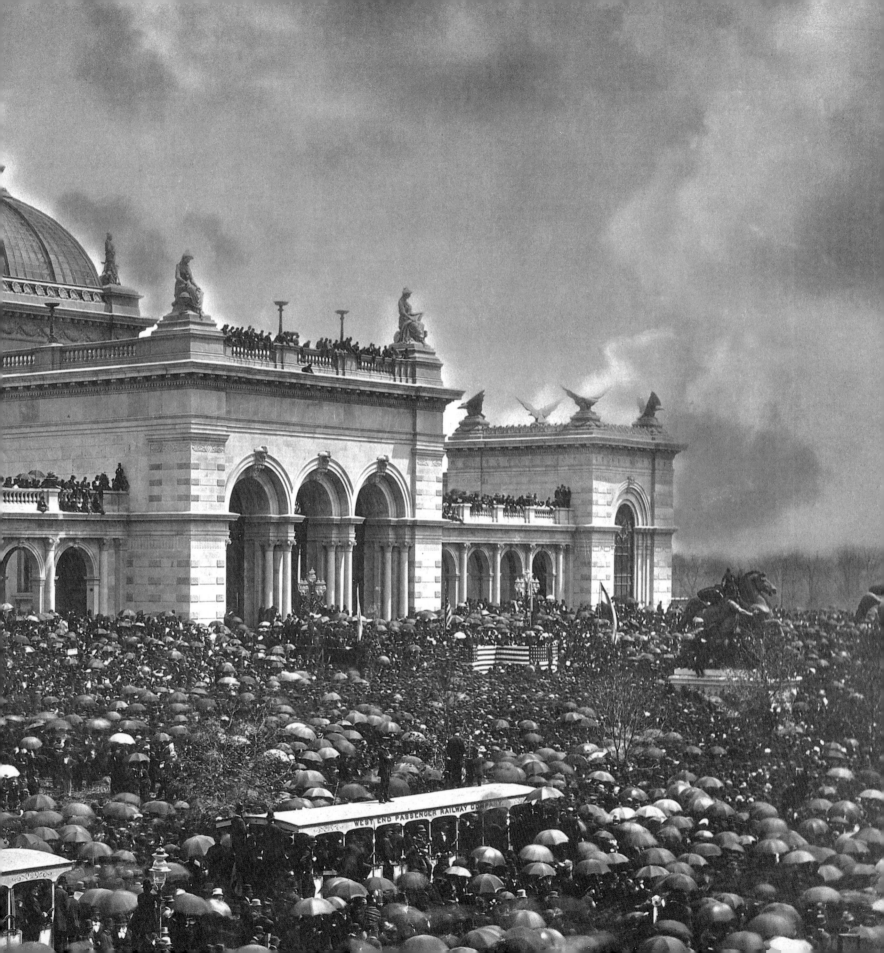

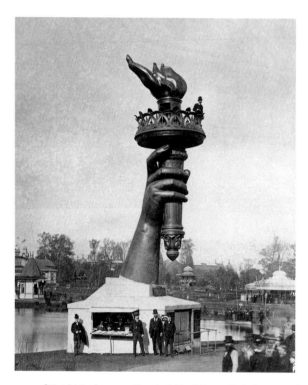

The torch-bearing arm of Frédéric-Auguste Bartholdi's *Liberty Enlightening the World* on display
at the Centennial Exposition in Philadelphia, 1876. The head and torso of the statue were placed
on display in France at the same time.

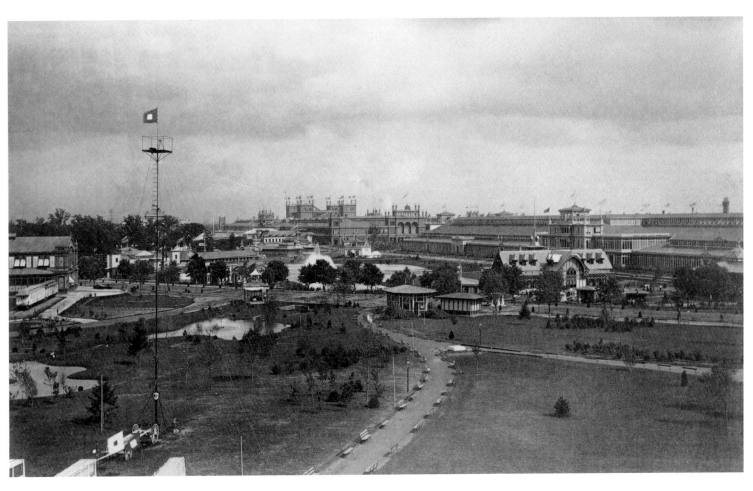

Centennial grounds, looking east, Philadelphia
Centennial Exhibition, 1876

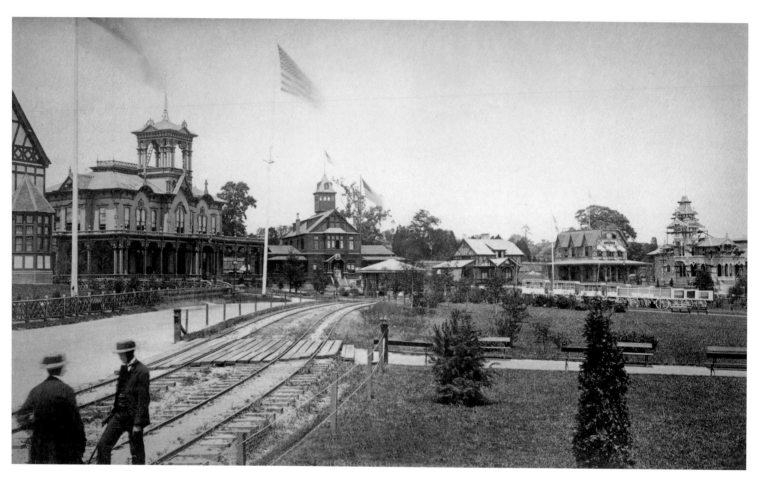

This general view of the state buildings at the
Philadelphia Centennial Exhibition in 1876 shows
some of the individual buildings sponsored by
twenty-four American states. The buildings were
used primarily as meeting venues.

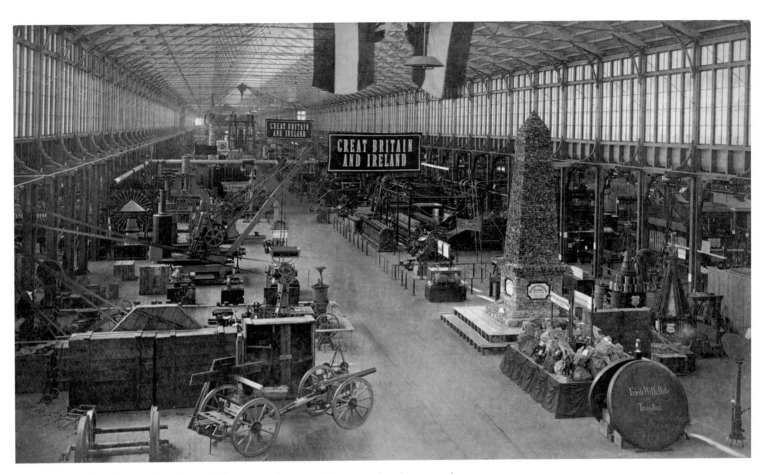

Extensive displays of manufacturing techniques, products, and the natural and man-made resources of the United States are visible in this interior view of Machinery Hall. The exhibits suggest the primary purpose of the Exhibition: to highlight the tremendous history of the United States while also celebrating its seemingly inevitable progress as the most prominent manufacturing nation in the world.

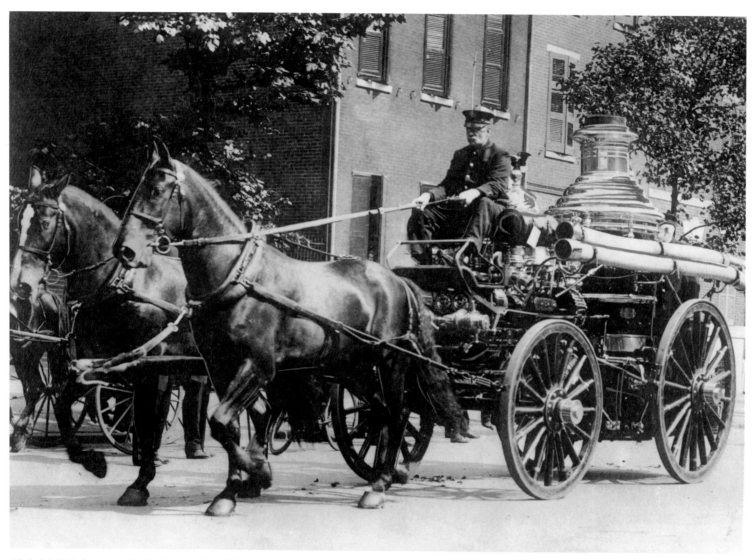

Philadelphia's first organized voluntary fire-fighting service was established by Benjamin Franklin as the Union Fire Company on December 7, 1736. The official Philadelphia Fire Department was created by City Council in 1870. This fire engine was in use ca. 1880.

BIG BUSINESS, BIG POLITICS, AND BIG PROFITS

1880-1899

In the years immediately following the great centennial exposition, Philadelphia embraced new technology and became the preeminent home to America's greatest industries. Known for big business, big politics, and big profits, Philadelphia was buoyed by the successes of powerful businesses in industries as varied as shipbuilding, locomotive manufacture, and retail. Names like Wanamaker, Baldwin, Brill, Cramp, and Widener dominated the city's industrial, political, and social scenes.

Philadelphia's population grew in tandem with the growth of industry as thousands of Southern and Eastern European and Asian immigrants arrived via steamship, hoping to fill the newly available manufacturing jobs. The new immigrants joined those that had come before, most notably the German and Irish. The resulting demand for inexpensive housing led to further crowding in the city's few slums and the inspired development of "company towns" built around several large factories.

More established Philadelphians with economic means were on the move as comfortable suburban neighborhoods, made more convenient by the availability of the new railways, attracted a growing number of wealthy and middle-class families. Electric lights blazed on Chestnut Street for the first time in 1881 and horse-drawn streetcars soon gave way to the newer, more efficient electric cars.

By century's end, Philadelphia remained one of the largest cities in the nation with a population of nearly 1.3 million people. Businesses and industries of every kind powered the city's drive toward the future. The grand old city once defined by its history had evolved into a symbol of the future, built of iron, steel, and brick.

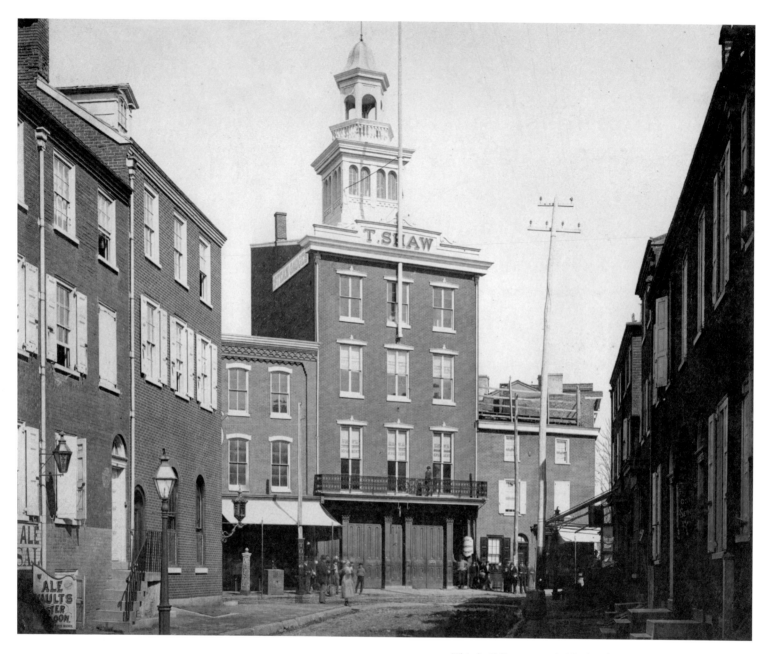

This building, occupied by T. Shaw, Manufacturer, ca. 1880, originally served as the home base of the Fairmount Fire Company at the intersection of Ridge Avenue and Vine Street.

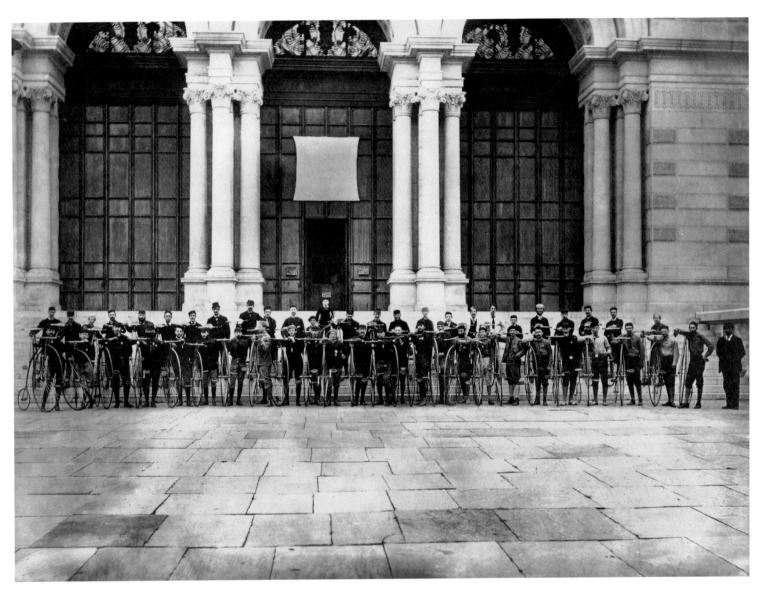

First bicycle meet, ca. 1885. The group is posing in front
of Memorial Hall, one of the only permanent structures
remaining from the Philadelphia Centennial Exposition.

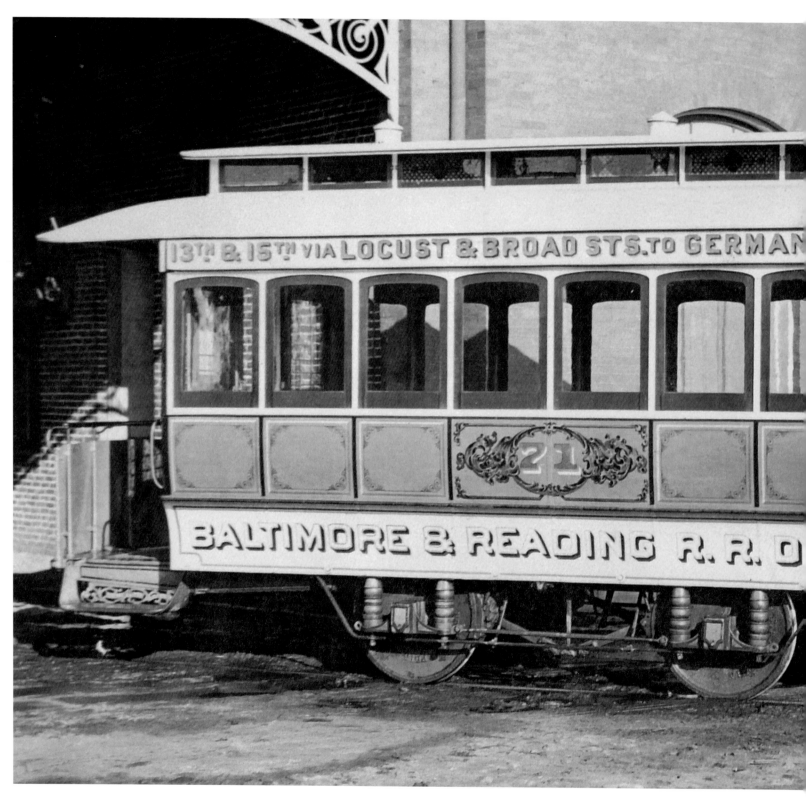

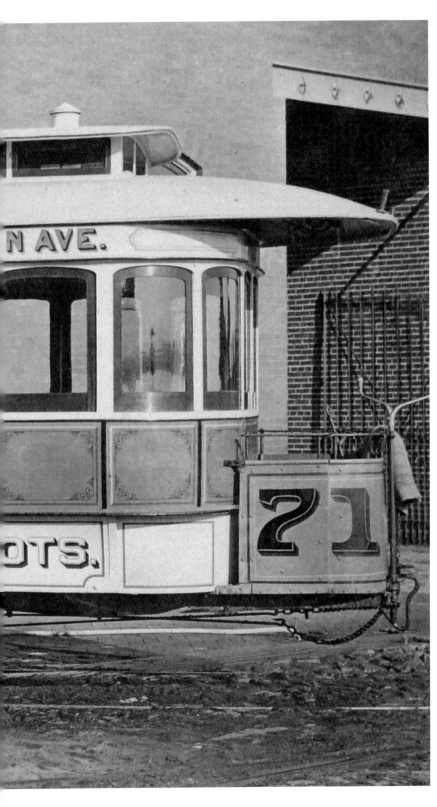

Manufactured in the city in 1880, this J. G. Brill & Company railway car was one of the hundreds serving Philadelphians by the end of the 1880s. Brill, which issued its first streetcar in 1869, continued to manufacture trains, cable, and electric streetcars, street cleaners, and trolleys until the mid 1940s.

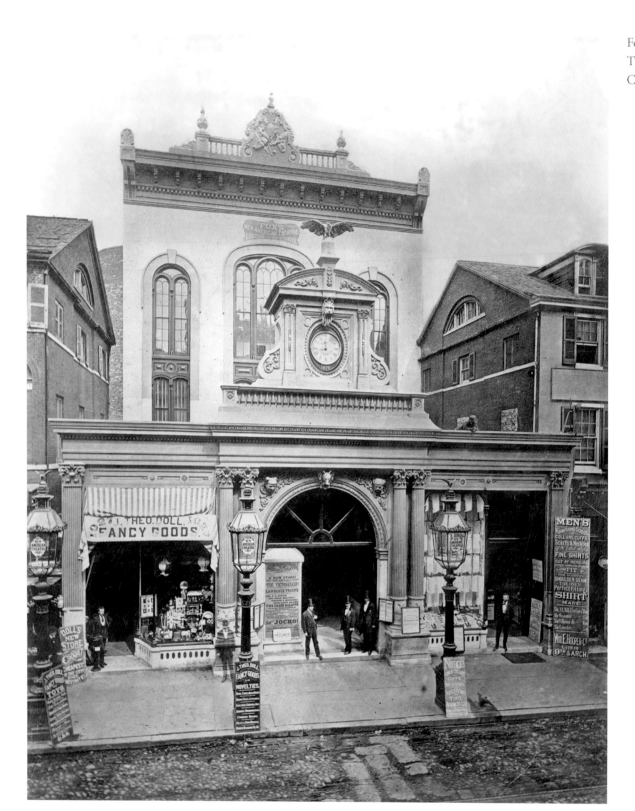

Fox's New American Theater, 10th and Chestnut streets, ca. 1885

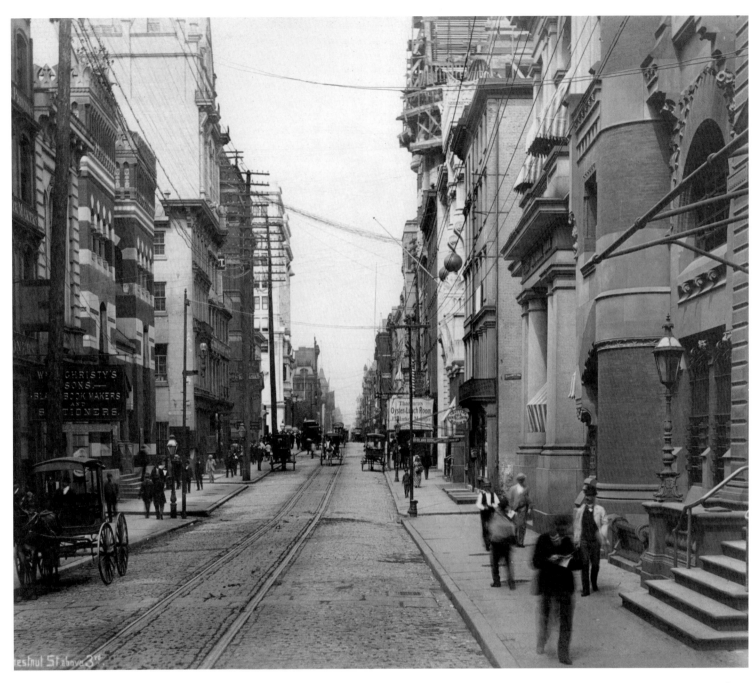

Chestnut Street, looking west from
3rd Street, ca. 1885

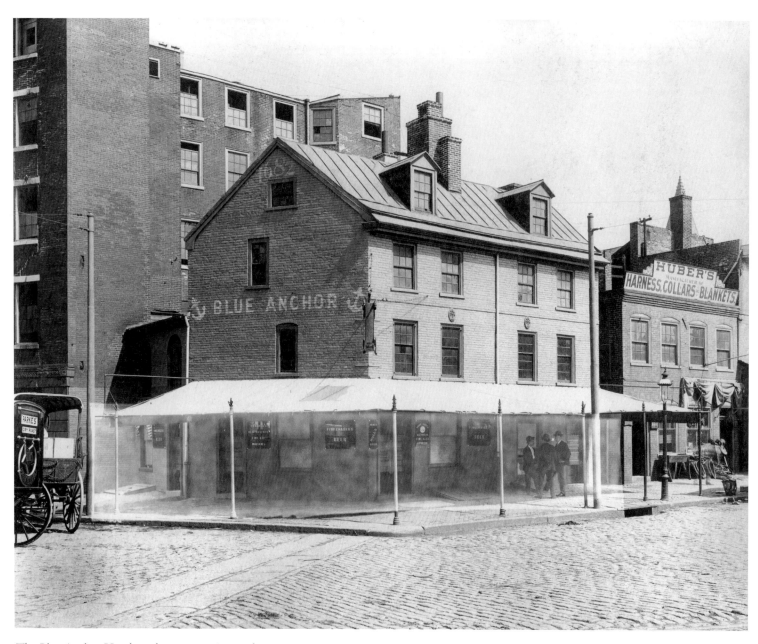

The Blue Anchor Hotel, under construction at the
time, is believed to have been where locals gathered
to greet city founder William Penn upon his arrival in
1682. This photo dates to ca. 1885.

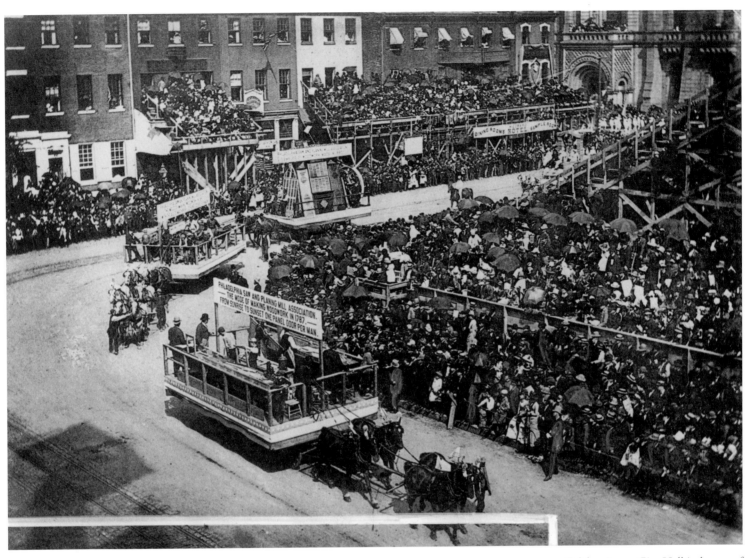

Celebration at City Hall in honor of
the centennial of the United States
Constitution, 1887

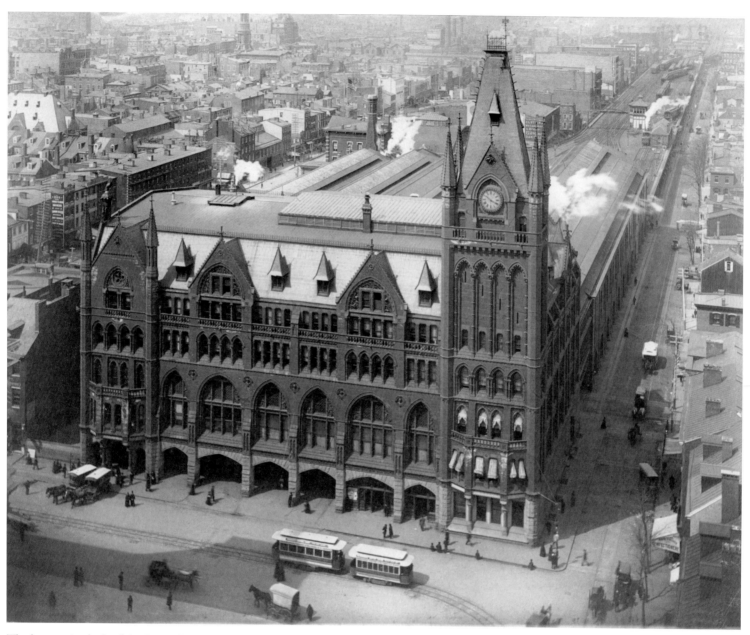

The large train sheds of the Pennsylvania Railroad Station are visible to the rear of the building in this photo ca. 1889, as is the "Chinese Wall," which supported the elevated train lines as they extended westward from the building. The station was demolished in 1953 and subsequently replaced with the below-ground railroad station and office building complex known as Penn Center.

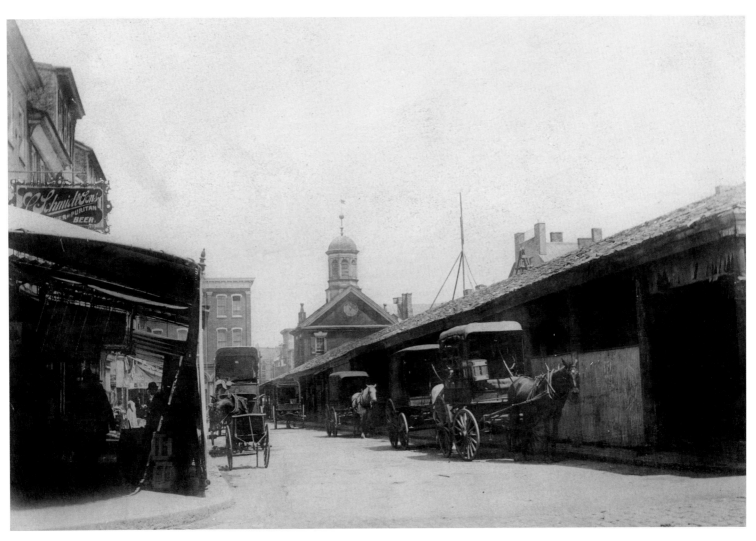

Market sheds along 2nd Street near
Lombard Street, ca. 1856. The
building in the center is the fire-
engine house (also known as the "head
house") built in 1805.

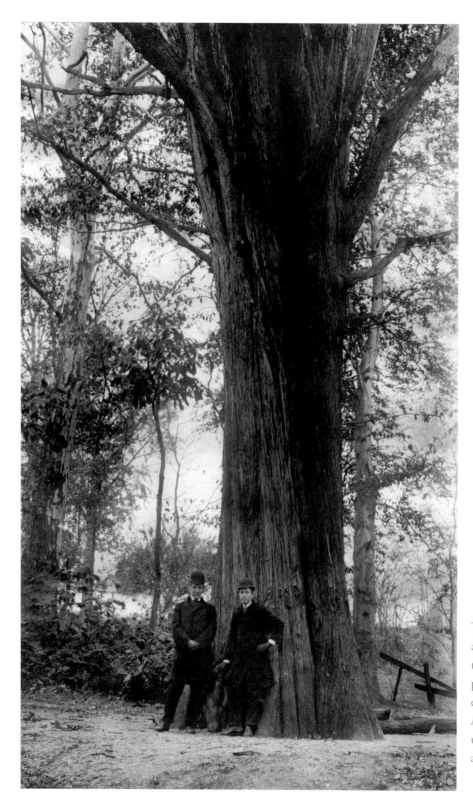

This photo of two men and a cypress tree was taken shortly after the city purchased the home and estate of John Bartram, America's first botanist, for use as a public arboretum and park.

36

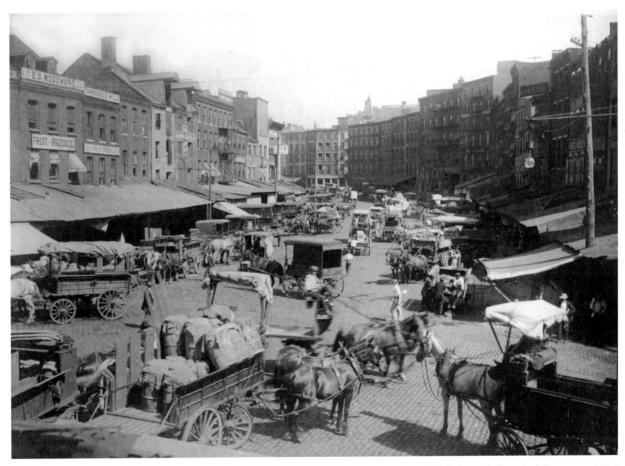

Dock Street below 2nd Street, ca. 1890

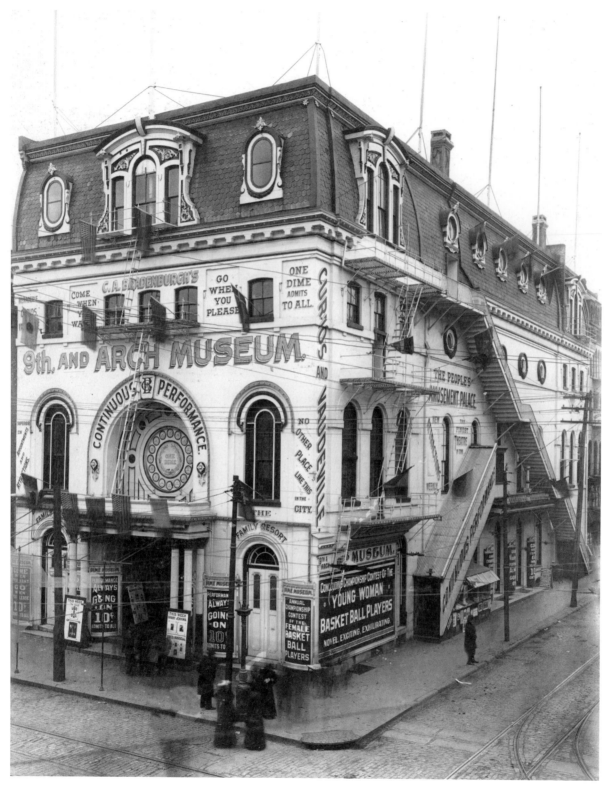

C. A. Bradenburgh's Museum was one of many "variety houses" in the city offering a wide selection of amusements, ranging from sports expositions to vaudeville performances. Photo ca. 1890s

The University of Pennsylvania's first library, designed by Frank Furness, ca. 1890. The building has recently undergone a complete restoration and is still in use.

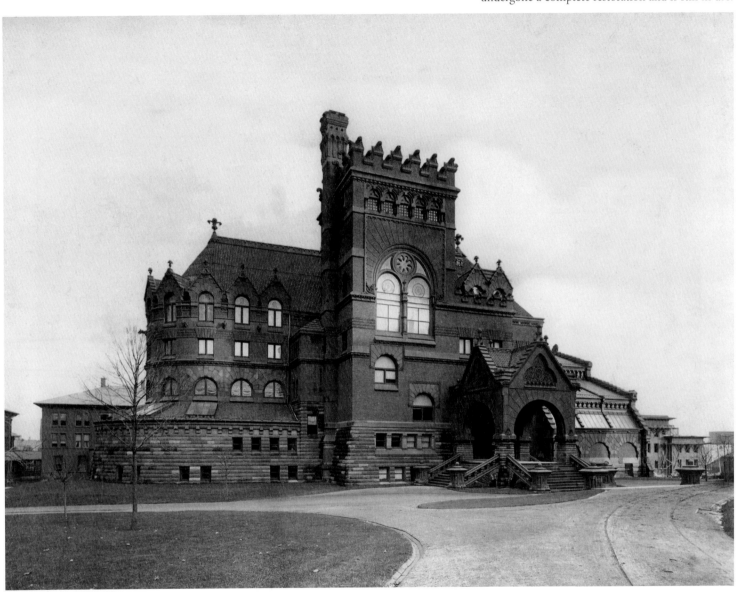

Garden of the Patterson mansion, 1892. The mansion, located at 13th and Locust
streets, is currently the home of the Historical Society of Pennsylvania.

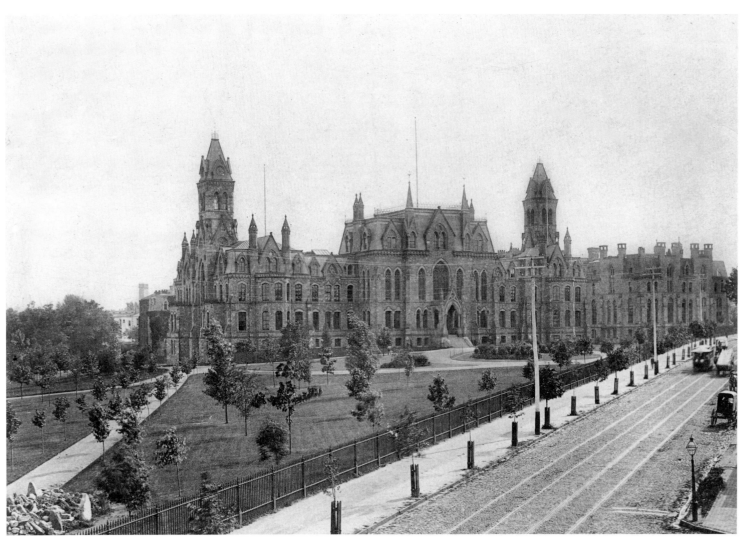

College Hall and Logan Hall viewed from Woodland Avenue, the
University of Pennsylvania Medical College, ca. 1892

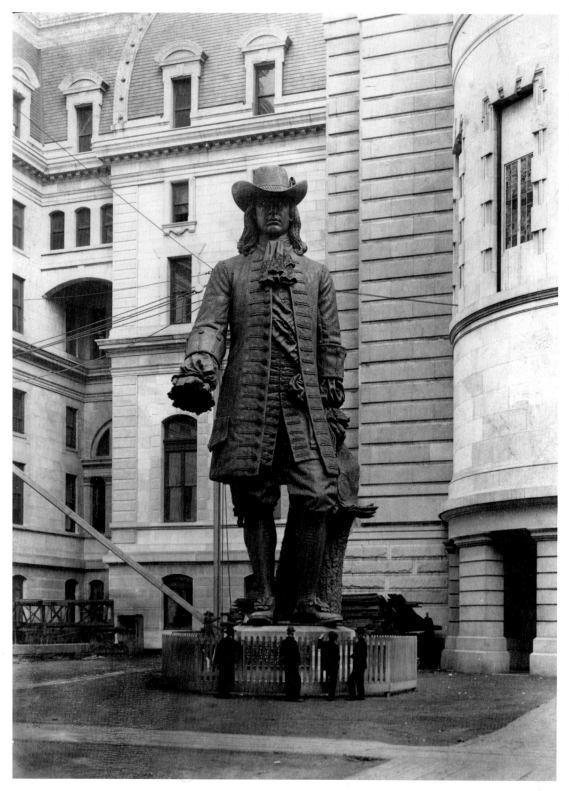

Sculptor Alexander Milne Calder's statue of Pennsylvania and Philadelphia's beloved founder, William Penn, was placed on display in the courtyard of the new City Hall for one year prior to its installation on the masonry tower in November 1894. It is the tallest known statue displayed on a building in the world.

Rigors' Detective
Agency, 13th and
Market streets,
ca. 1894

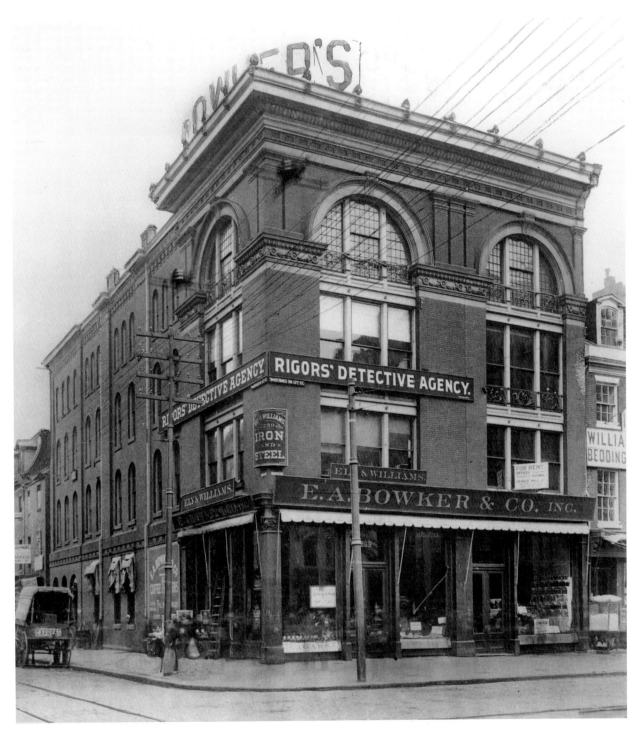

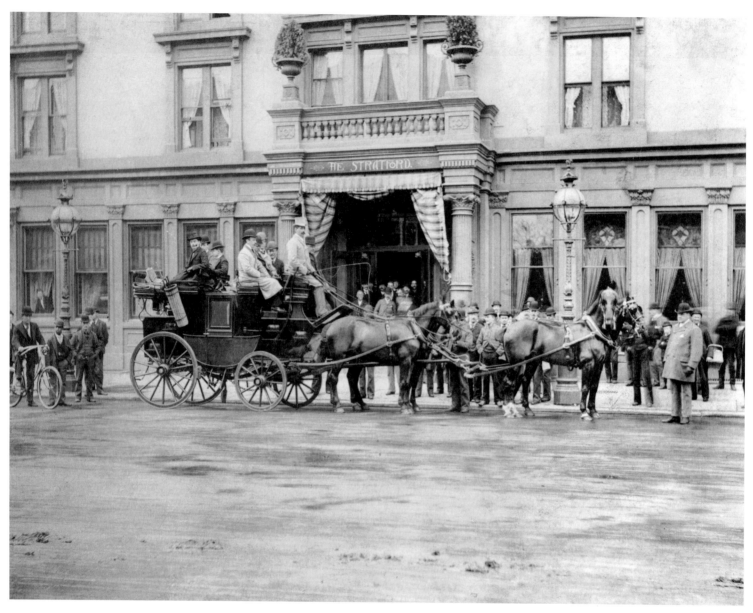

Within a few years of this photo taken in 1895, the Stratford
Hotel merged with its neighbor to form Philadelphia's most
famous hotel and ballroom, the Bellevue-Stratford.

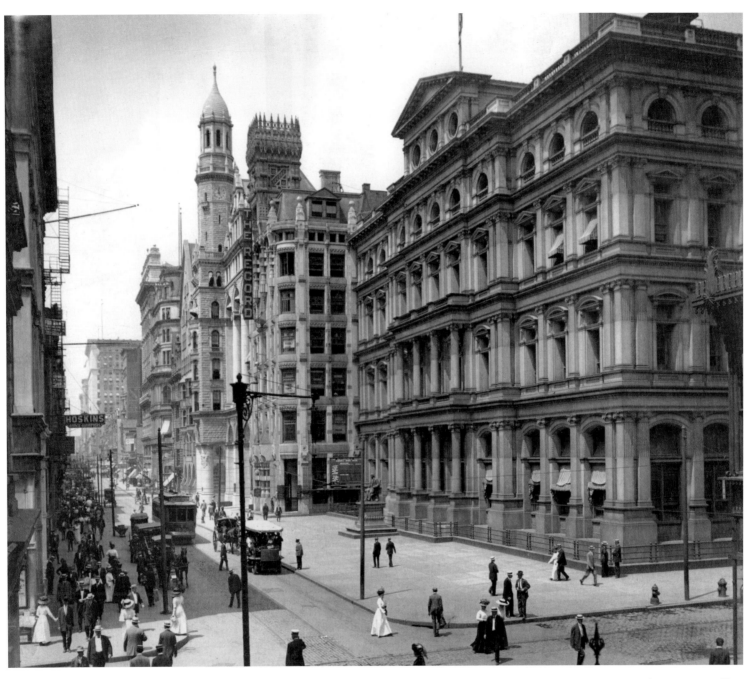

The large building in the foreground is the United States Post Office. Occupying a full block from Chestnut Street to Market Street at 9th Street, it was demolished prior to the 1935 construction of the current post office on the same site.

St. George's Hall, 13th and Arch
streets, ca. 1895

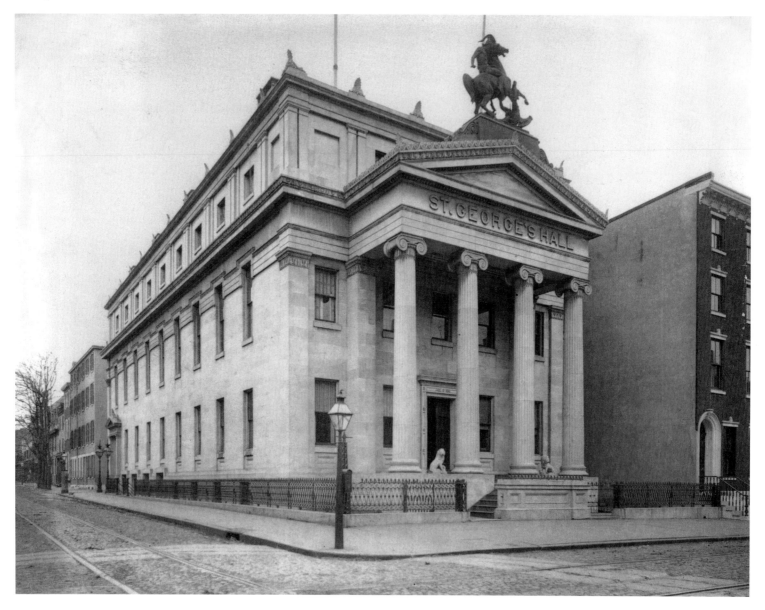

The Pennsylvania Museum and School of Industrial Art acquired this John Haviland-designed building, located at Broad and Pine streets, from the Pennsylvania Institute for the Deaf and Dumb in 1893, shortly after this photo was taken. Built in 1824 and now home to the University of the Arts, it is the oldest surviving building on Broad Street.

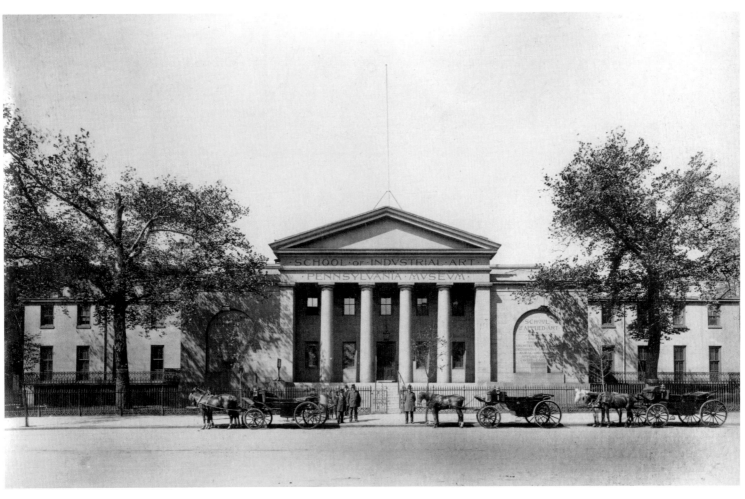

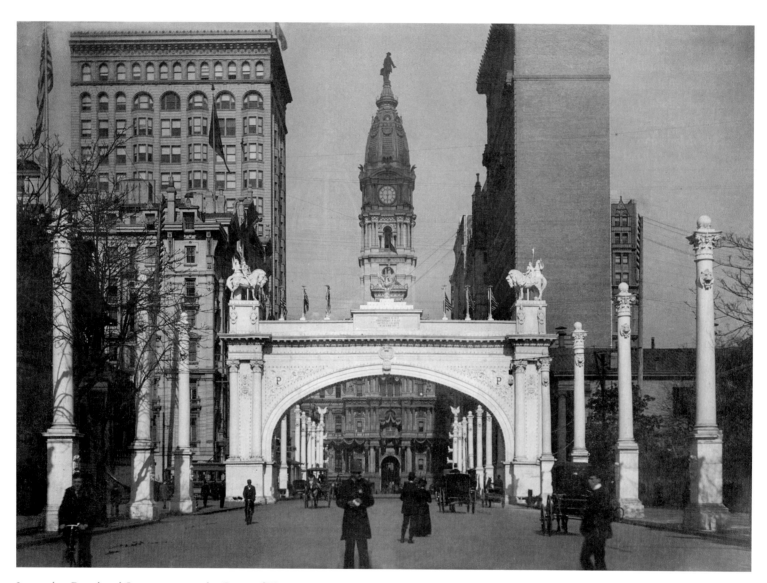

Located at Broad and Sansom streets, the Court of Honor was temporarily erected in October 1898 as part of a three-day celebration of the end of the war with Spain.

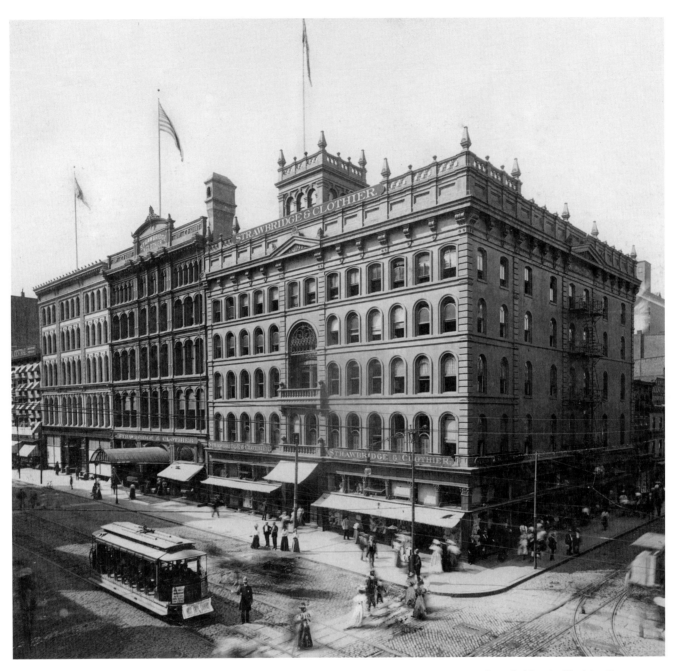

Strawbridge & Clothier Department
Store, 8th and Market streets, ca. 1898

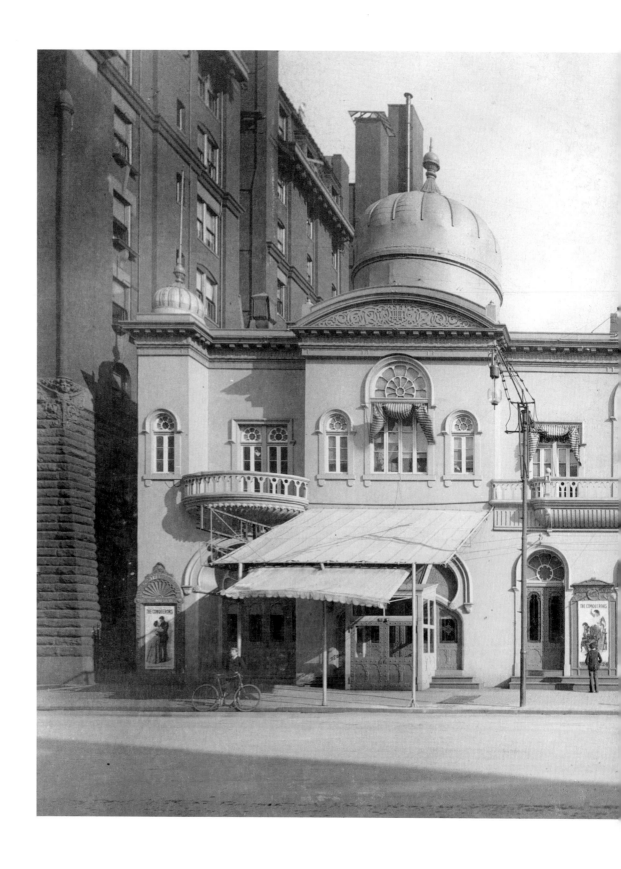

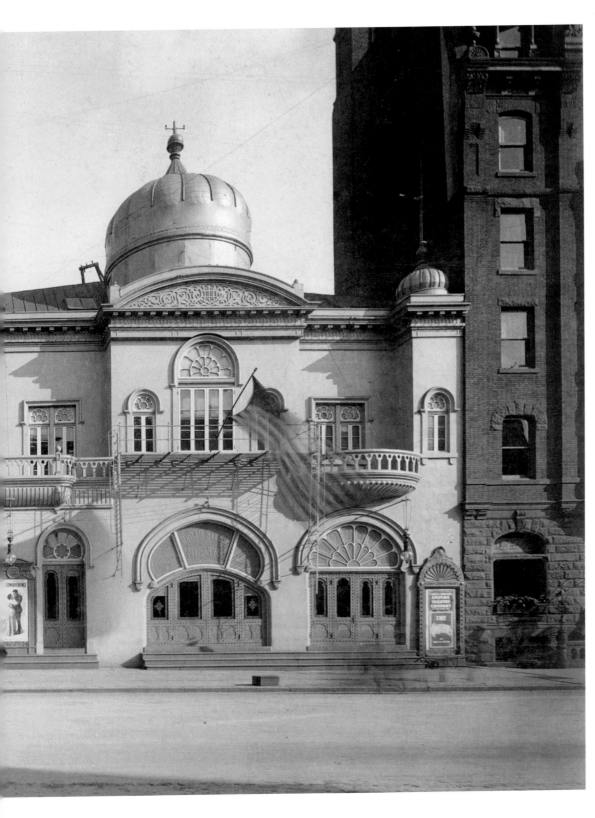

Broad Street Theater, Broad and
Locust streets, ca. 1898

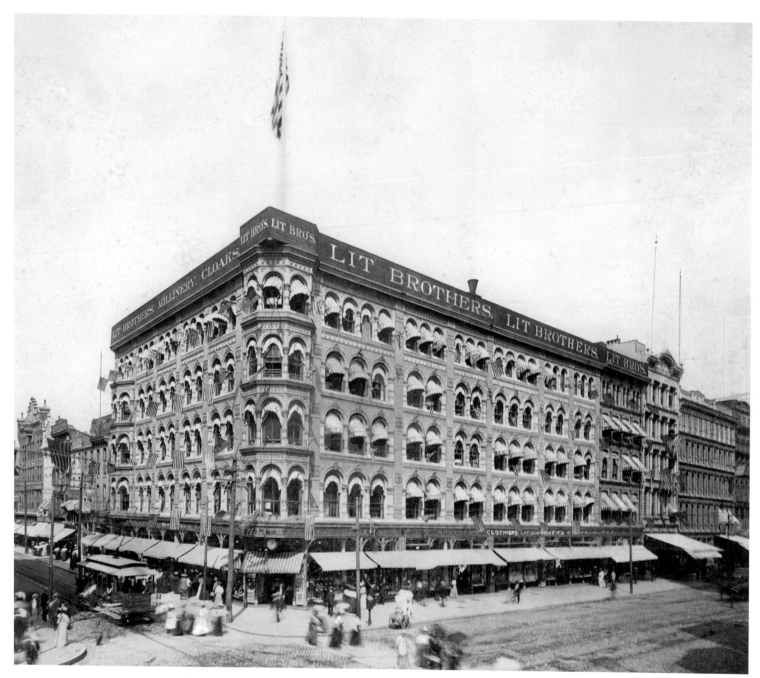

Famous for its wide selection of ladies hats, Lit Brothers Department Store opened in 1891 and finally closed its doors in 1977. Ten years later, the crumbling building at the corner of 8th and Market streets was at the center of a widely publicized and successful effort to restore and reconfigure the building into office space.

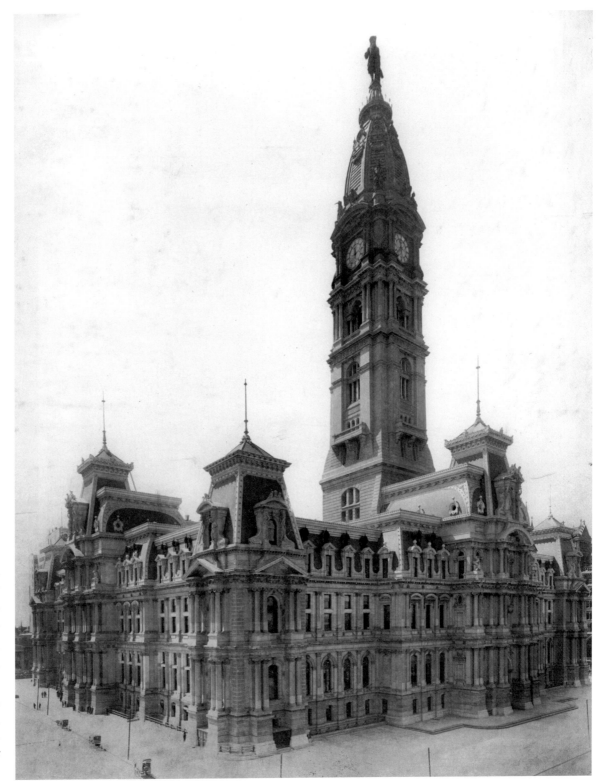

Towering over 511 feet, Philadelphia's grand City Hall is the tallest masonry building in the world. Reviled by many people from its inception in 1860 through its completion in 1901, the country's largest and most expensive municipal building continues to serve as the primary seat of Philadelphia government.

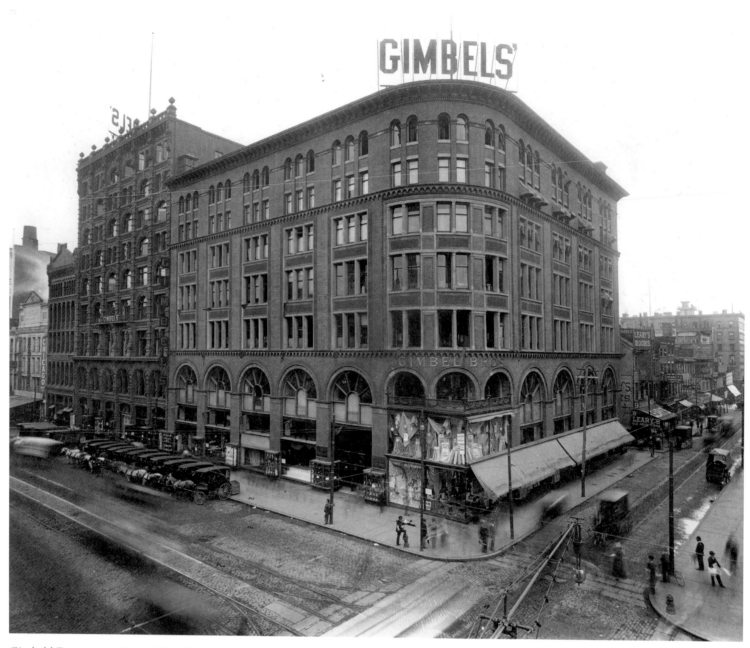

Gimbels' Department Store, 9th and
Market streets, ca. 1899

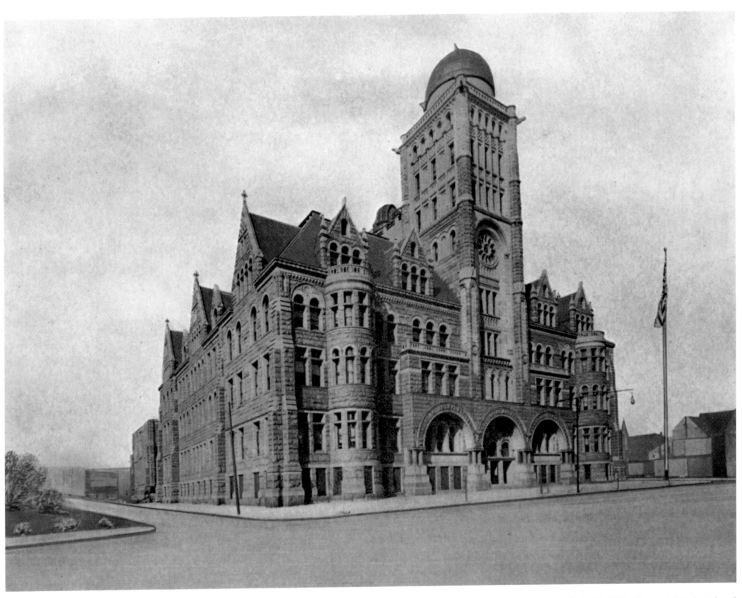

Located in the 600 block of North Broad Street, this building was the third home for Philadelphia's Central High School for Boys, the second oldest public school in the country. Open to girls for the first time in 1983 as the result of a legal challenge, the school is currently located in North Philadelphia at Olney and Ogontz avenues.

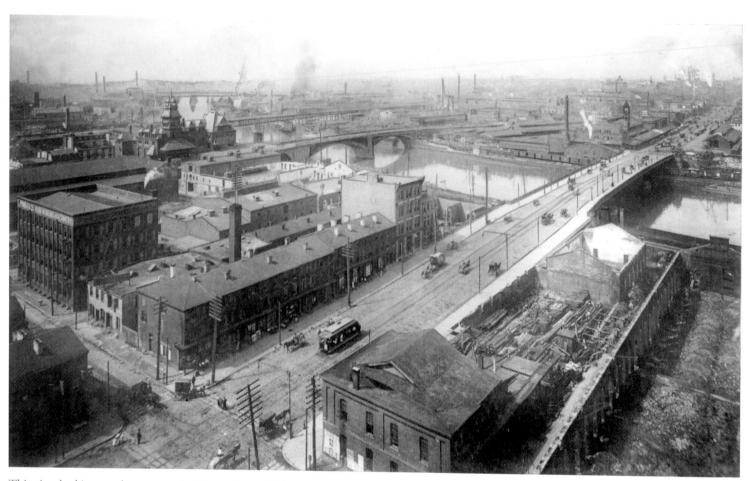

This view looking southwest over the Market Street Bridge and the Schuylkill River illustrates the extent to which the western part of the city had become heavily industrialized by the end of the nineteenth century.

A Time for Work and a Time for Play

1900–1919

The first two decades of the new century saw little change in Philadelphia's role as "workshop of the world. Large industries continued to dominate the region, especially those that served the country's need for machines to move people and products from place to place.

By 1910 the city's first elevated train lines, on Market Street and Broad Street, were running smoothly and combined with dozens of other streetcar lines to provide extensive access to public transportation. Additionally, where there had been fewer than 500 automobiles and trucks in the city at the turn of the century, nearly 100,000 crowded the downtown streets by the end of World War I.

In tandem with the increased ease of regional travel, Philadelphia offered unlimited opportunities for amusement to wealthy and poor alike. Dozens of vaudeville theaters, dime museums, and nickel theaters stood side by side with the city's more elegant restaurants, theaters, and music palaces. Ferries regularly traveled between Philadelphia and various points "down the shore" in New Jersey, where cities like Atlantic City and Wildwood enjoyed new favor as the perfect spot for a holiday or day trip.

The city's many industries proved useful to the nation during the First World War, and Philadelphia thrived. Shipbuilding, which was on the decline before the war, was the primary industry to benefit from the need to send war supplies overseas. Baldwin Locomotive works began to manufacture artillery shells and railroad gun mounts, in addition to nearly 500 locomotives of various types. The city's leather, textile, and steel industries also saw a dramatic increase in production. Despite the difficulties of war shortages and the disastrous Influenza Epidemic of 1918, the city prospered.

But even as the city seemed to flourish, increased concerns over immigration, labor reform, and an unchecked political machine hinted at the challenges the city would face in the years to come.

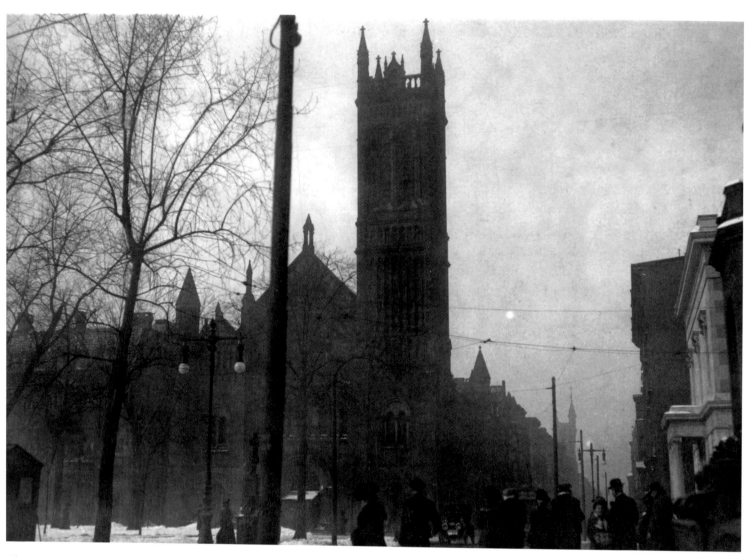

Church of the Holy Trinity, 19th and
Walnut streets, ca. 1900

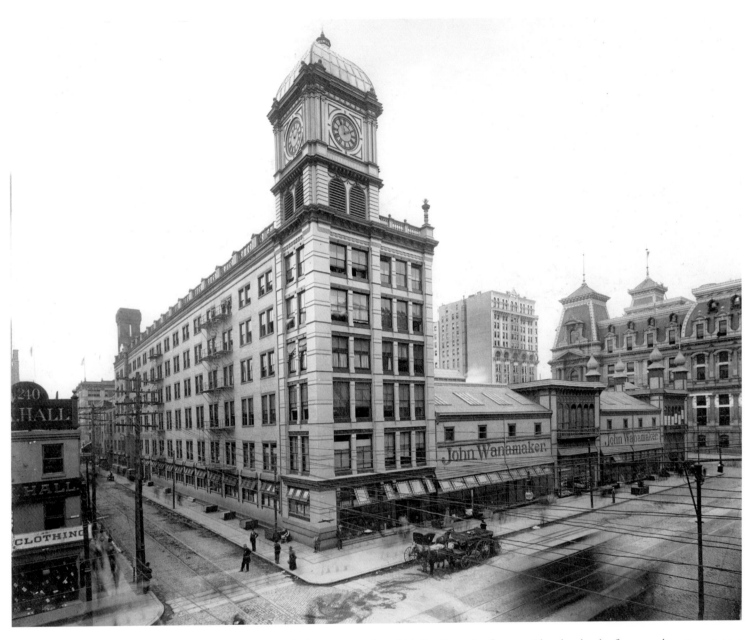

John Wanamaker's store at 13th and Market Street is often considered to be the first true department store in the country. Innovative in display and marketing techniques, Wanamaker's remained an important retail business until it began to decline in the 1980s and was ultimately absorbed by Hecht's in 1995. This building, known as the Grand Depot, was demolished to make way for the new store, opened on this site in 1905.

Market Street Trolley Loop, Delaware
Avenue and Market Street, ca. 1900

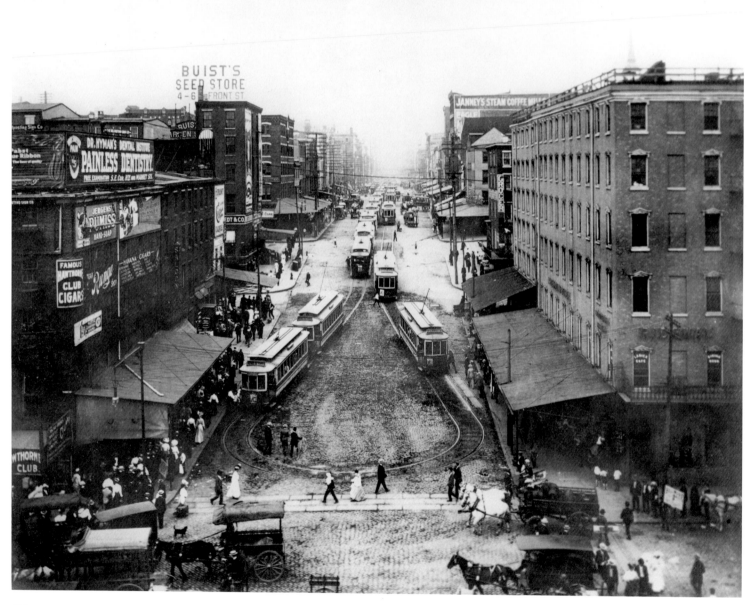

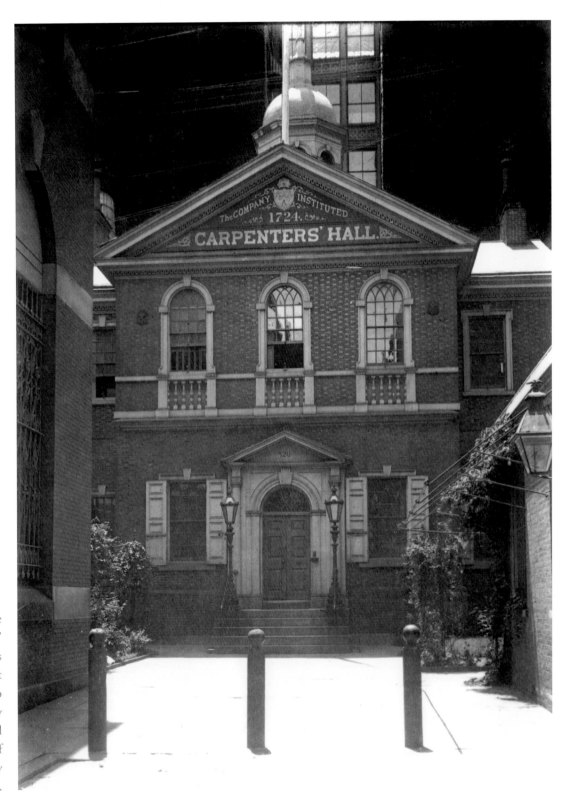

Now a part of Independence National Historical Park, Carpenters' Hall was built by the carpenter's guild as a meeting hall in 1770. It served many roles in the years to follow, most notably as the assembly place for the First Continental Congress in 1774 and the location of the nation's first bank robbery in 1798.

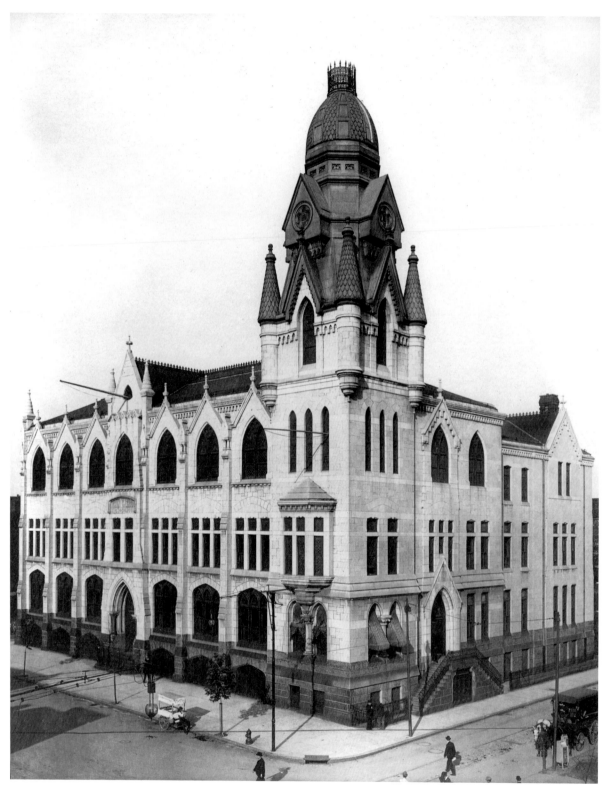

Roman Catholic High
School of Philadelphia,
Broad and Vine streets,
ca. 1900

As a result of the patriotic fervor and growing interest in Philadelphia history during the Centennial Exposition in 1876, this small tenant house became one of America's enduring icons. It is believed that Betsy Ross sewed the first American flag while renting this home.

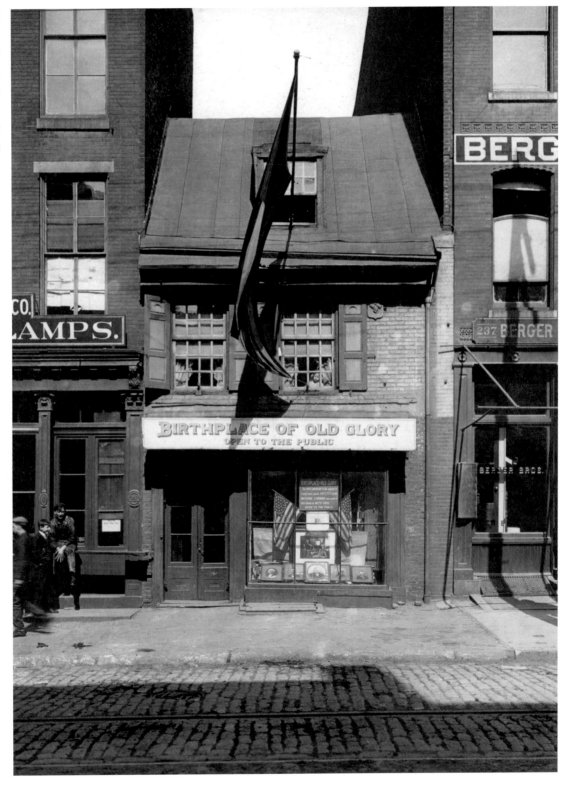

One of the many private art and culture clubs that served as meeting places and exhibit venues for Philadelphia's prolific community of artists, the Philadelphia Art Club was located at Broad Street near Walnut Street. The building was completed in 1896 and demolished a century later.

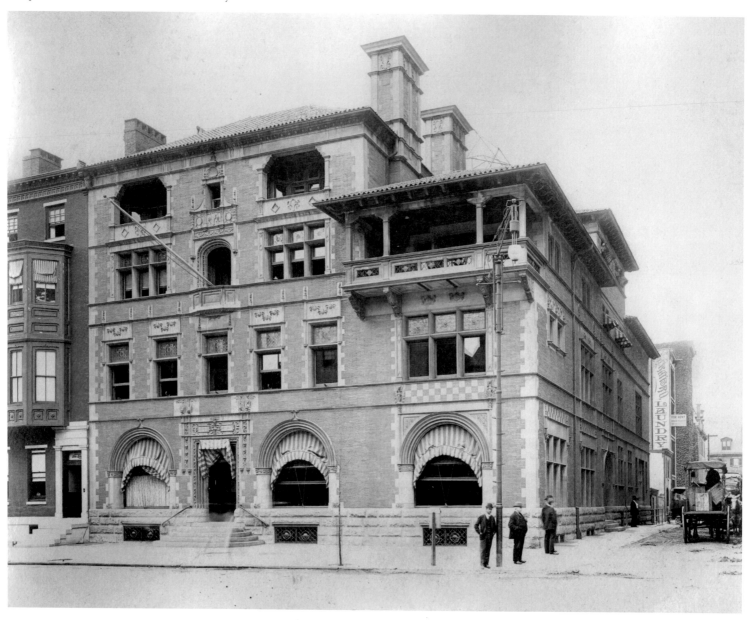

Masonic Temple, northeast corner of Penn Square at Broad Street, ca. 1900

Broad Street, looking north from Walnut
Street toward City Hall, ca. 1900

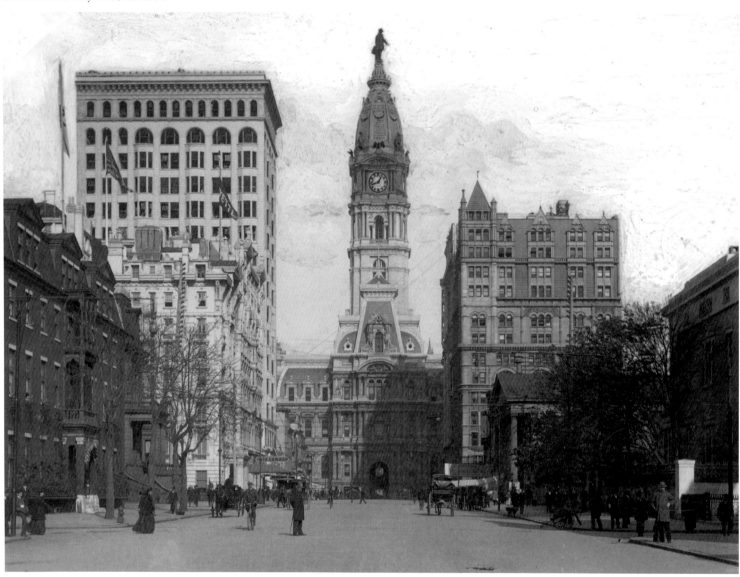

Philadelphia streetcars, 8th and
Market streets, ca. 1900

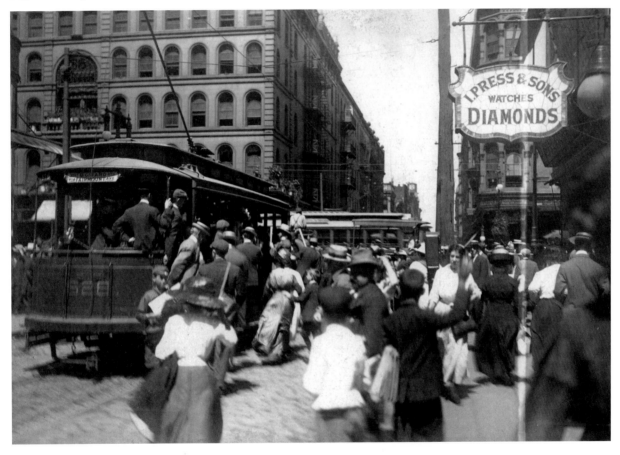

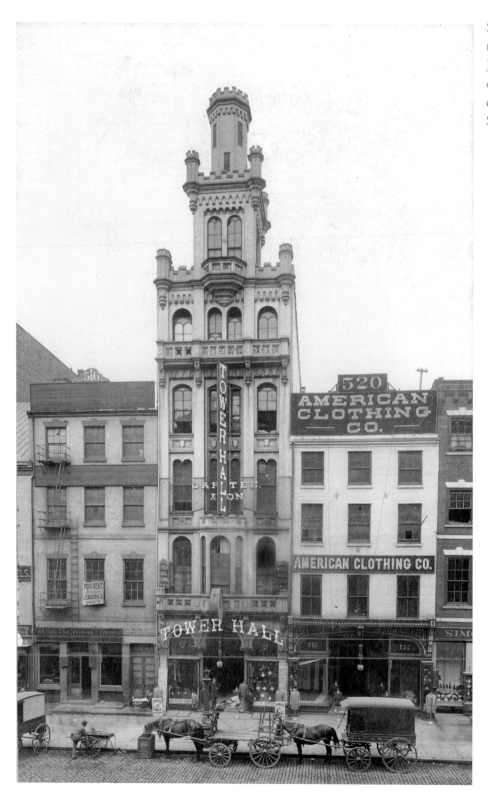

Seen here in 1900, this remarkable home to Joseph M. Bennett's clothing business was designed and built by Samuel Sloan in 1867.

In this view of the west side of Penn Square and Broad Street in 1903, the large portico and columns to the right form the southwest corner of City Hall.

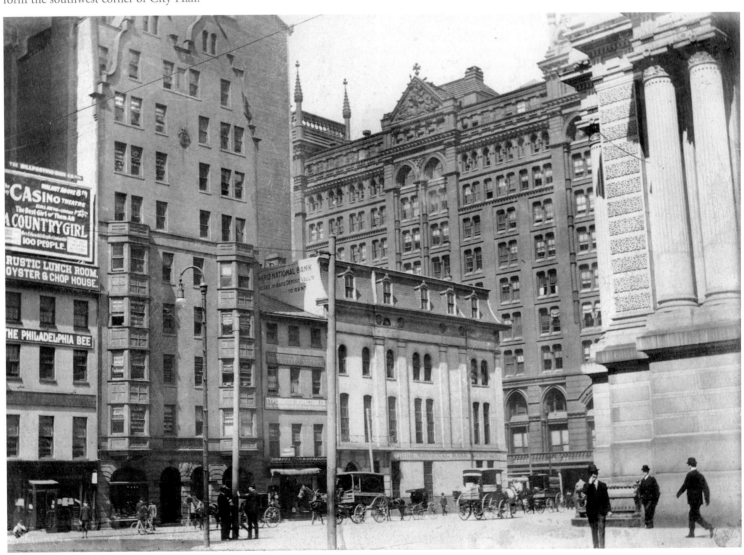

The Union League, on Broad Street near Walnut Street, is a private society organized in 1862 in support of the Republican policies of President Abraham Lincoln. In this photo, a large campaign billboard from 1904 shows the League's support of Theodore Roosevelt and his running mate Charles Fairbanks. The League continues today as an important private club.

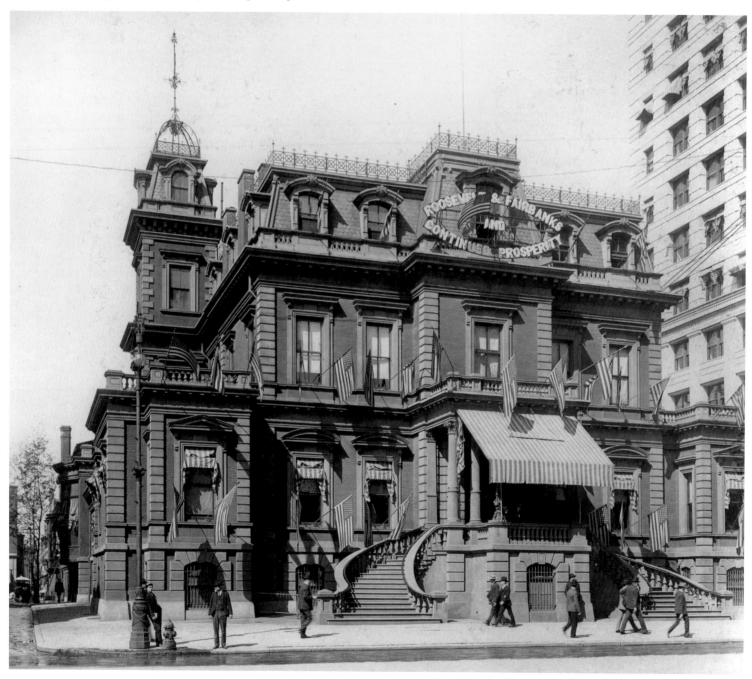

Christ Episcopal Church on 2nd Street near Market Street served as the religious home to many of Philadelphia's most important residents, among them Benjamin Franklin, Betsy Ross, and George and Martha Washington. It is the birthplace of the American Episcopal Church.

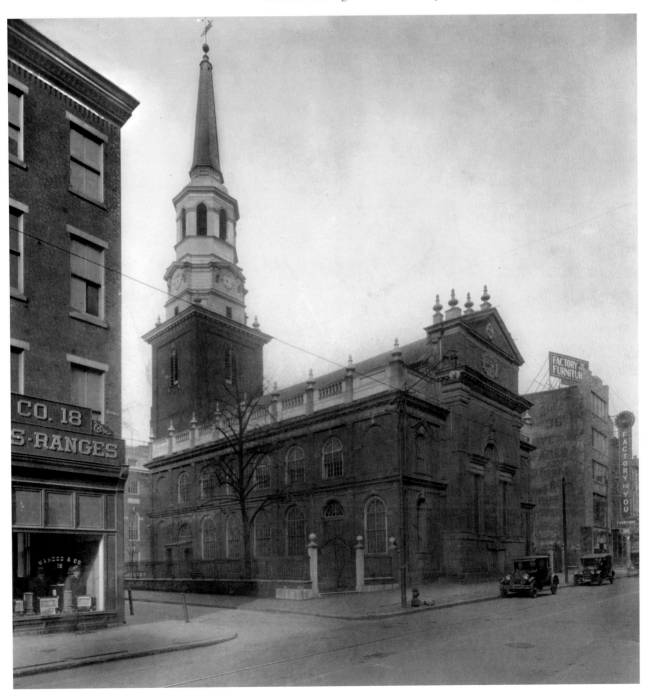

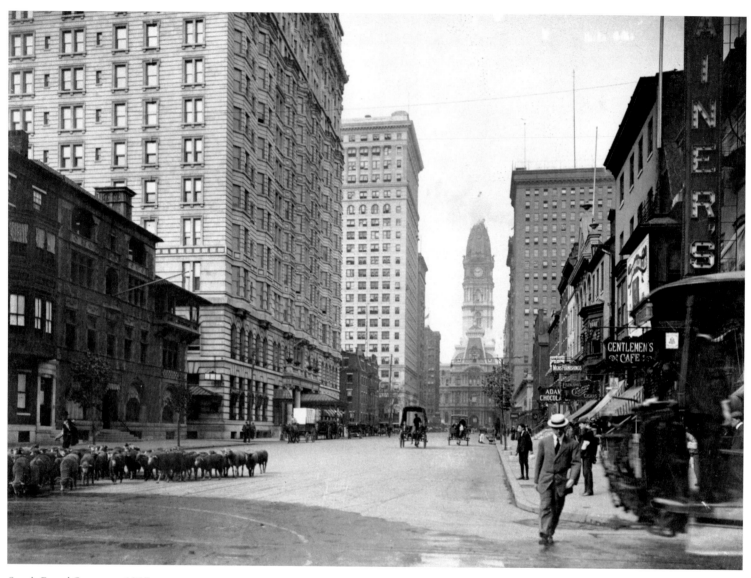

South Broad Street, ca. 1905

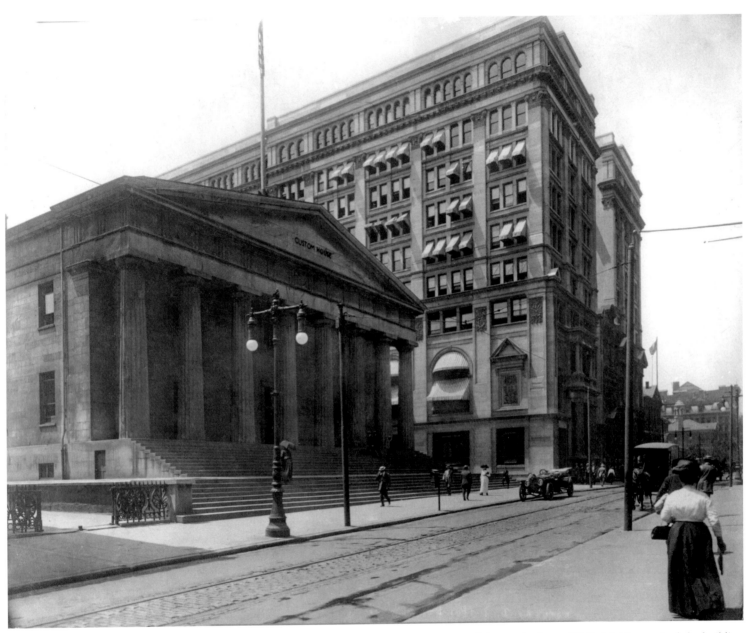

Completed in 1824 as the Second Bank of the United States, the Port of Philadelphia acquired the building located on Chestnut Street near 4th Street in 1841 and used it as a Custom House until 1934. Fifteen years later, the abandoned building was included in the development of Independence National Historical Park and is currently a national portrait gallery.

One of two statues now located on the north side of City Hall, the sculpture depicting Civil War General George B. McClellan on horseback is moved to its final position on May 18, 1906.

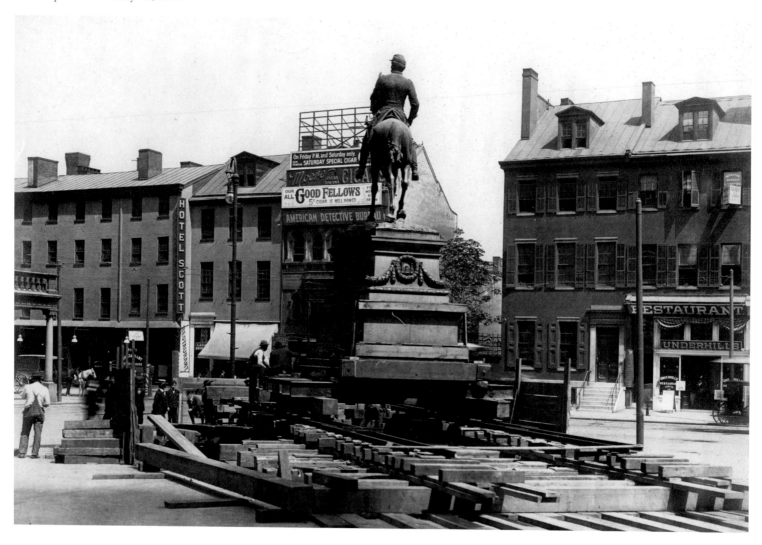

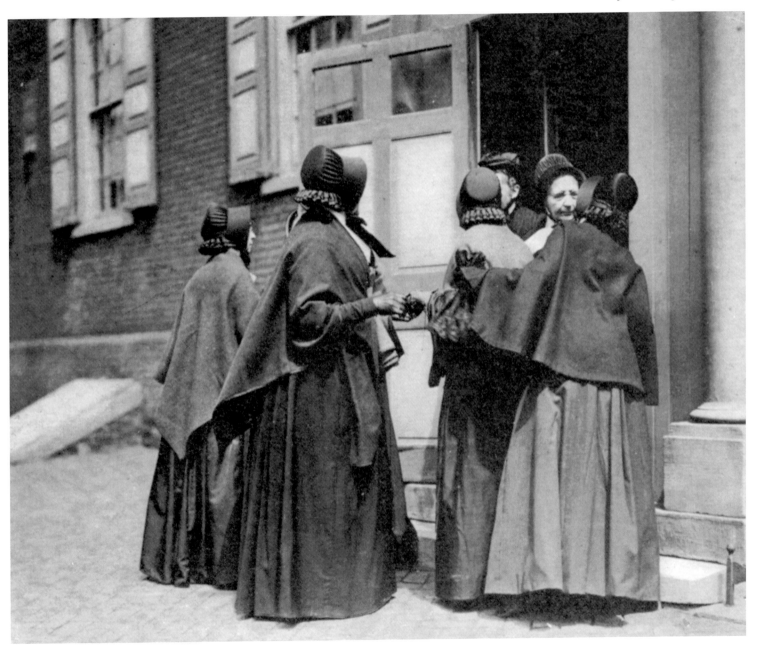

Construction of the Market Street
Subway, Philadelphia Rapid Transit
Company, October 7, 1906

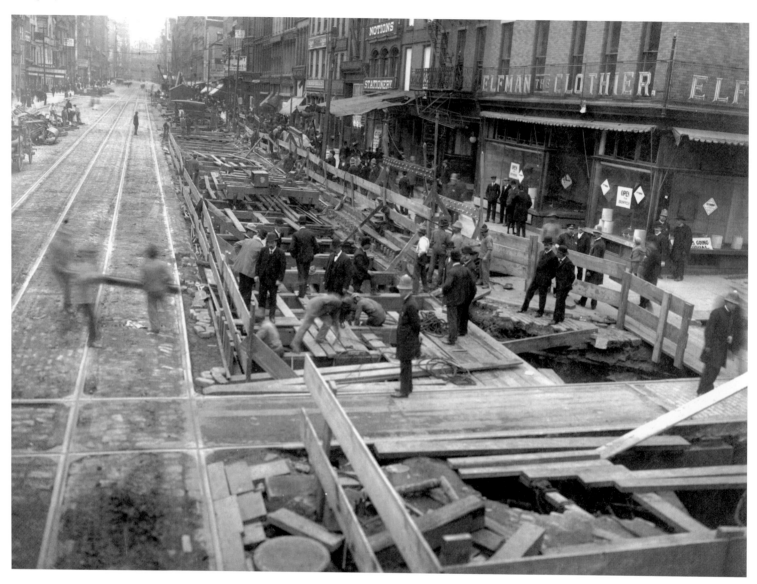

Market Street at Broad Street, 1907. This view shows the pedestrian bridge between the Broad Street station and Pennsylvania Railroad offices in the Arcade building.

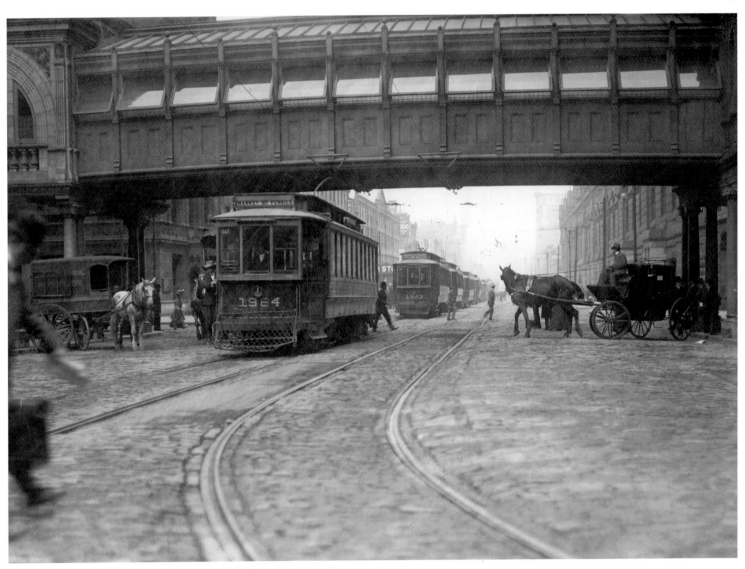

Market Street, looking west from 12th
Street, June 23, 1907

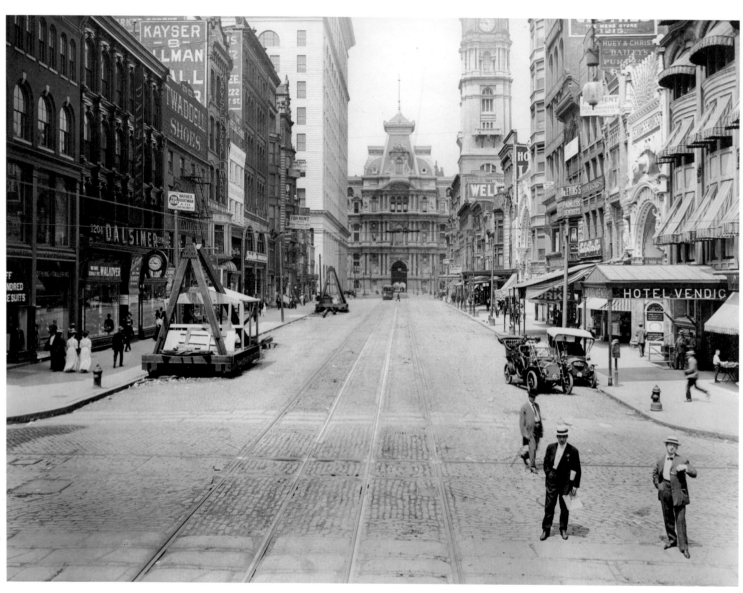

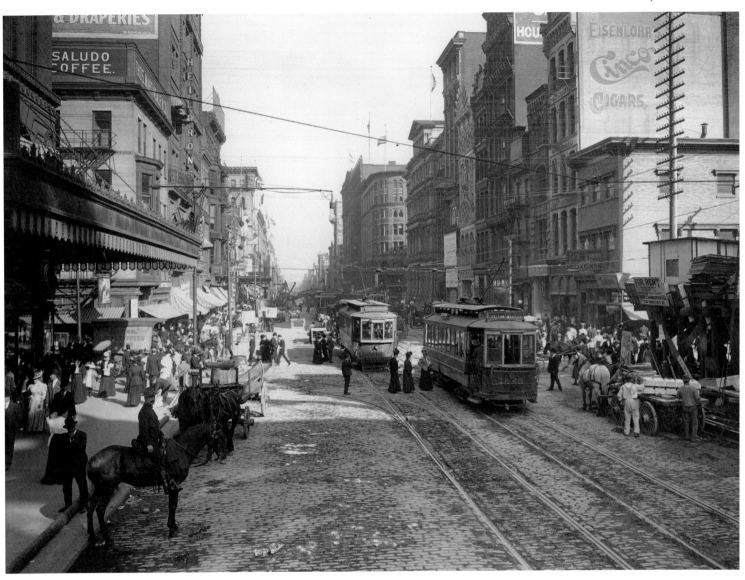

View of Philadelphia across the Delaware River
looking west from Kaighn's Point, Camden,
New Jersey, ca. 1910

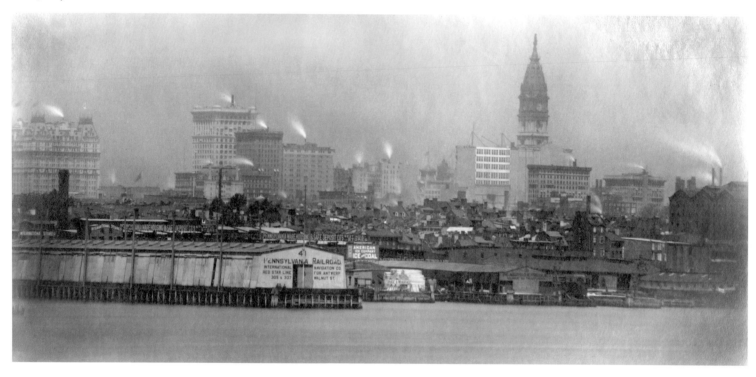

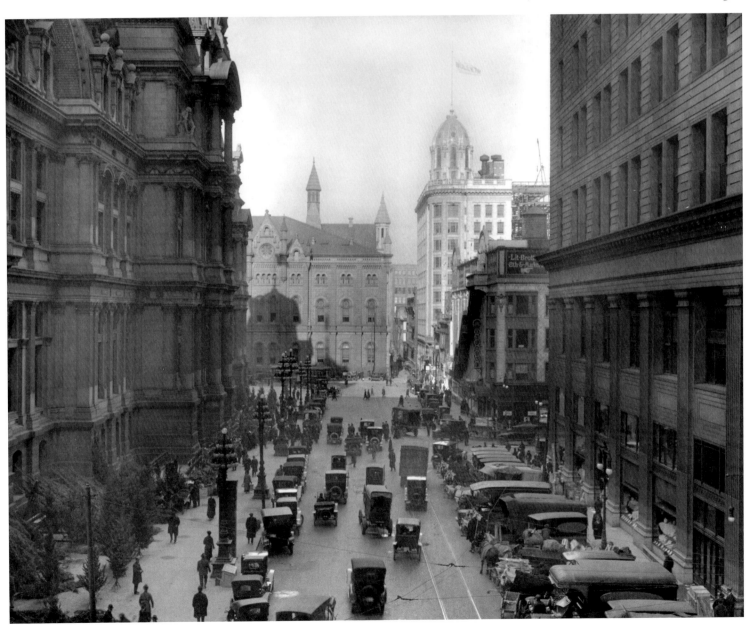

Traffic on East Penn Square, City Hall, ca. 1910. City Hall is to the left, and Wanamaker's new store is to the right.

The Metropolitan Opera House was commissioned by New York opera and theater builder Oscar Hammerstein I (grandfather to the famous Broadway producer) in 1907. The building is currently occupied by a local church and is undergoing renovations.

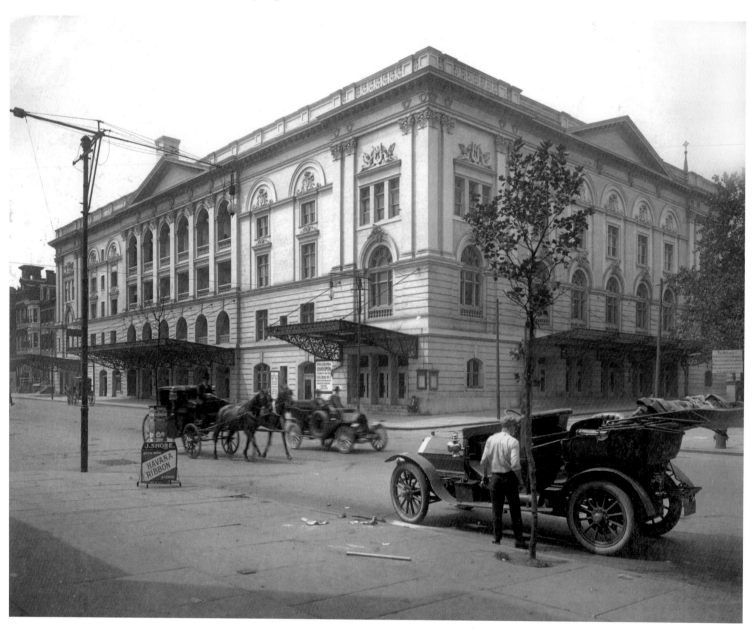

The homes in this unidentified neighborhood are typical of those that were built in North and West Philadelphia at the turn of the century. Photo ca. 1910

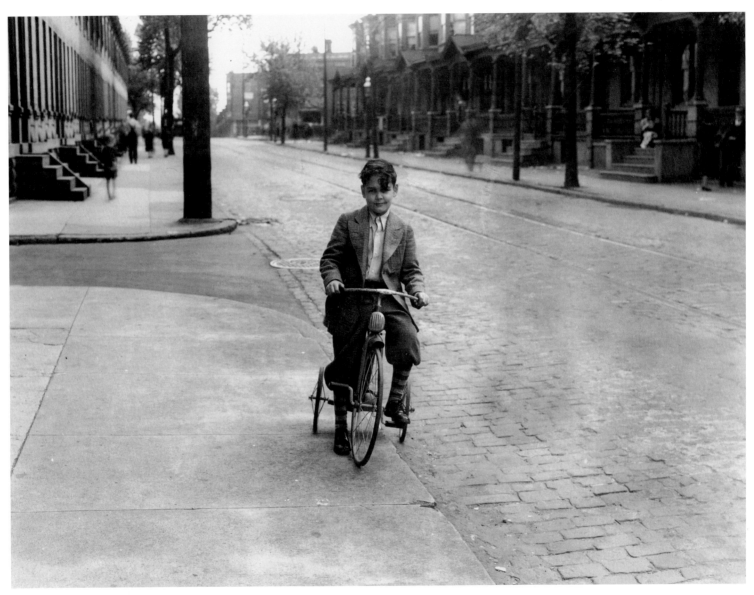

Horace Furness Public School, 2nd and Mifflin streets, ca. 1910

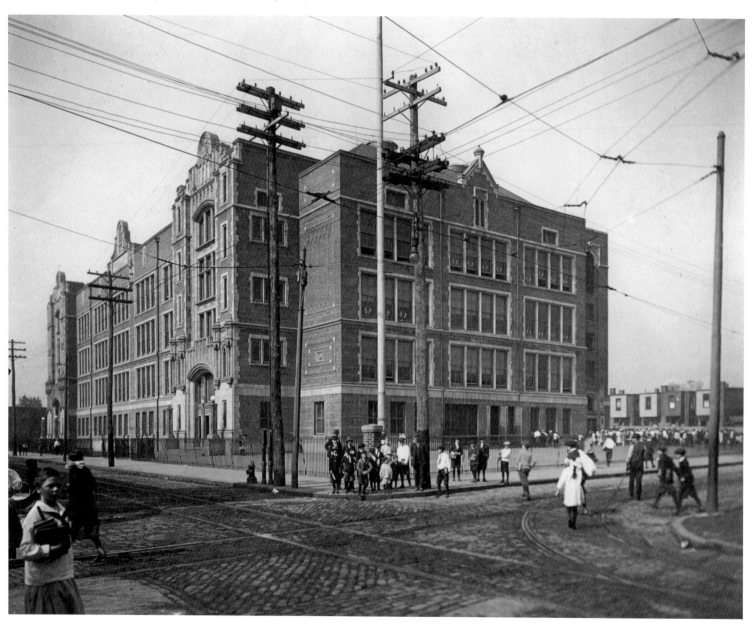

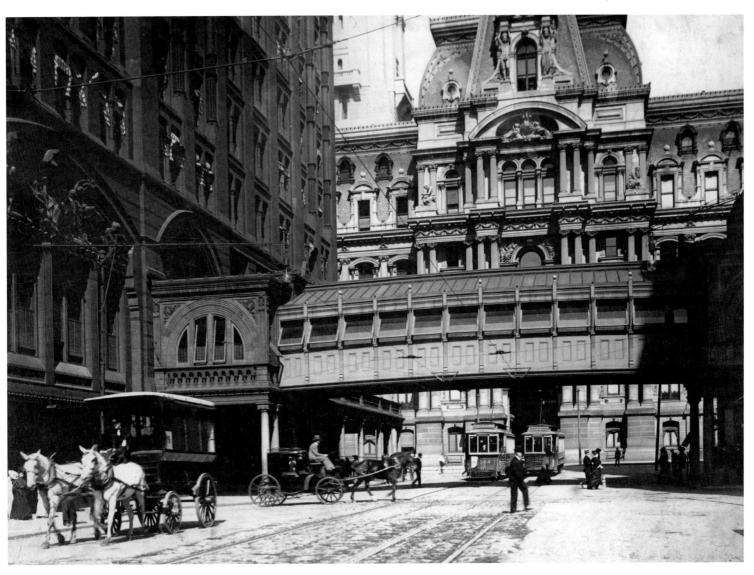

15th and Market streets looking east to City Hall, ca. 1910

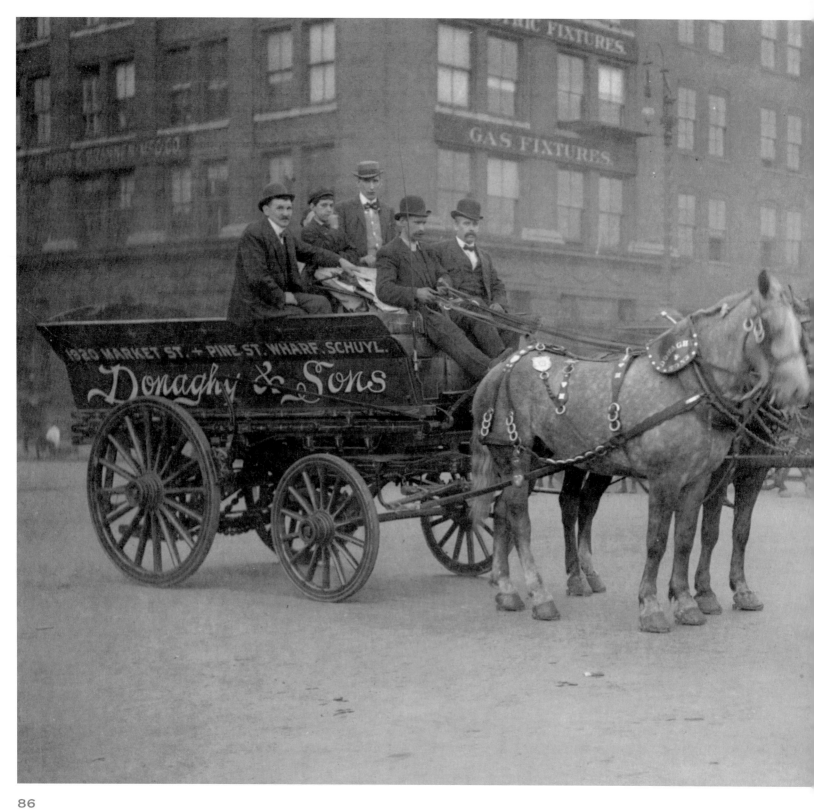

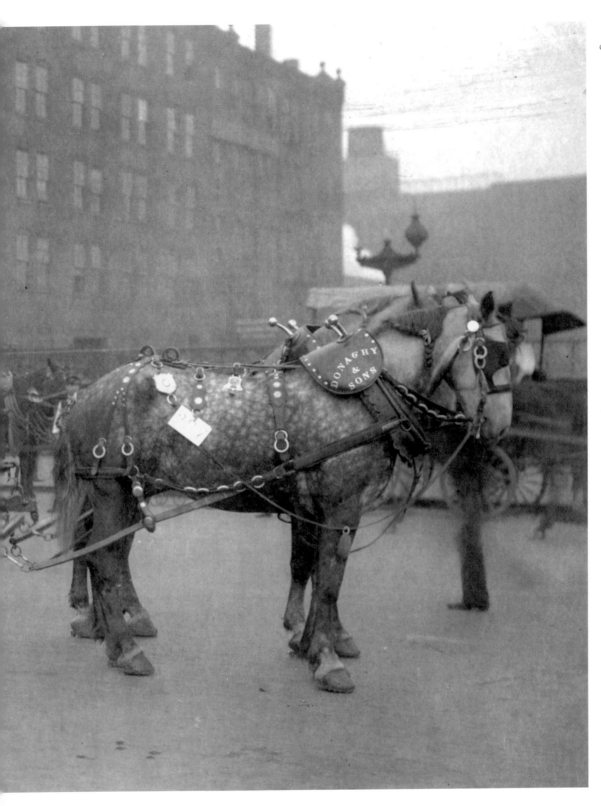

Donaghy & Sons, purveyors of coal, ca. 1910

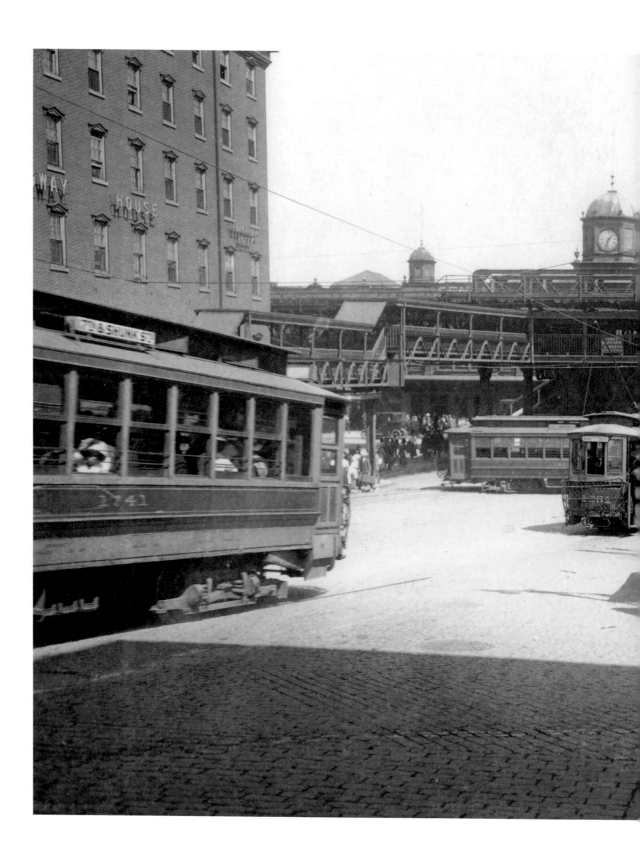

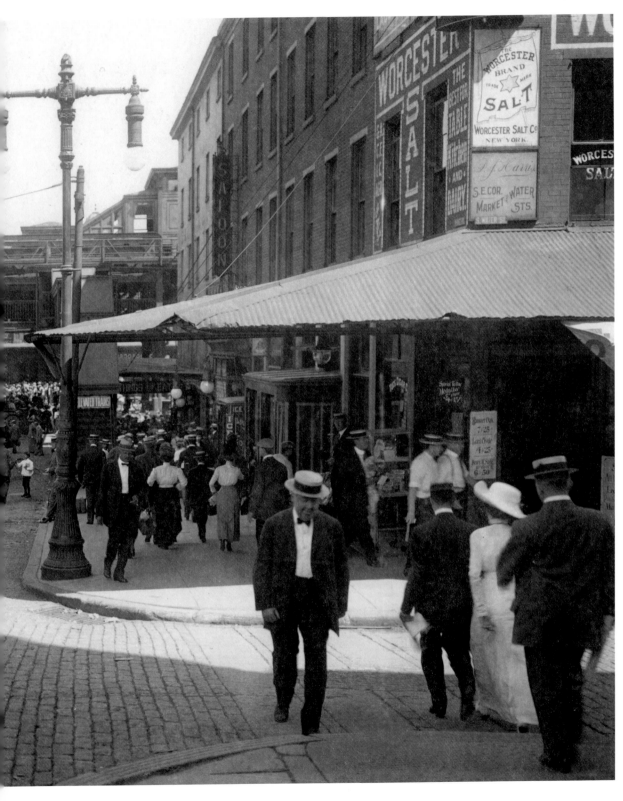

The ferry station linking Philadelphia to Cape May and other New Jersey points south was located at the easternmost end of Market Street. In this photo ca. 1900, the Market Street trolley "loop" can be seen as well as the Delaware Avenue elevated train line completed in 1908 and discontinued thirty years later.

The Pennsylvania and Reading Railway Terminal Head House at
12th and Market streets, seen here in July 1911, is now part of the
Pennsylvania Convention Center.

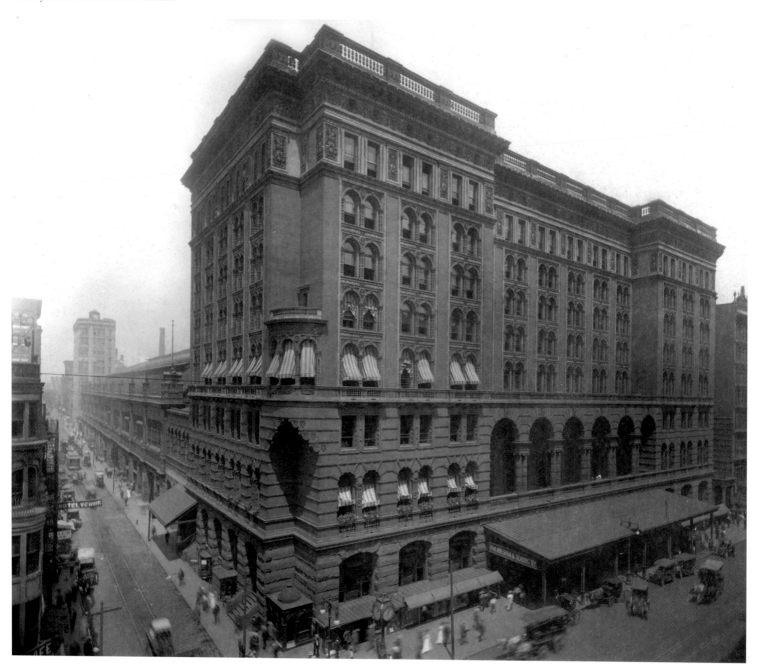

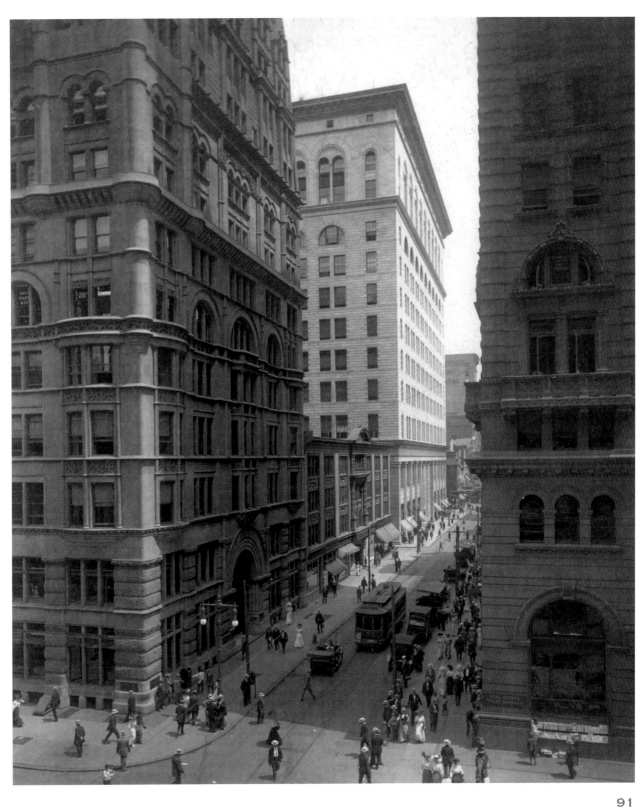

Chestnut Street
at Broad Street,
August 1911

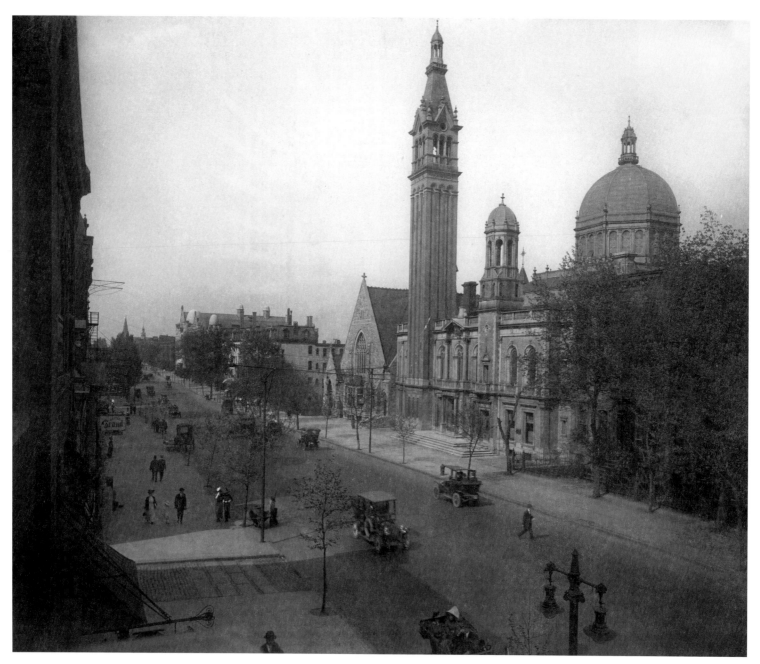

Keneseth Israel Temple, currently located in Elkins Park, Pennsylvania, was the first Jewish reformed congregation in Philadelphia. This view shows the temple in North Philadelphia at Broad Street and Columbia Avenue in 1911.

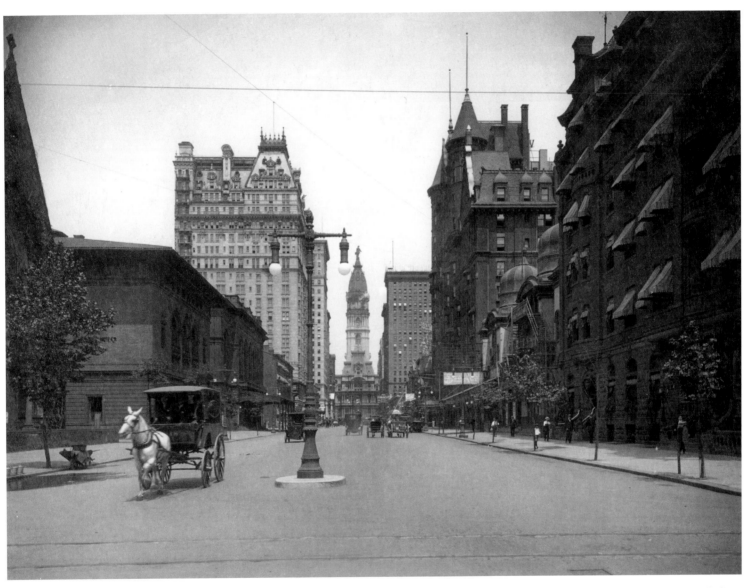

Broad Street, looking north from
Spruce Street, August 1911

By the time this photo was taken in 1913, fewer horses populated the city as the number of automobiles and electric streetcars increased. Prior to 1900, well over 10,000 horses traveled the streets of the city, pulling countless wagons, carriages, carts, and streetcars.

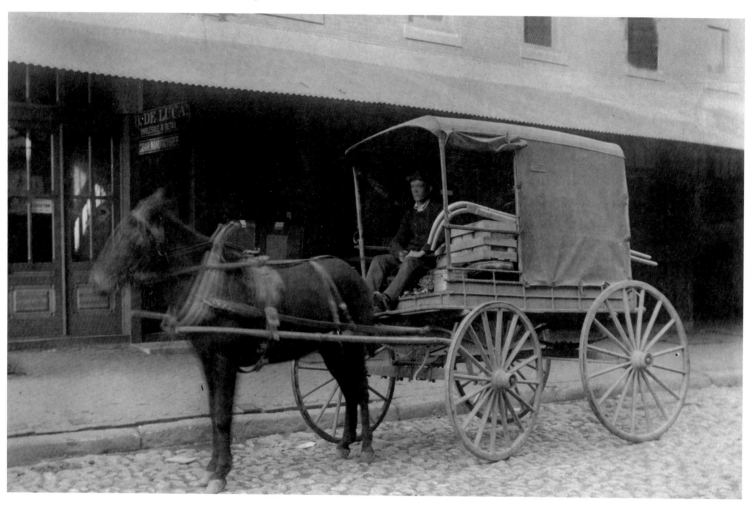

A reflection of the city's position as a major port along the eastern seaboard, Philadelphia was home to hundreds of oyster houses like the one pictured here in 1913, many catering to a late-night crowd.

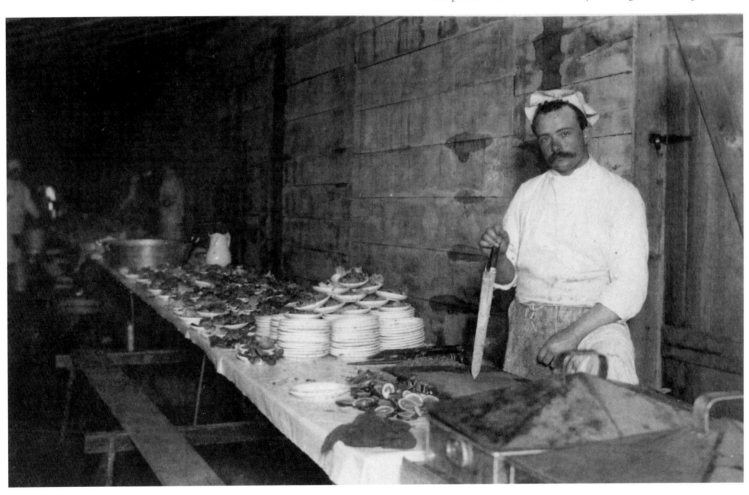

Football game, Franklin Field,
University of Pennsylvania,
December 9, 1913

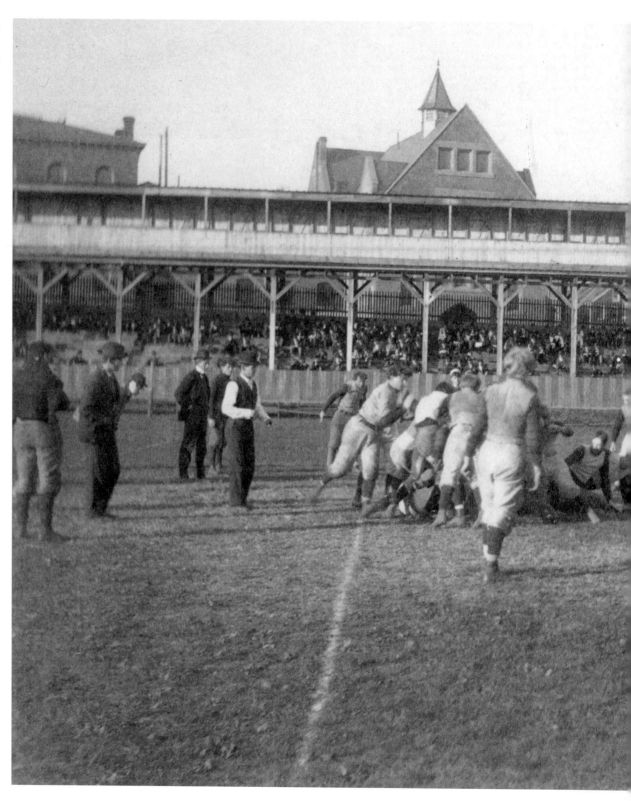

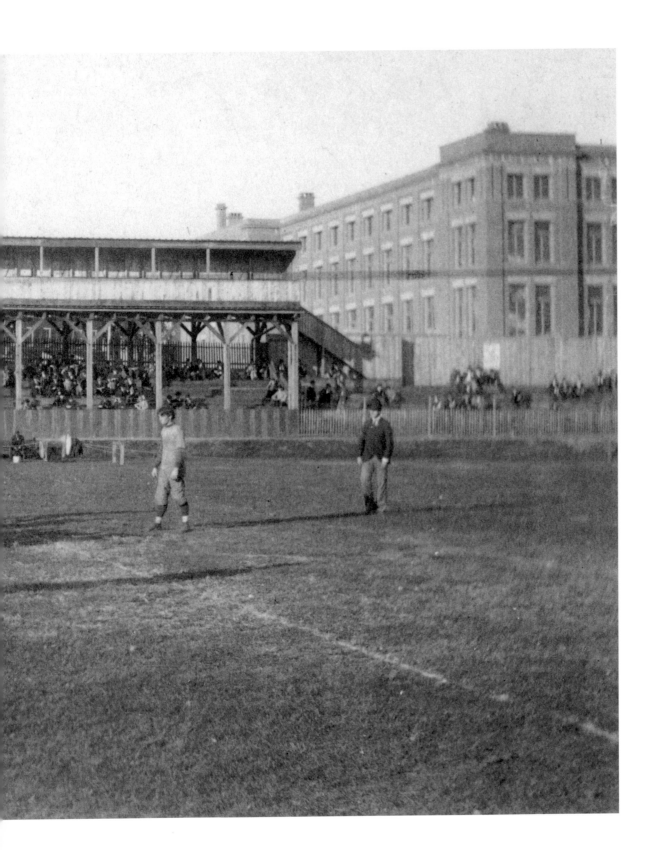

General view of Willow Grove Park, July 20, 1914. Bandleader John Philip
Sousa wrote many of his famous marches while regularly performing at the
Willow Grove amphitheater. The park was popular because it was easily
accessible to city residents via local streetcar lines.

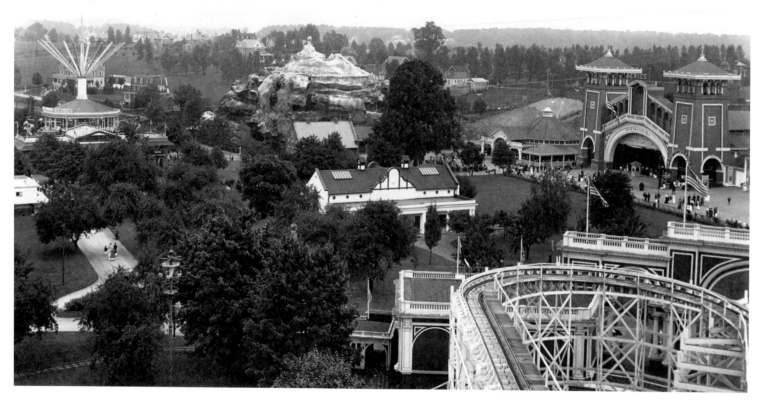

Between 1885 and 1915, the Liberty Bell was permitted to travel by train seven times to World's Fair expositions in other states. Thousands of Americans had an opportunity to view the Bell up close in more than 400 small towns and cities. This photo was taken ca. 1915.

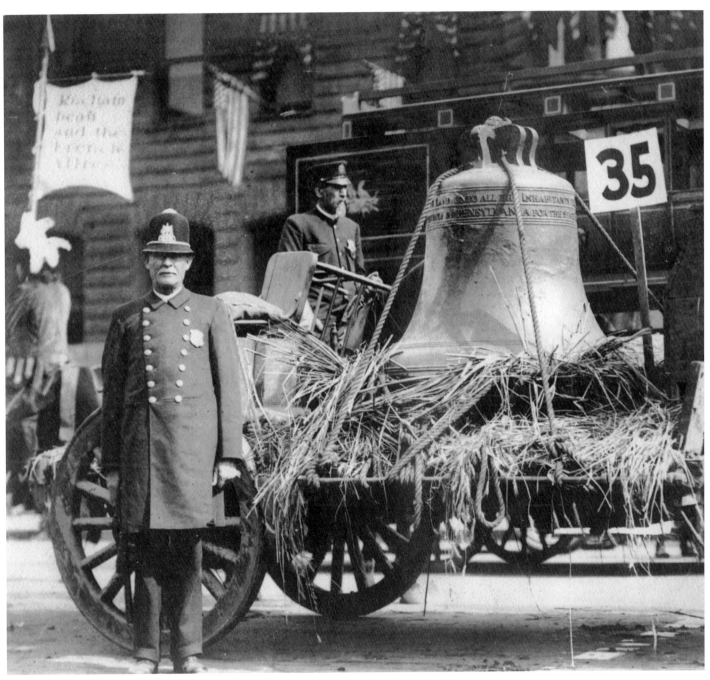

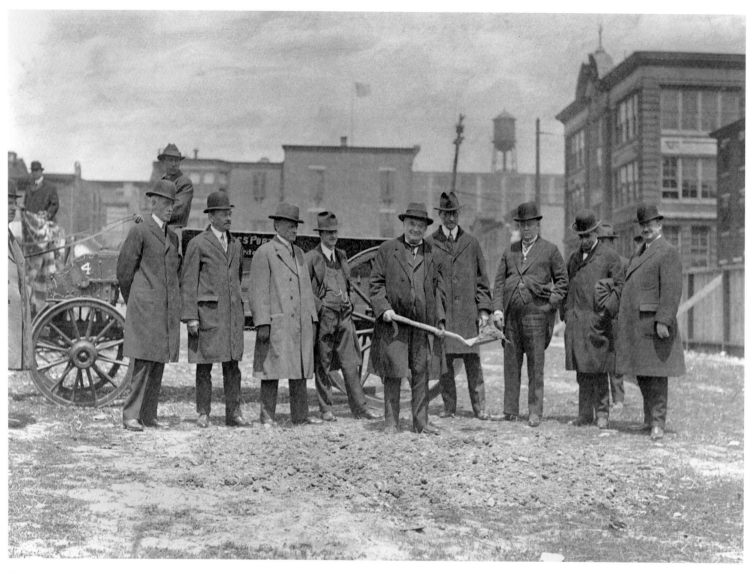

Groundbreaking for the Central Library of the Free
Library of Philadelphia on May 12, 1917

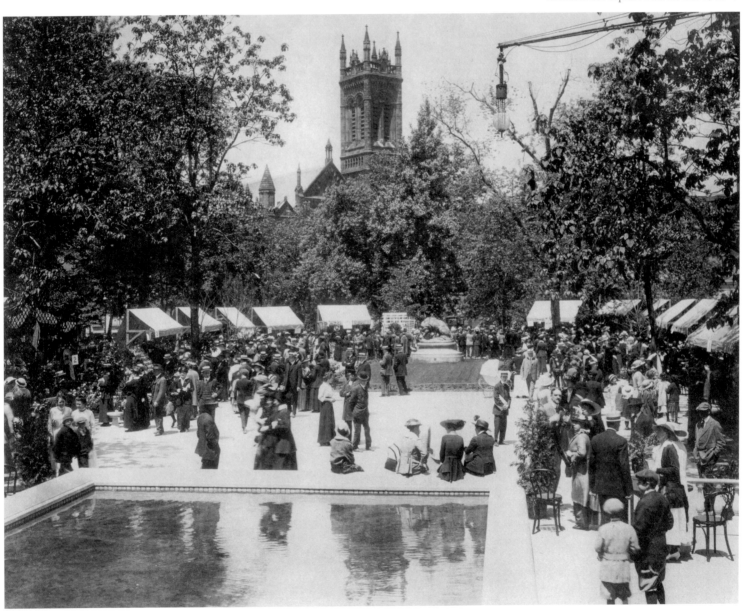

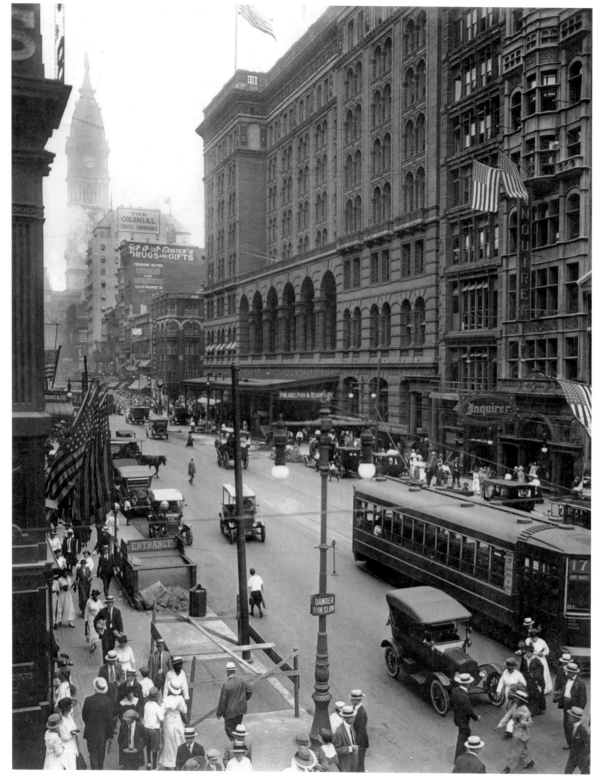

The Philadelphia and Reading Railway Terminal Head House, located at 12th Street, stands at the center of this view of Market Street on August 30, 1917.

Philadelphia's Chinatown was firmly established by the time this photo was taken in 1917, although it was primarily occupied by single men. Families did not begin to populate the area around 10th and Race streets until the period following World War II.

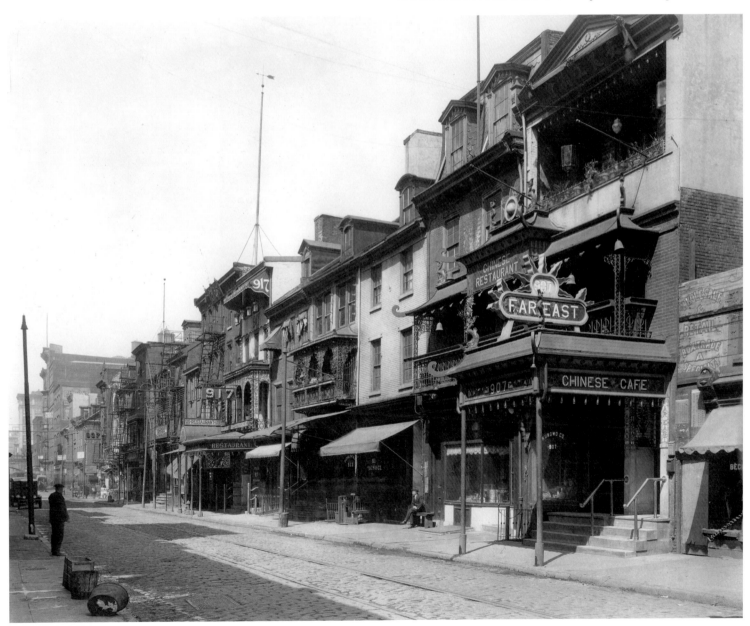

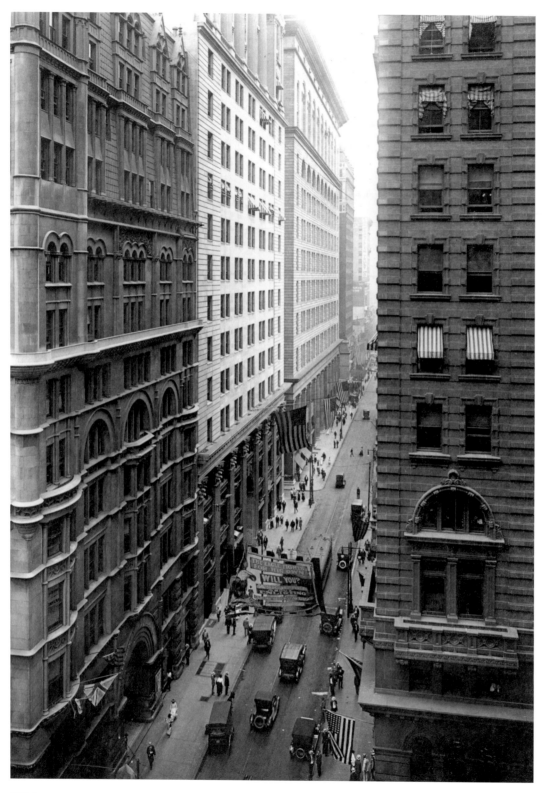

Chestnut Street near Broad Street, ca. 1917. Note the World War I recruitment banner suspended over the street.

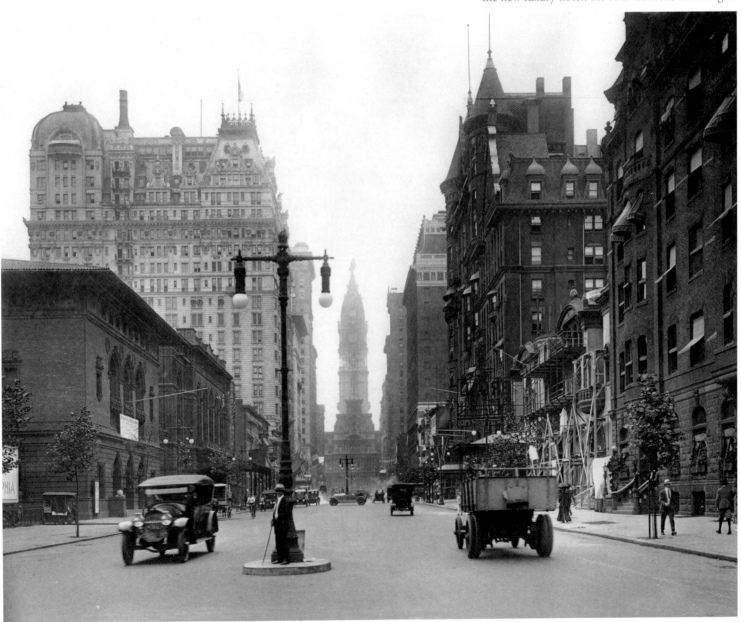

Broad Street, looking north from Spruce Street, August 1917. Note the expansion of the Bellevue-Stratford Hotel to the left, and the addition of the new luxury hotel, the Ritz-Carlton, to the right.

The region's various shipyards functioned at peak level during World War I, producing a total of 328 ships. Hog Island, the largest and newest shipyard, employed over 30,000 workers and required the importation of additional workers from other cities in the region. These men, employees of the New York Shipbuilding Company of Camden, New Jersey, are arriving at South Street via the Gloucester Ferry in 1919.

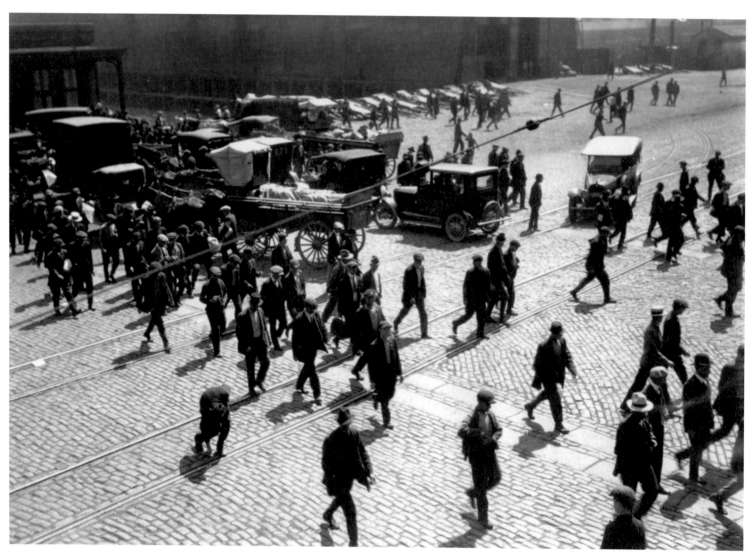

Dock Street and Delaware Avenue, July 1919

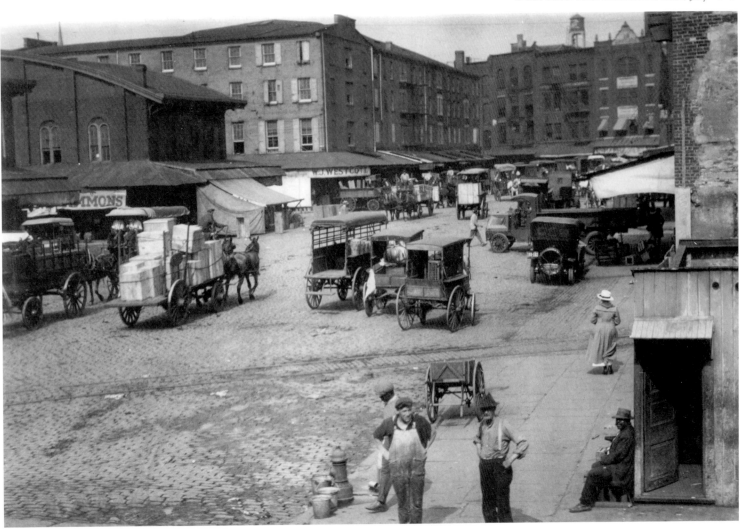

Throughout Philadelphia's history a number of ferries provided service across the
Delaware River to New Jersey, as was this ferry from Gloucester, New Jersey, in 1919.

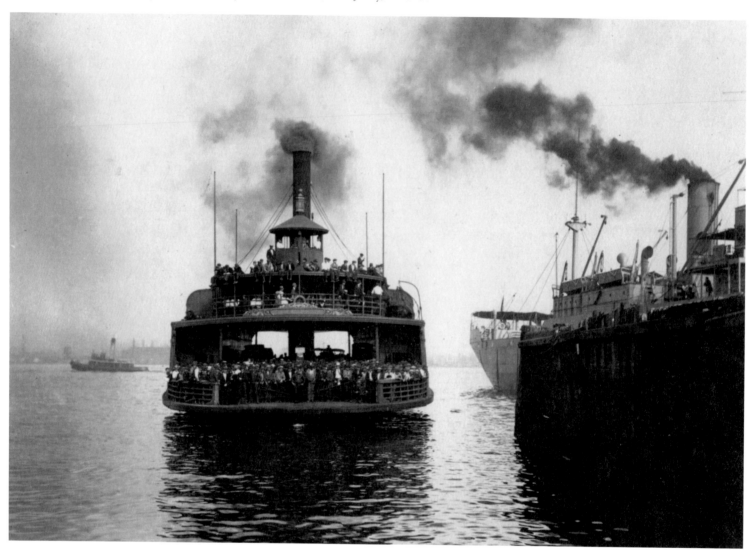

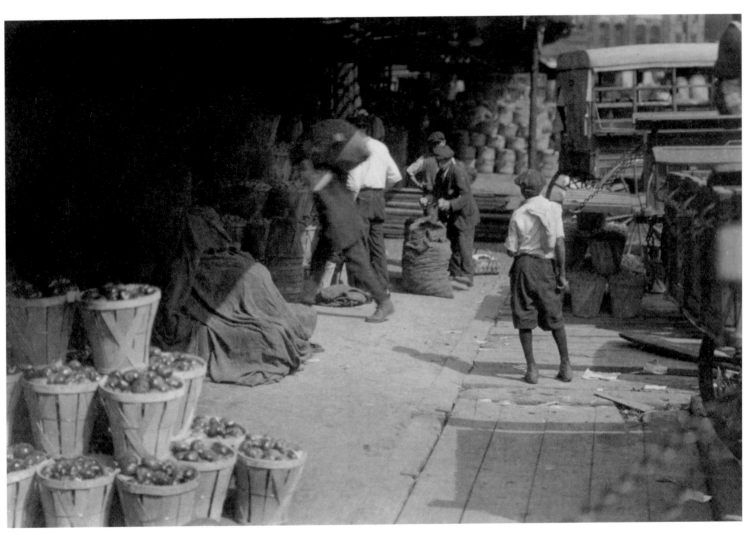

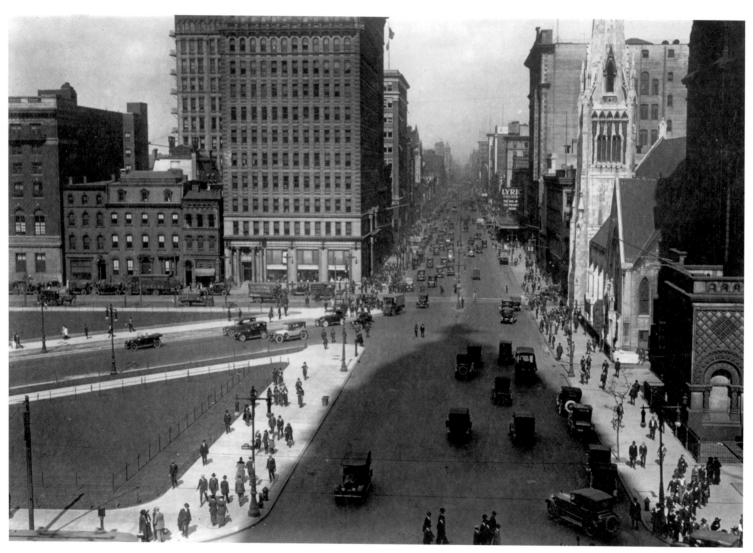

North Broad Street from City Hall, October 1920. Note the shadow of City Hall tower and its William Penn statue in the foreground.

CHALLENGES AND CHANGES

1920-1939

Much as was the case in many of the nation's largest cities, the start of the second quarter of the twentieth century in Philadelphia was marked by the challenges of economic instability and political change. The postwar drop in manufacturing affected the availability of jobs in the city, and by 1930 the average unemployment rate was 10 percent, while unemployment among the city's foreign-born whites rose at a higher rate of 15 percent. News of gangs and organized crime accounted for countless newspaper headlines, intensifying the conflicts between the middle class and blue-collar (mostly immigrant and African American) communities. Political reform, driven by an independent movement for changes in the structure of local government, stalled in the face of resistance from the powerful Republican "bosses."

Philadelphia's varied manufacturing base fared better than many cities during the Great Depression, and the city suffered only a limited number of major bank and business failures. Thanks in part to private support from the city's wealthiest citizens, Philadelphia was able to rally the necessary resources and subsequently pursued the development of premier projects such as the Benjamin Franklin Parkway, the Philadelphia Museum of Art, and a dozen new skyscrapers. The city's night life continued, even as more than 10,000 bootleggers and liquor dealers were arrested under Prohibition. Philadelphians were not fond of the new dry laws, and perhaps not surprisingly only 10 percent of those arrested were tried and of those most were only asked to pay minimal fines.

As the Depression progressed, Philadelphia's Republican-controlled local government resisted the implementation of many aspects of Roosevelt's New Deal, refusing government subsidies for public housing and food, and necessitating the intervention of the state legislature. With the divide between citizen and local government expanding, support for national Democratic policies increased, especially among the poor and immigrant communities. Issues such as unionization, civic and social services, and jobs (typically the platform of twentieth-century Democrats) seemed more significant in the face of economic pressures. Republican control of city politics was coming to an end and the city once known for its unusual Republican political machine was evolving into a stronghold for Democratic candidates and policies. At the same time, the city was losing its battle for economic security and a positive future as national trends affected Philadelphia's ability to prosper.

Penn Square, northwest from City
Hall, October 1920

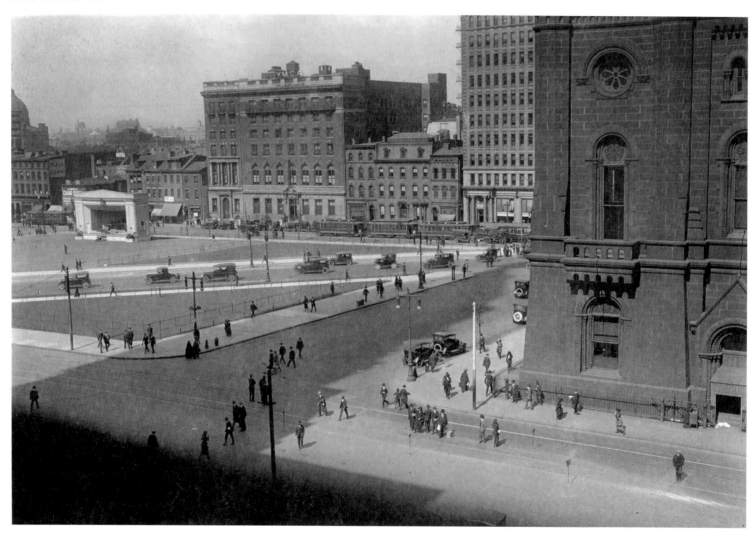

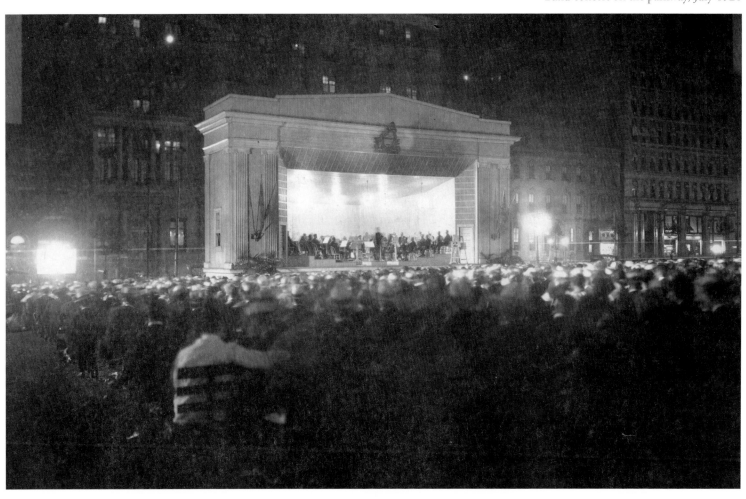

Band concert on the parkway, July 1920

Pennsylvania Railroad Station's train shed to the left of City Hall's tower is visible in this photo looking northeast from Rittenhouse Square ca. 1920. The shed was destroyed by fire in 1923.

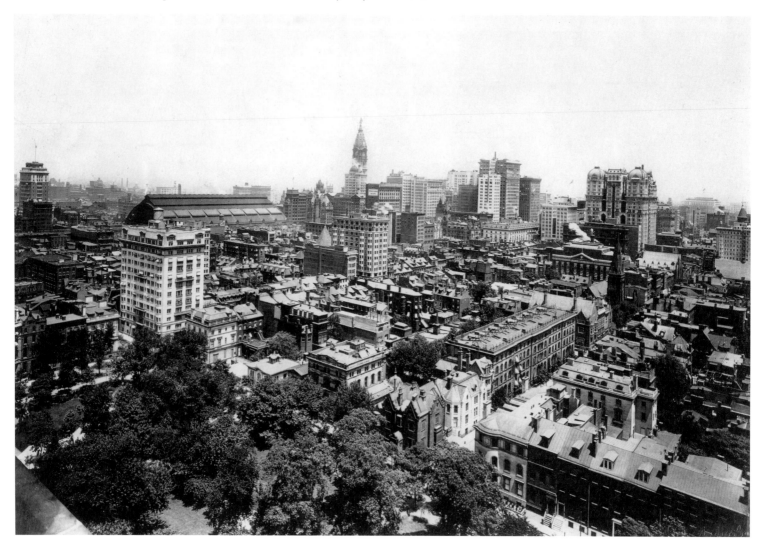

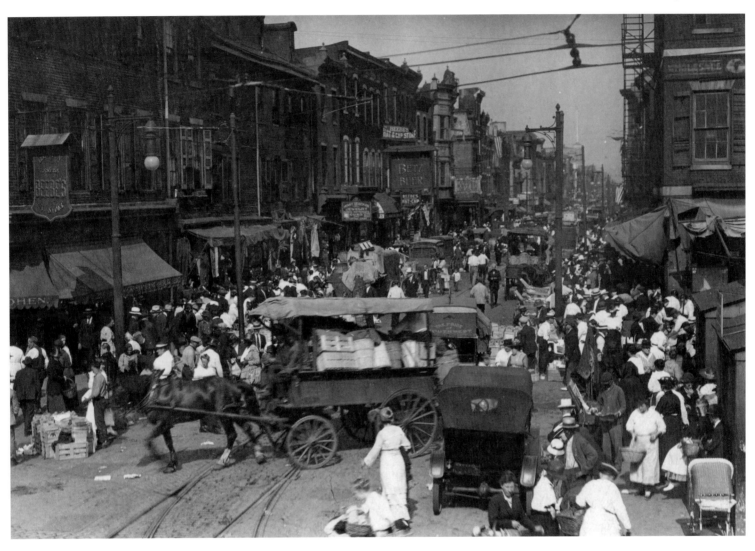

First known as Cedar Street and the original southern boundary of the city, South Street had become the center of the Jewish and African-American communities by the early twentieth century. In this view from September 1920, dozens of vendors and small businesses can be seen, just a few of the hundreds that served the communities on or near South Street from the Delaware River to Broad Street.

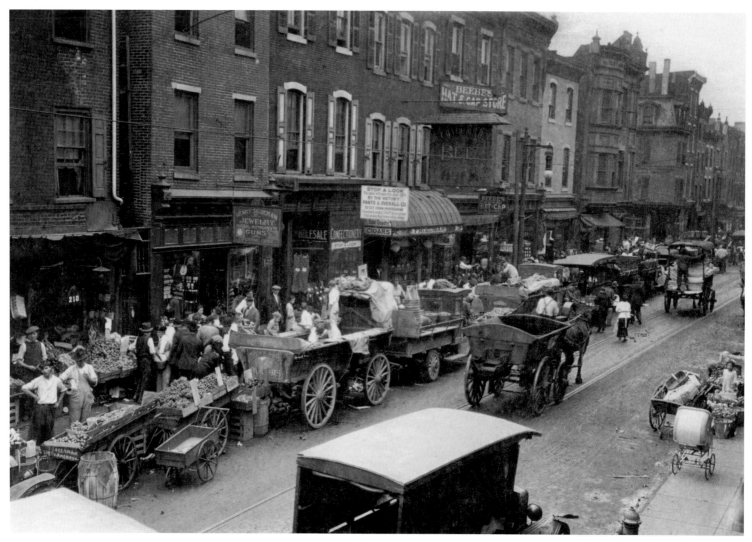

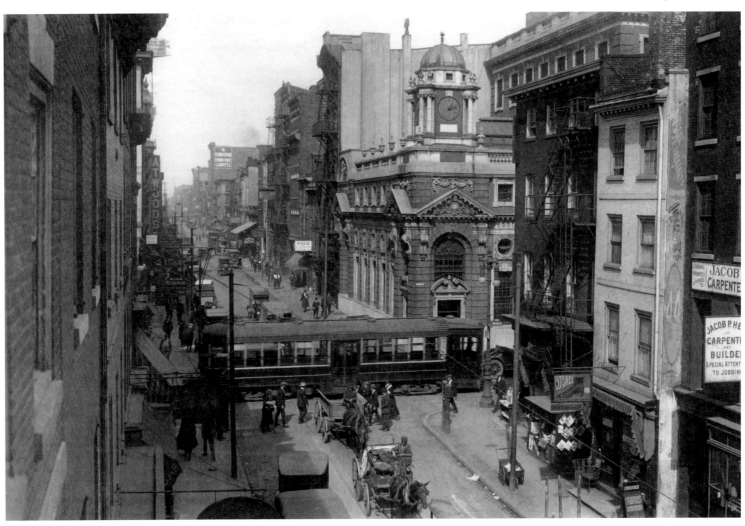

Looking east on Market Street from
13th Street, ca. 1920

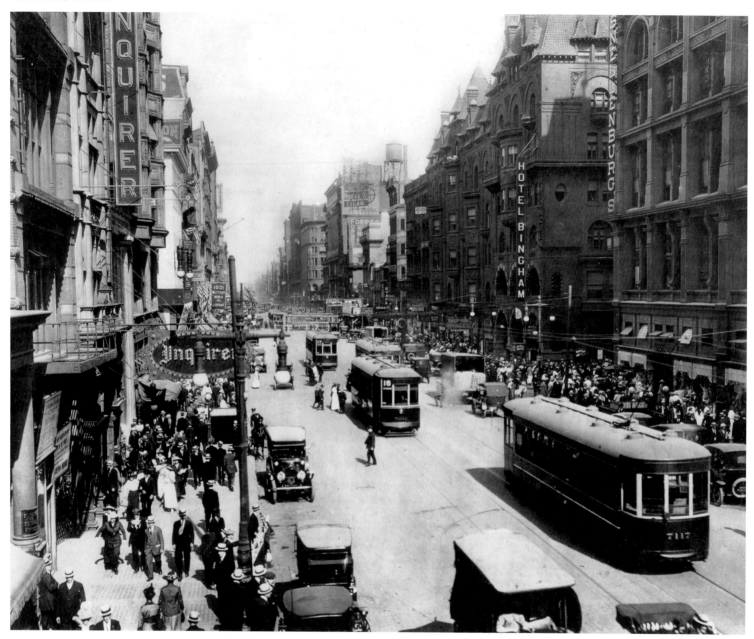

Subway entrances are visible along both sides of Market Street in this view looking west, September 1920. The subway and elevated train lines on Market Street were completed in 1908.

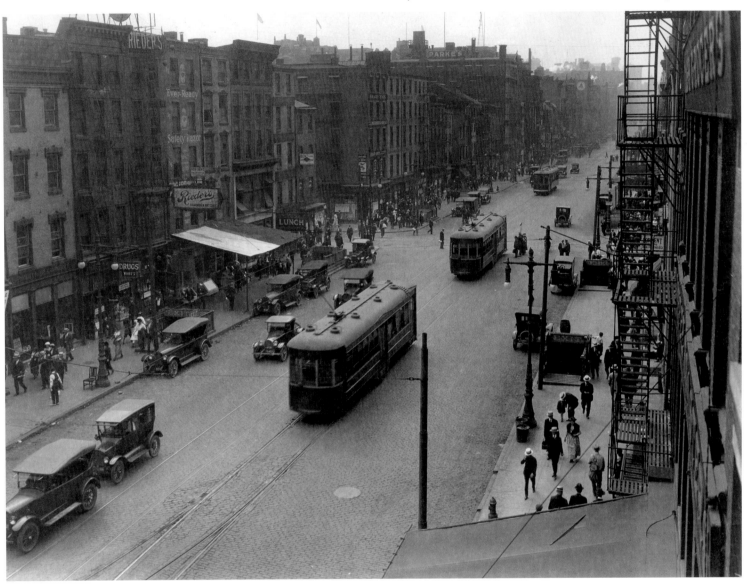

East on Market Street from City Hall,
October 1920

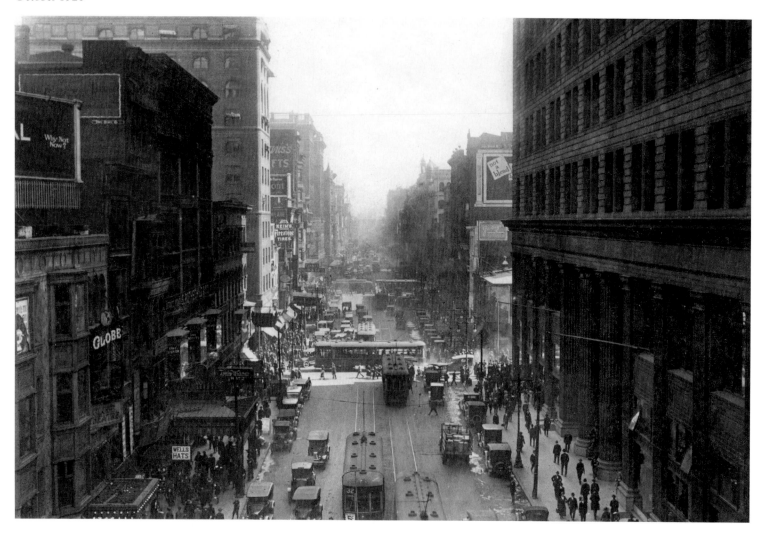

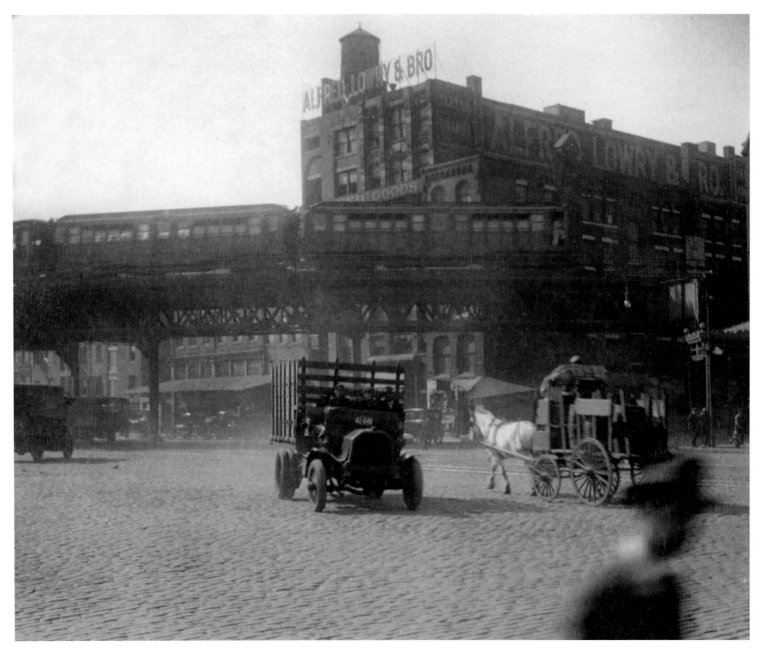

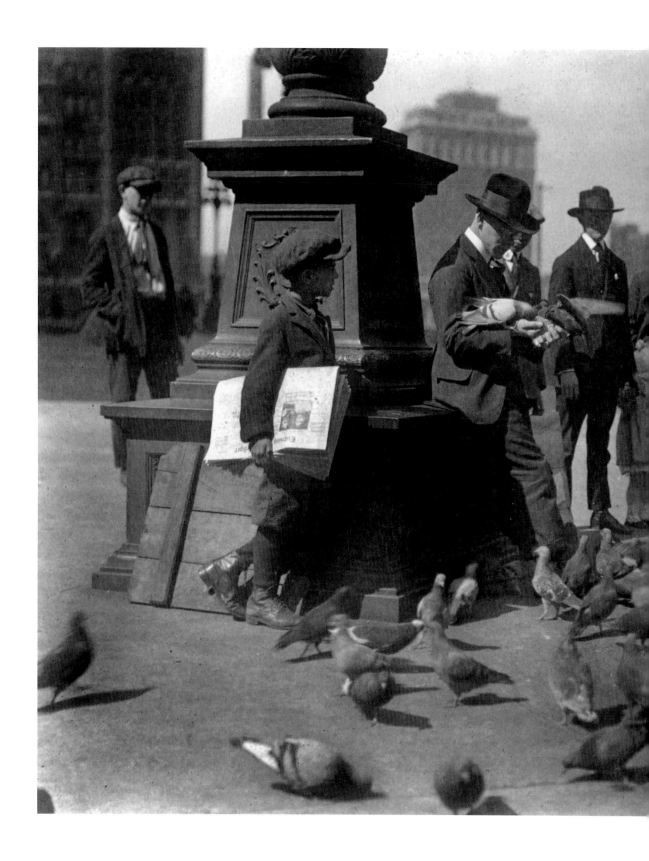

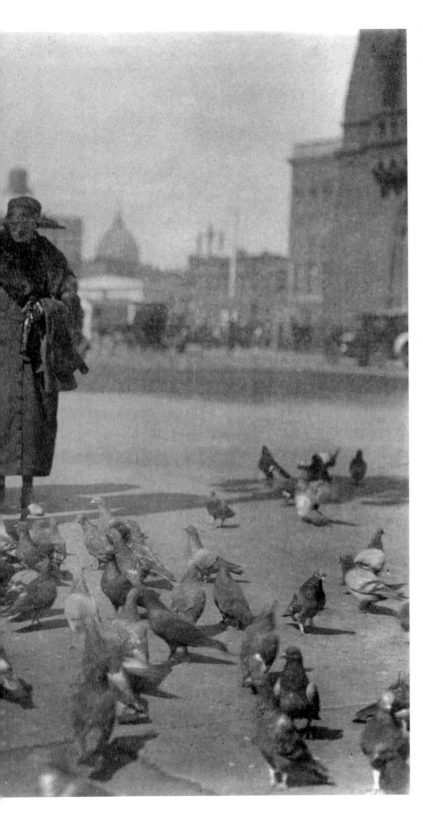

Feeding the pigeons on City Hall
Plaza, October 1920

Looking north on 4th Street from
Chestnut Street, October 1920

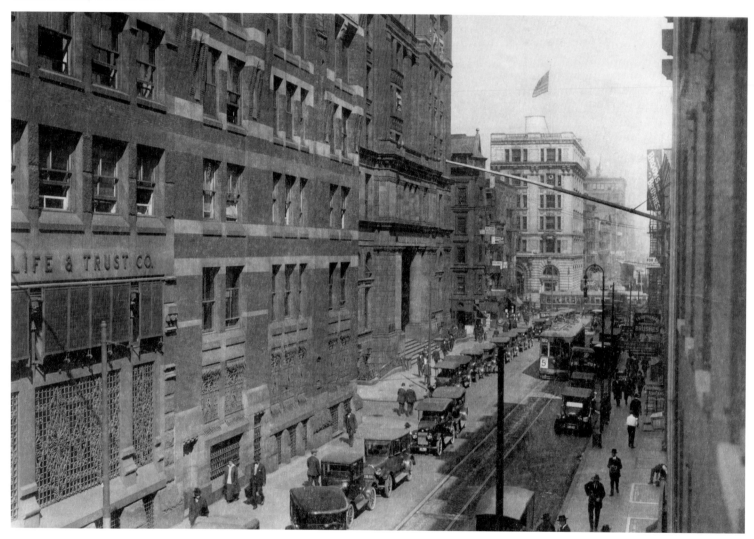

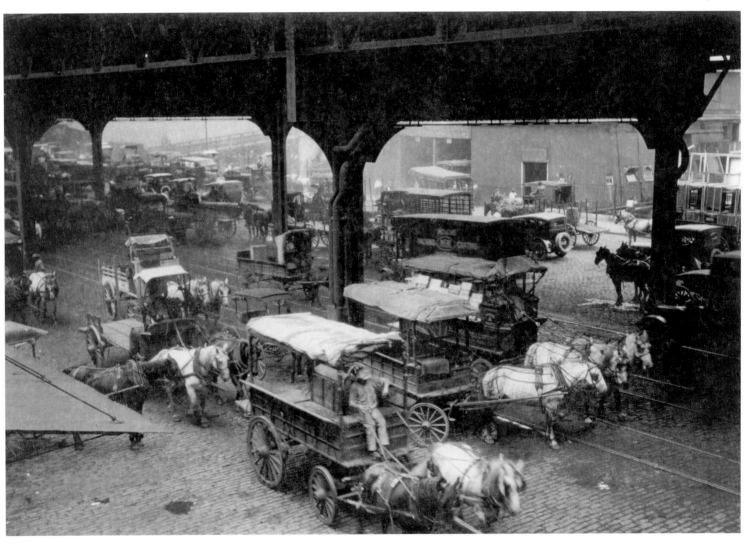

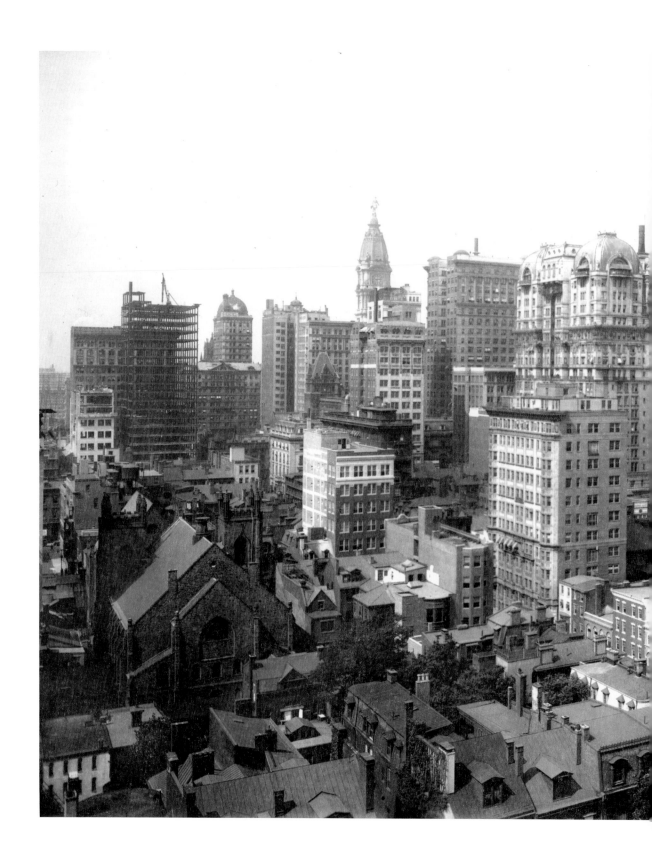

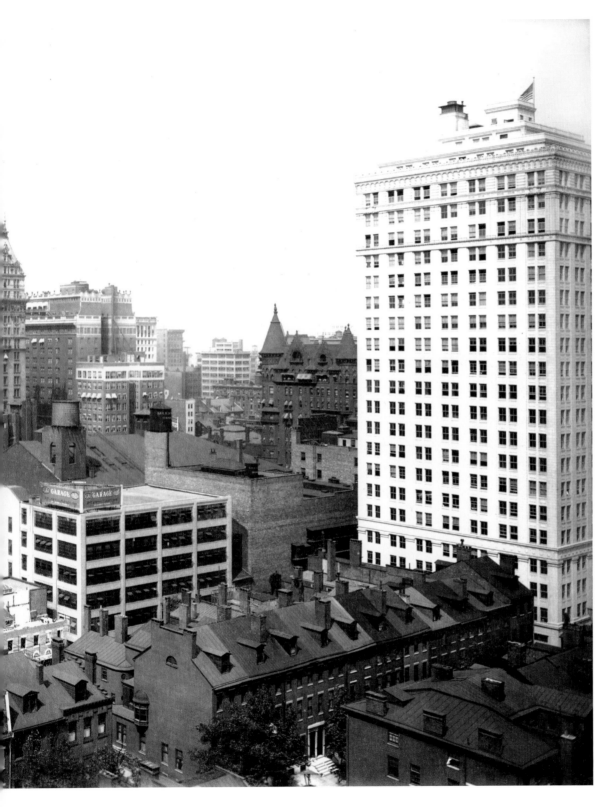

The ornate building at the center of this view from 1920 is the elegant Bellevue-Stratford Hotel on Broad Street.

Philadelphia skyline, looking northeast from 22nd
and Arch streets, November 1920

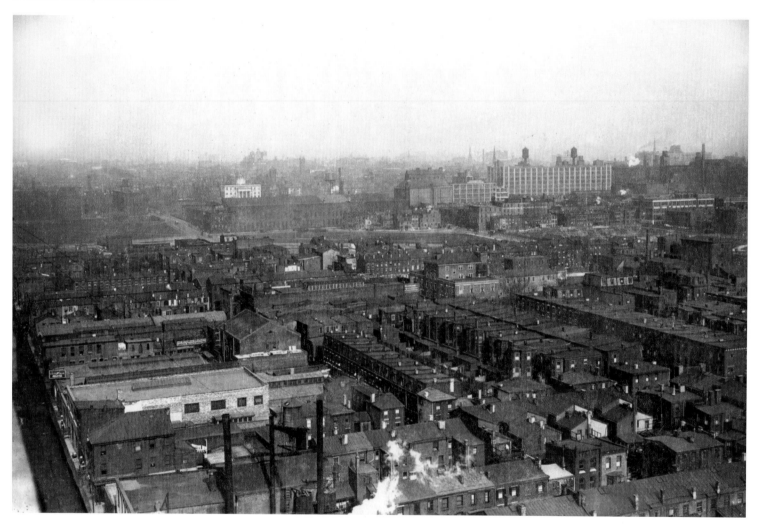

Famed for its outdoor sculptures and peaceful pool and fountain, Rittenhouse Square at 19th and Locust streets remains an integral part of the upscale neighborhood surrounding it.

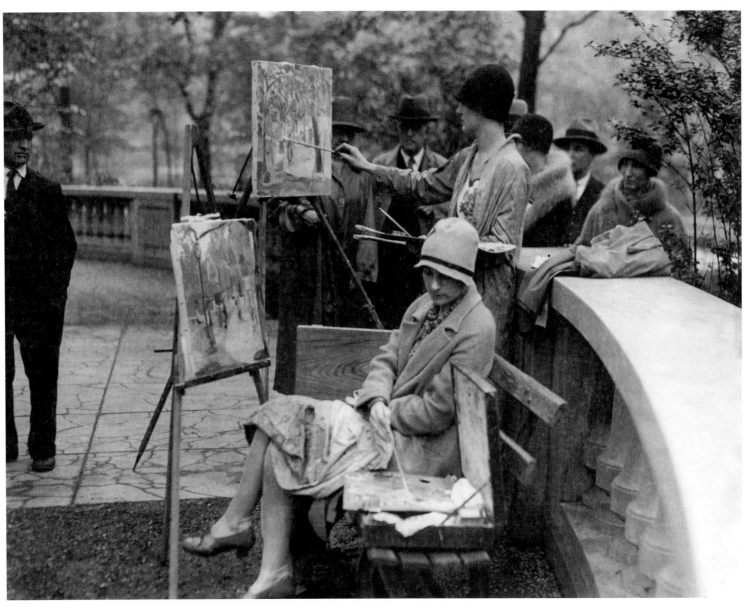

Seen here in 1920, Reading Terminal Market occupied the ground level of the massive Reading Railroad train shed. After several years of decline, the market has been revitalized and remains one of the most popular destinations for Philadelphia residents and visitors alike.

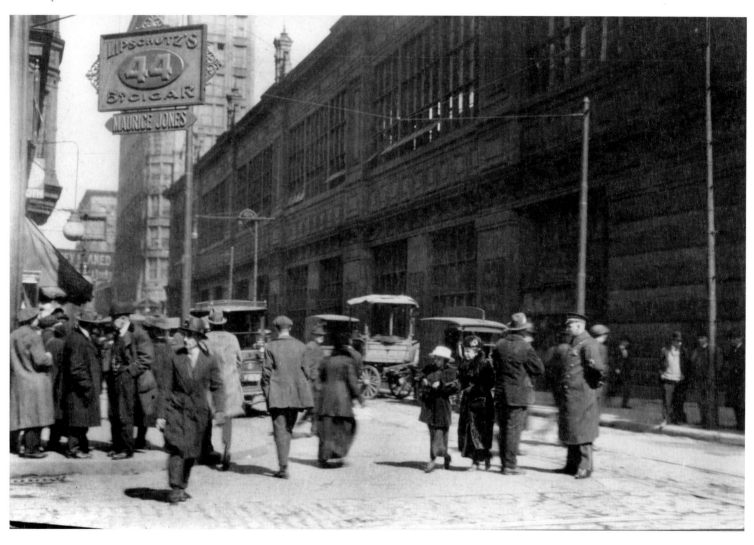

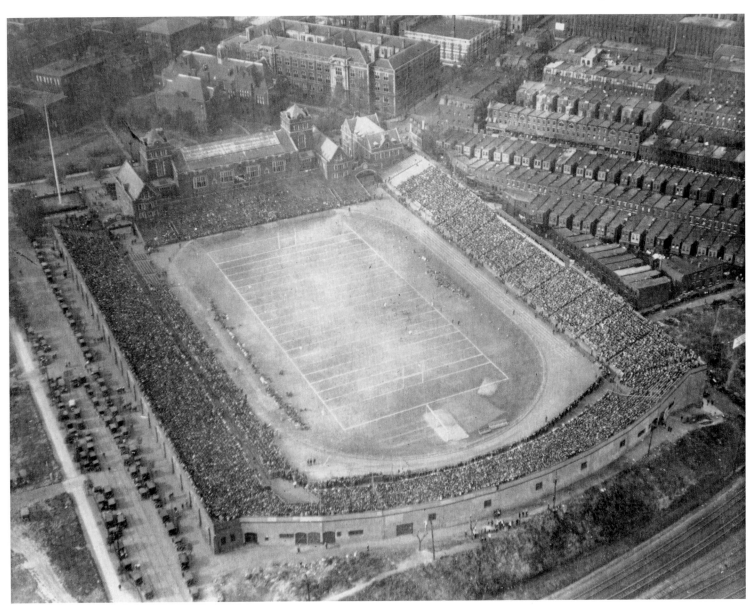

The Philadelphia Mummers Parade, most famous for its banjo and
saxophone bands, extravagant costumes, and the "Mummers Strut,"
is traditionally held on January 1 of each year and was first formally
marched in 1901.

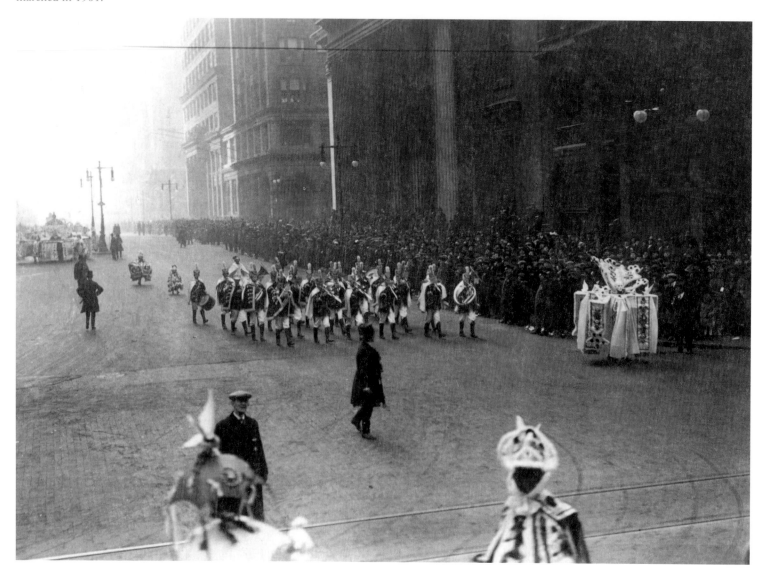

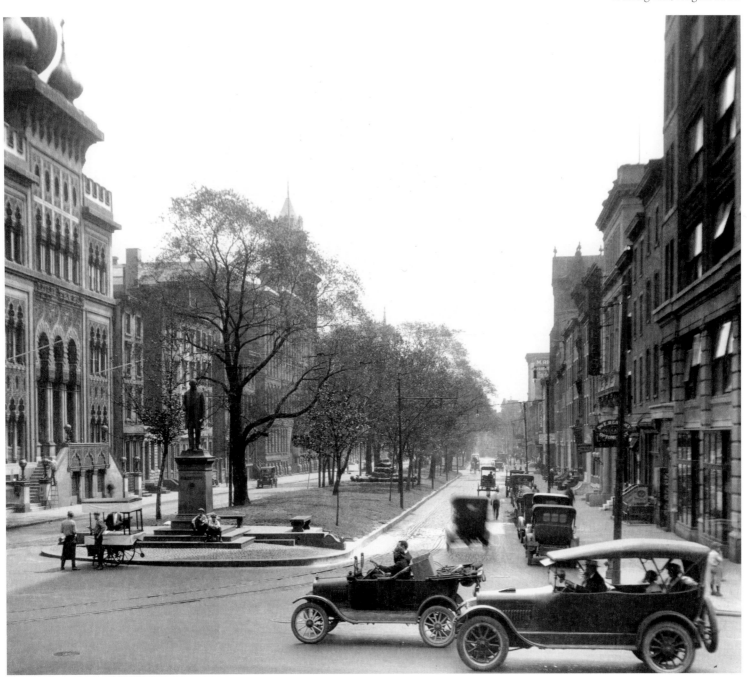

Spring Garden Street at Broad Street,
looking east, August 1921

The *J. Hampton Moore,* a fire boat commissioned by the city of Philadelphia in 1922 and named for one of Philadelphia's most prominent mayors, was the last to be launched from the Merchant Shipbuilding Company of Chester, Pennsylvania.

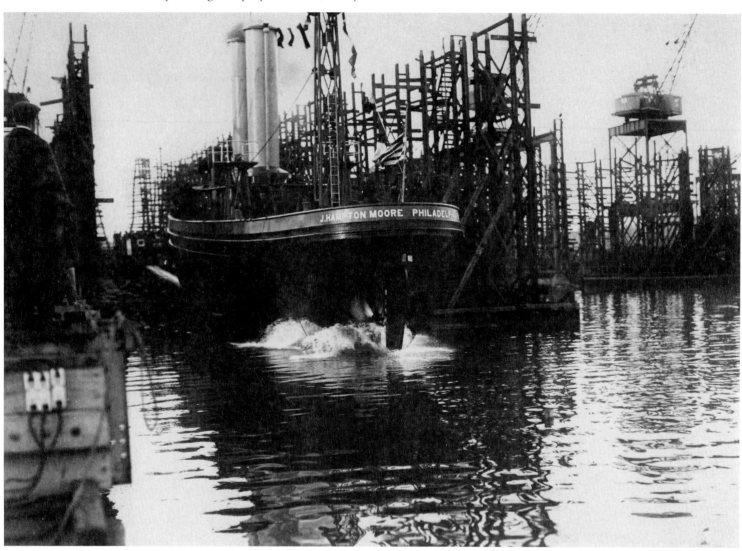

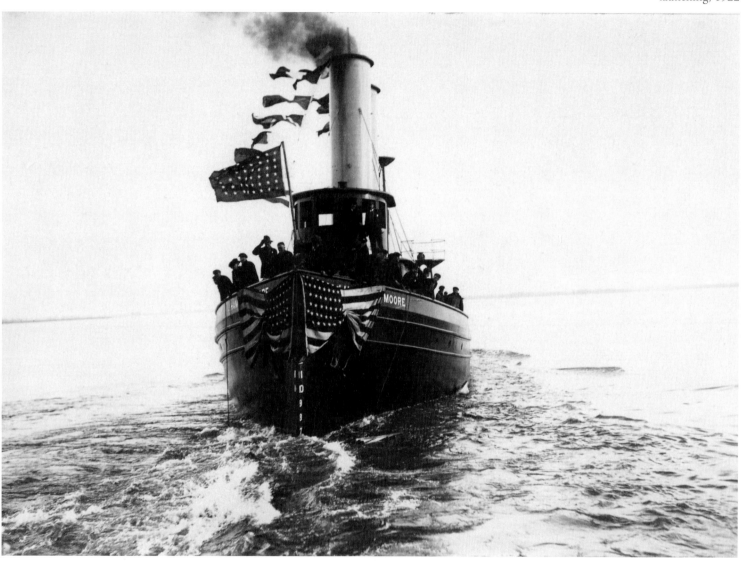

Aboard the U.S.S. *Kansas,* Philadelphia
Navy Yard, September 26, 1923

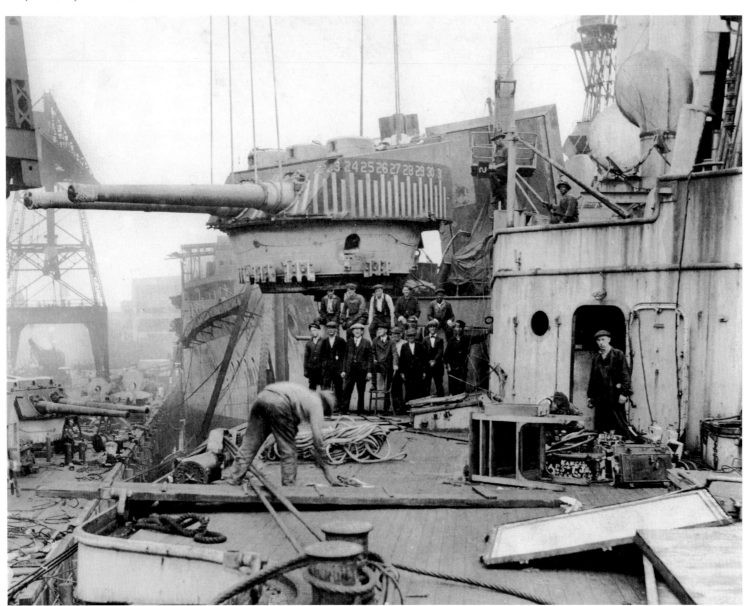

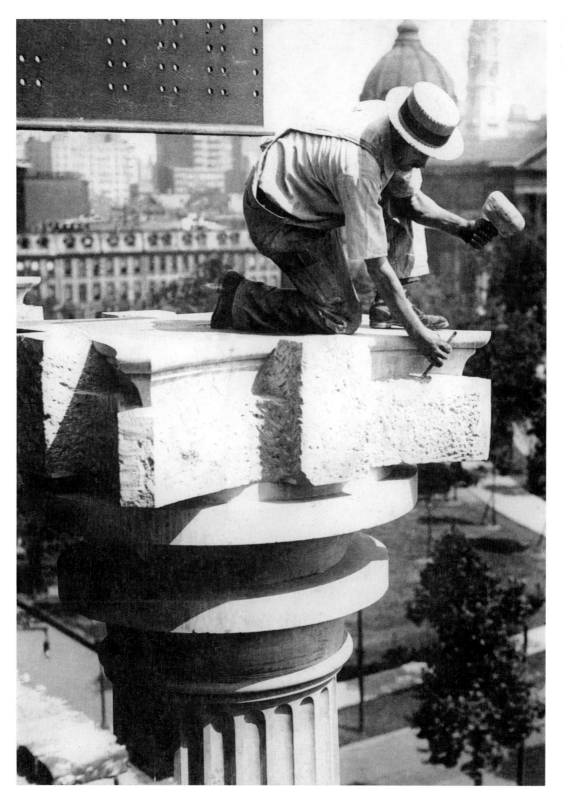

Stone carver beginning a column
during construction of the Central
Library on Logan Square, ca. 1924

Known for their dance music, Howard Lanin and his band played for a number of years in the ballroom of the Benjamin Franklin Hotel at 9th and Chestnut streets.

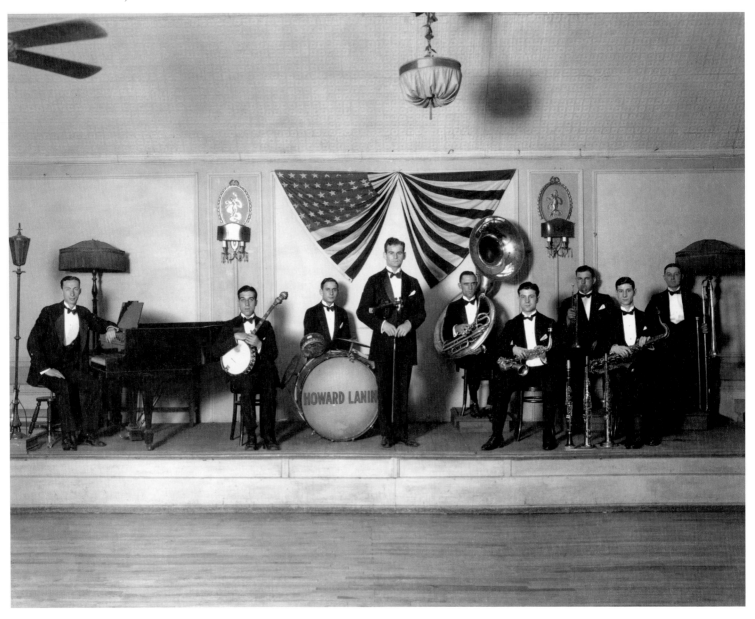

Philadelphia's own "Parisian Avenue," the Benjamin Franklin Parkway was completed in 1926. Construction of the one-mile-long diagonal avenue required the demolition of hundreds of eighteenth and nineteenth-century homes and factories. This view, ca. 1925, is looking southeast toward City Hall.

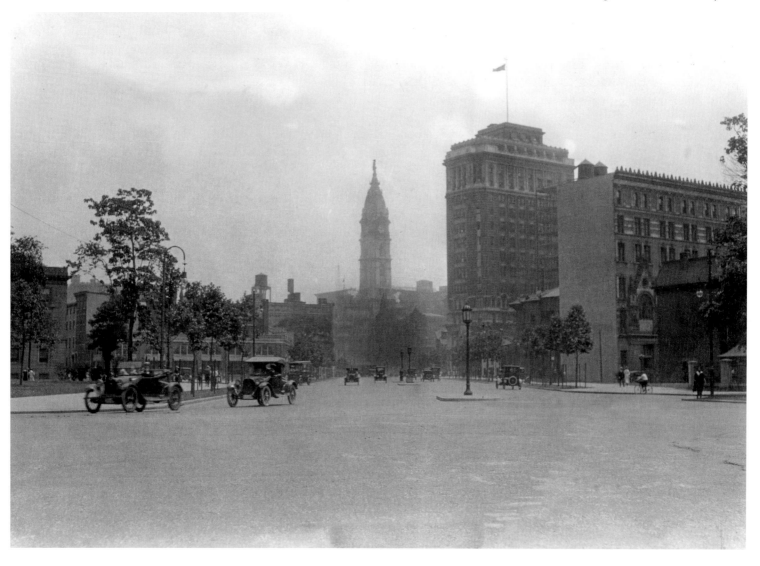

Also known as the Founders Bell, the Peace Bell was made in honor of retailer John Wanamaker and to celebrate the sesquicentennial of the United States in 1926. At nearly 35,000 pounds, it is believed to be the largest ringing bell in the world. It can still be seen (and heard) atop One South Broad Street, in the former Philadelphia National Bank building.

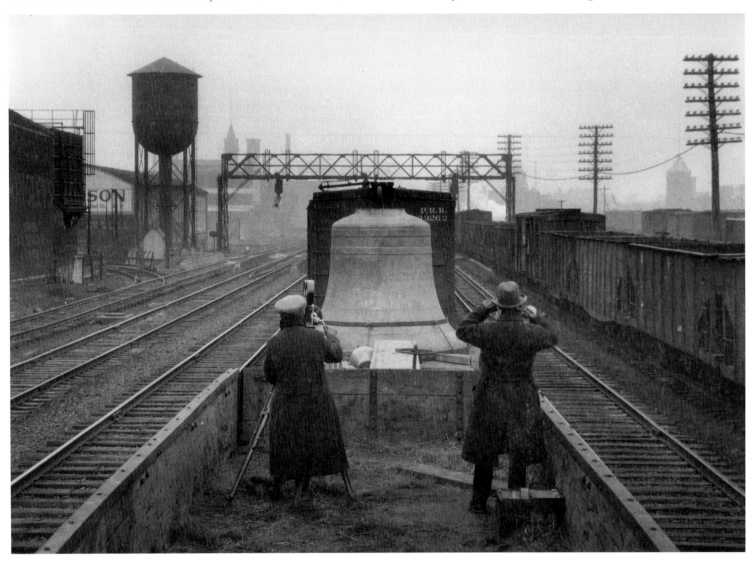

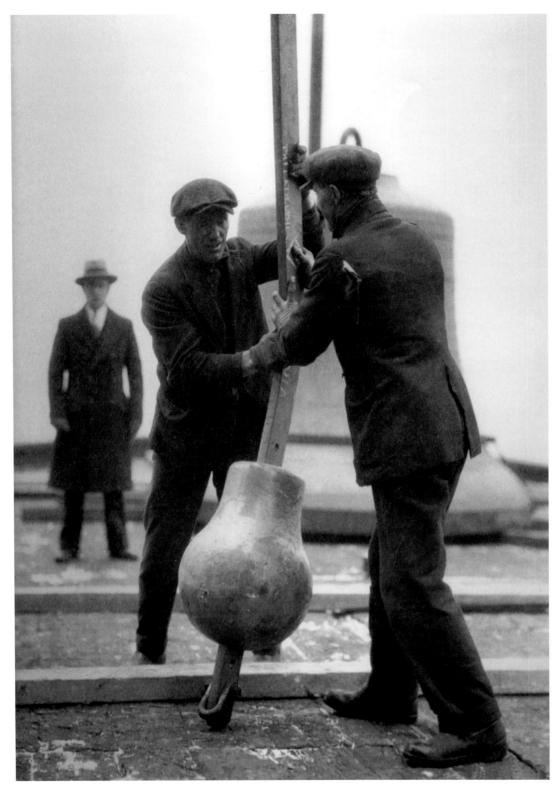

Workmen with the clapper from the
Peace Bell, March 11, 1927

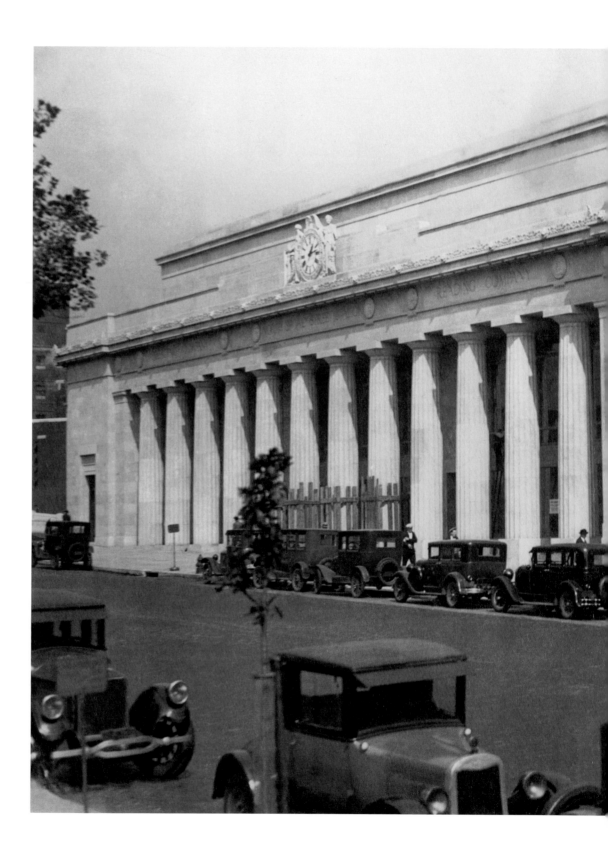

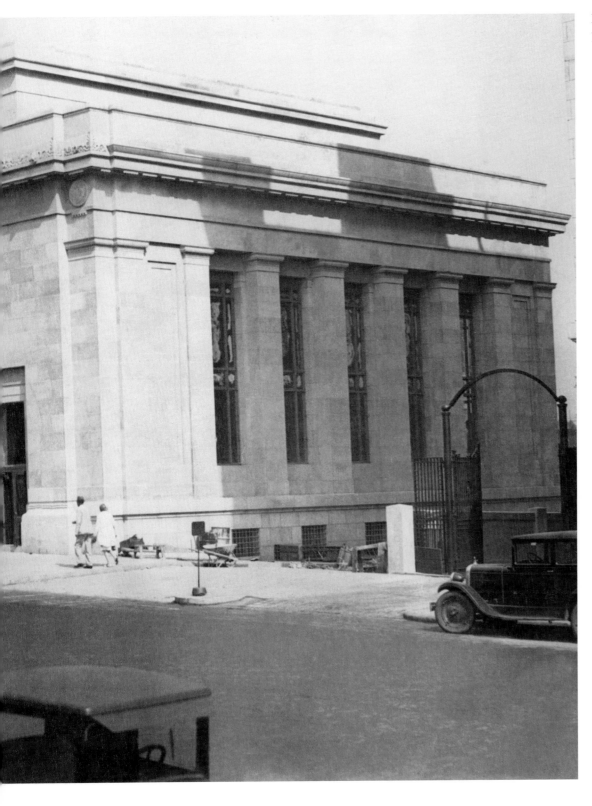

North Broad Street Station, 2600
Block of North Broad Street, 1928

143

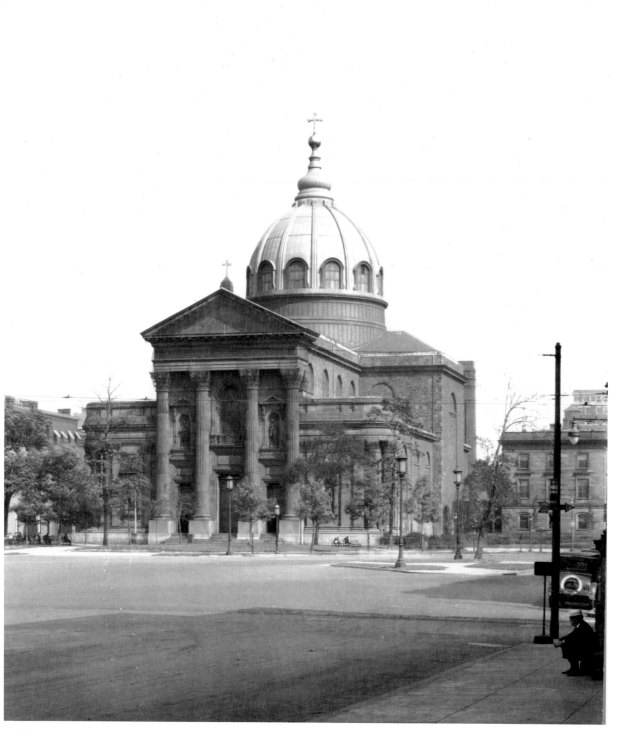

Built in 1864, the Cathedral of Saints Peter and Paul at 18th and Race streets was designed with very high and small windows to prevent damage that might result from anti-Catholic vandals. This view shows the cathedral in 1928.

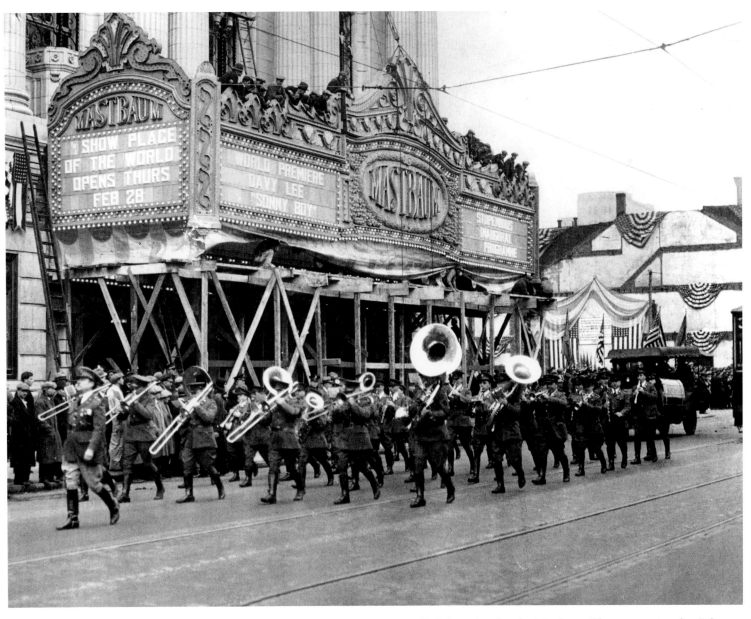

U.S. Army band at the Mastbaum Theater, opening day, February 28, 1929. Philadelphia's grandest movie theater, the Mastbaum closed on April 16, 1958.

The Central Library and the Philadelphia Museum of Art are visible along Philadelphia's grandest redevelopment project, the Benjamin Franklin Parkway. The Franklin Institute construction site is on the left side of the Parkway across from the Central Library. All three buildings were completed before 1930.

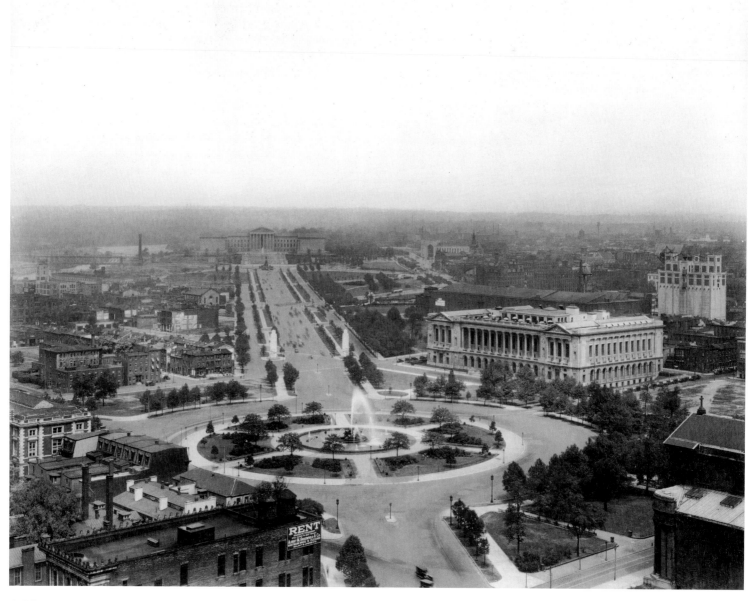

When completed in 1926, the Delaware River Bridge from Philadelphia to Camden had the longest main span of any bridge in the world. It was renamed the Benjamin Franklin Bridge in 1956.

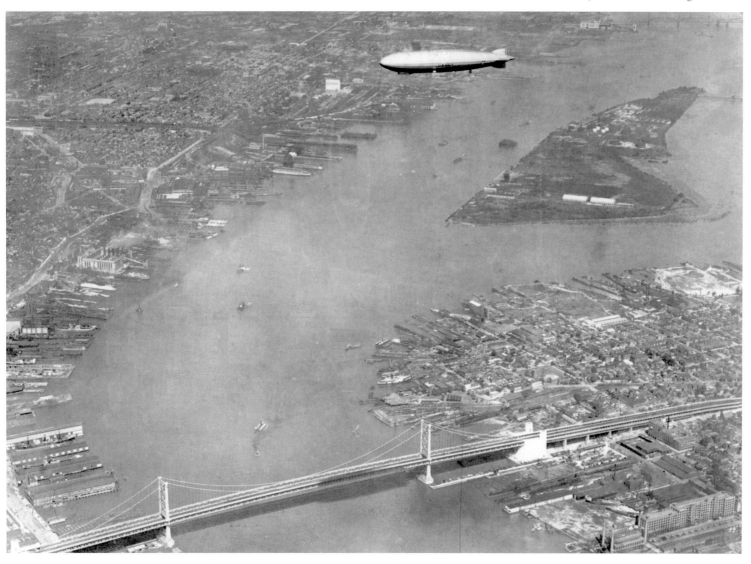

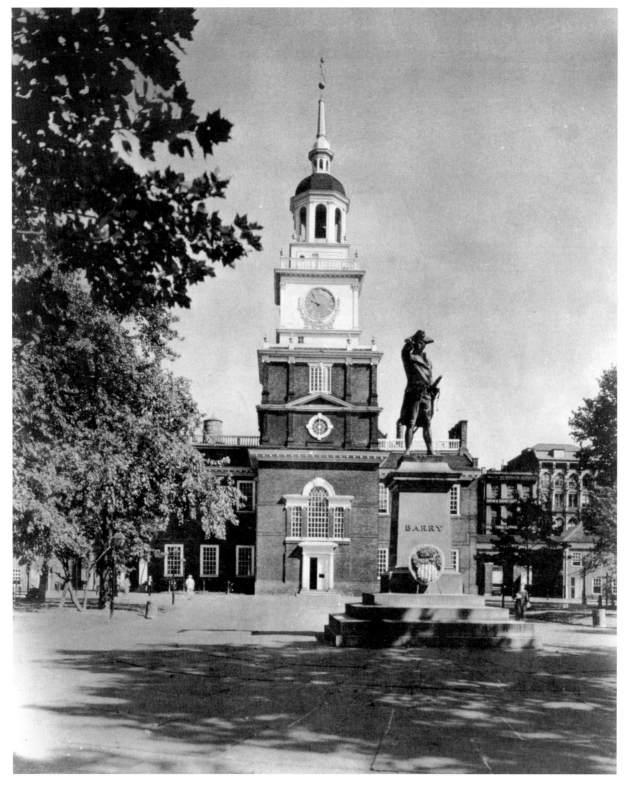

John Barry statue and
tower of Independence
Hall, facing north,
ca. 1930

Seen here in 1930, the Liberty Bell was first placed in the entrance foyer of Independence Hall in the late 1800s, where it remained until 12:01 A.M. on January 1, 1976. At that time, it was removed to a new facility across Chestnut Street and visible from the hall. The bell has since been moved again to a new pavilion within sight of Independence Hall.

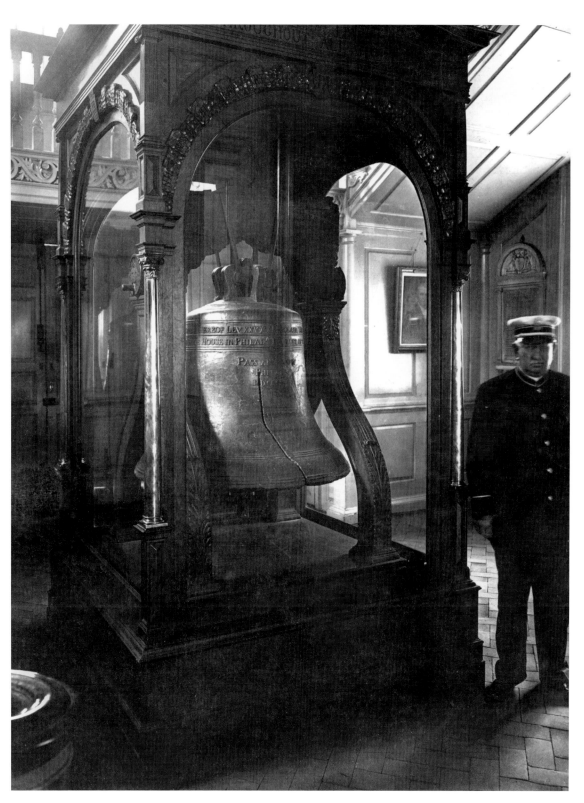

The American Grocery, ca. 1930

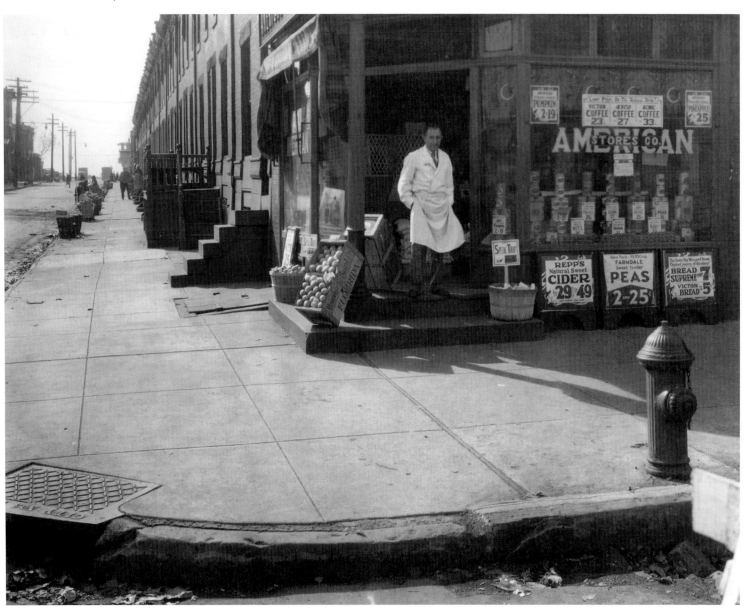

The large sculpture in the foreground of this view down the Benjamin Franklin Parkway features George Washington. Smaller fountains surrounding Washington represent four of the country's major rivers: the Mississippi, Hudson, Delaware, and Potomac.

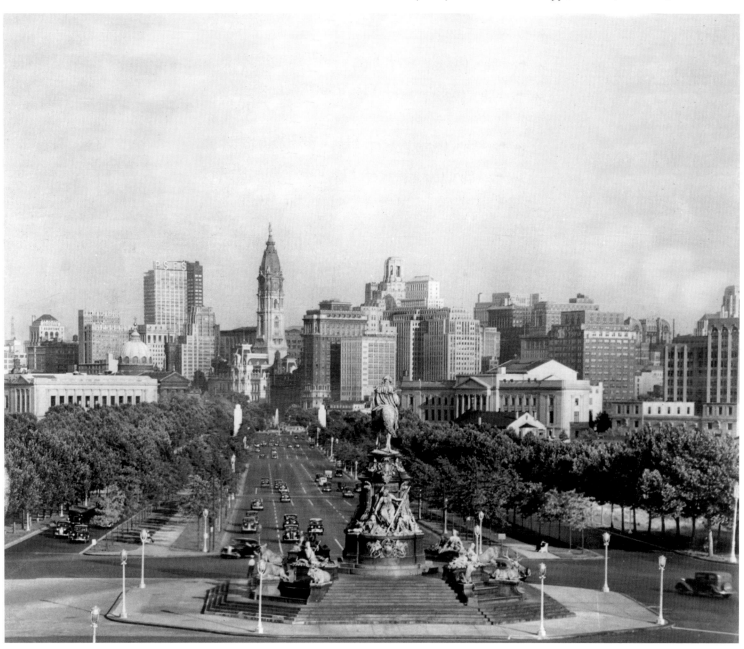

A typical street market, this scene on Poplar Street in 1930 was common among the many ethnic neighborhoods in the city.

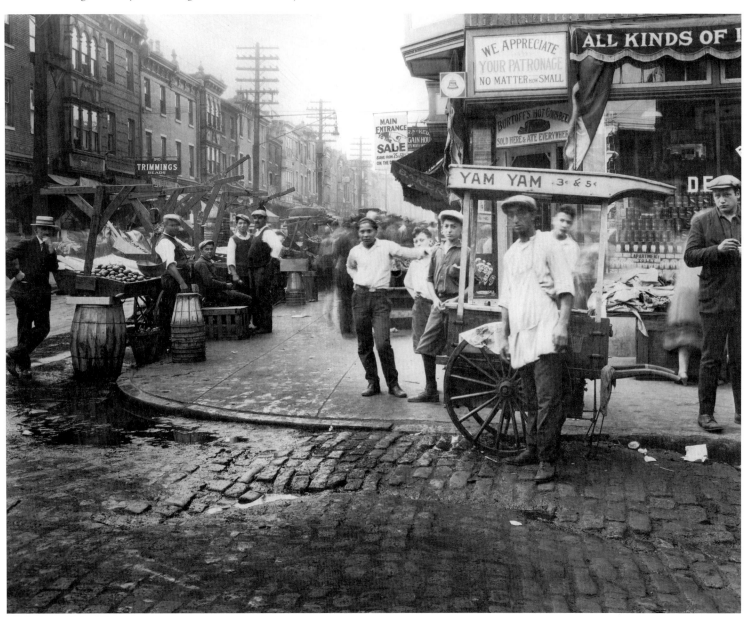

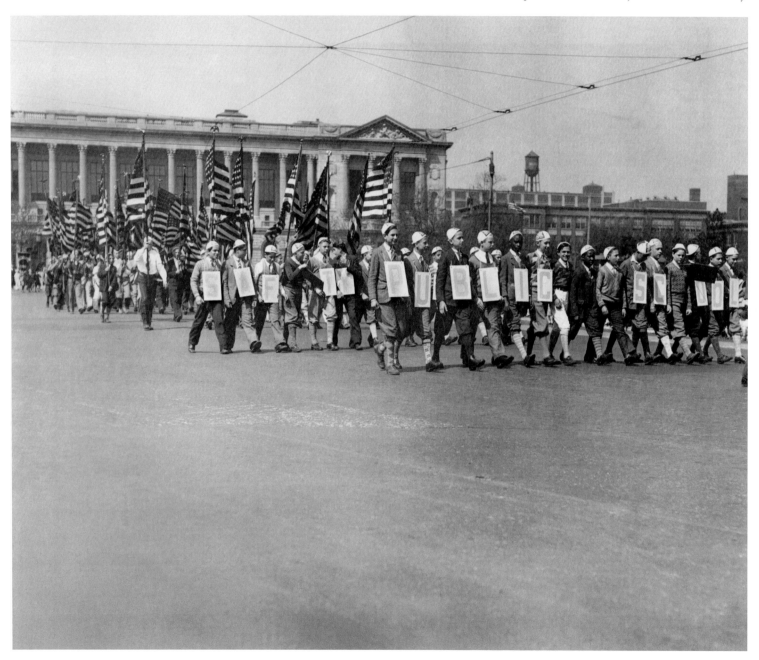

Boy Week celebration, May 4, 1930. It is estimated that 10,000 boys participated in the parade down the Benjamin Franklin Parkway.

These vintage fire engines, parading along the
Benjamin Franklin Parkway in 1931, belonged to the
Philadelphia Fire Department.

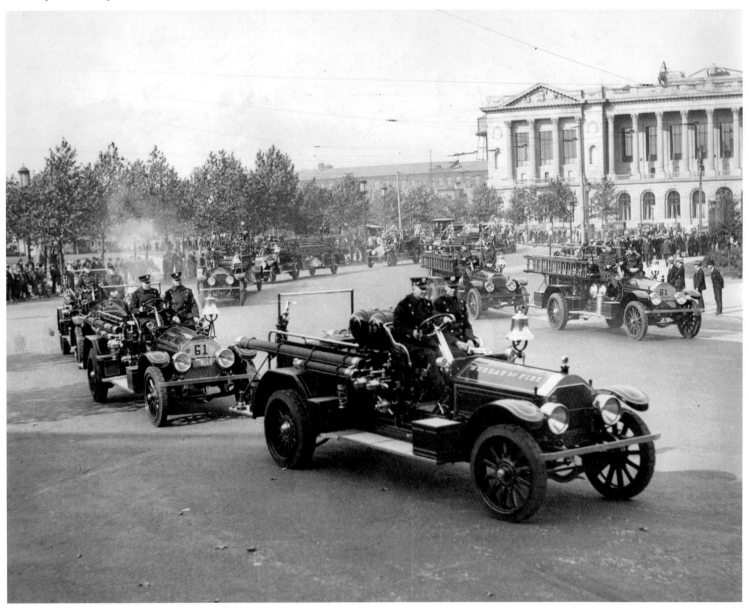

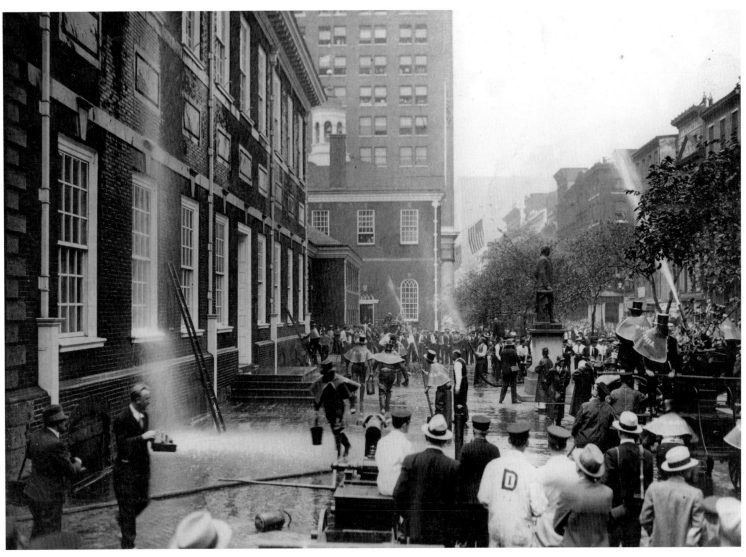

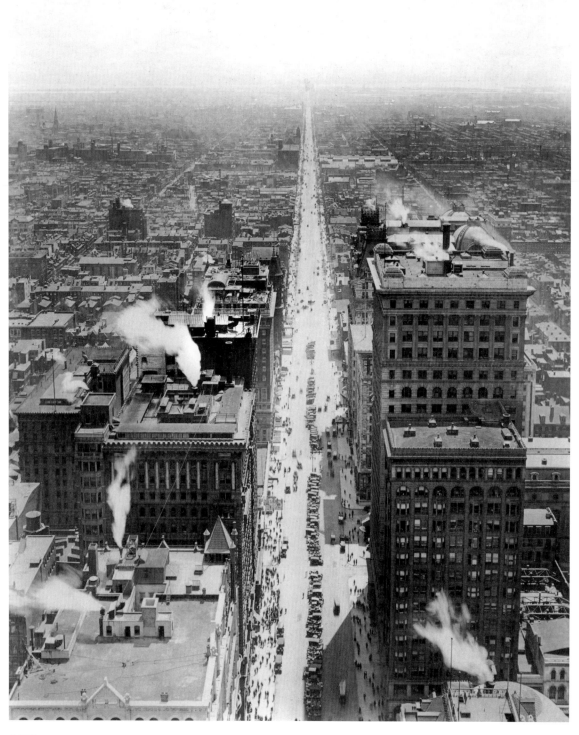

Looking south on Broad Street
from City Hall, ca. 1935

Fleet of cars, Philadelphia Police
Department, June 15, 1935

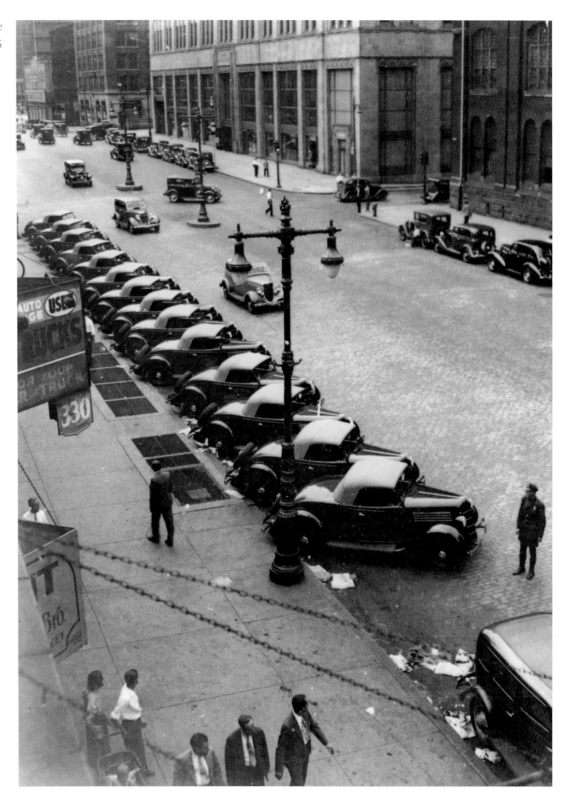

Looking southeast on the Benjamin Franklin Parkway toward City Hall, ca. 1935. Logan Circle (formerly Logan Square) is in the foreground.

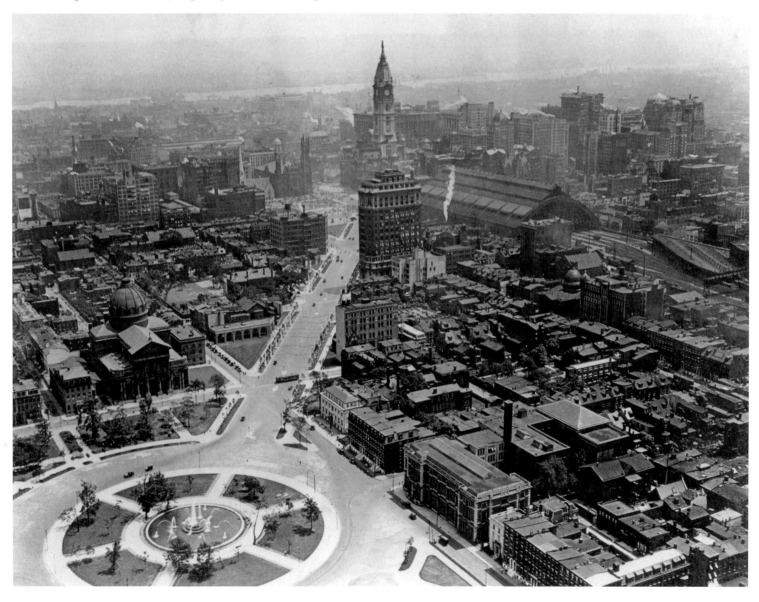

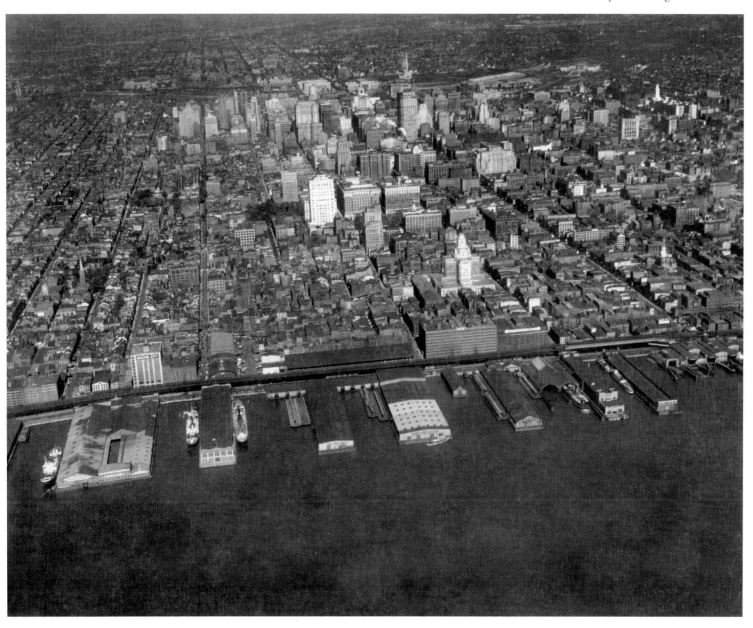

Market Street at night, ca. 1935

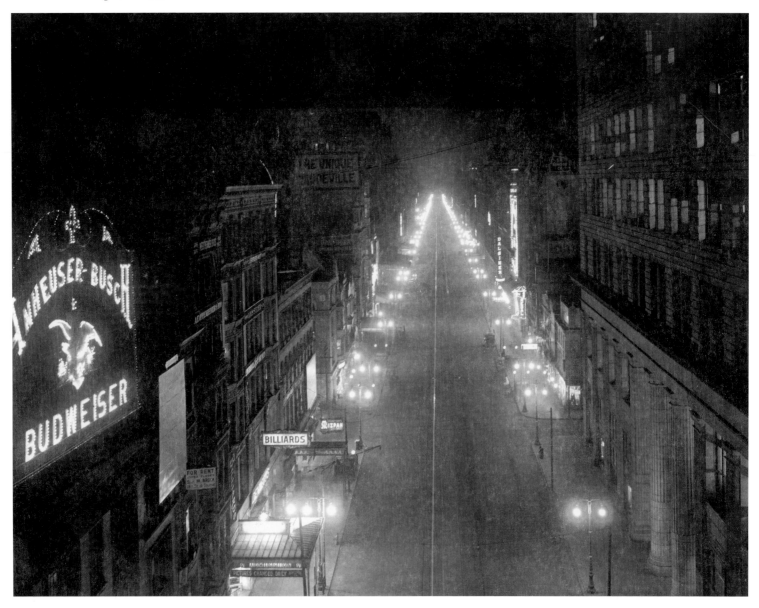

Girard College, originally founded as a boarding school for poor and fatherless boys, now serves a diverse community of over 700 students in first grade through high school.

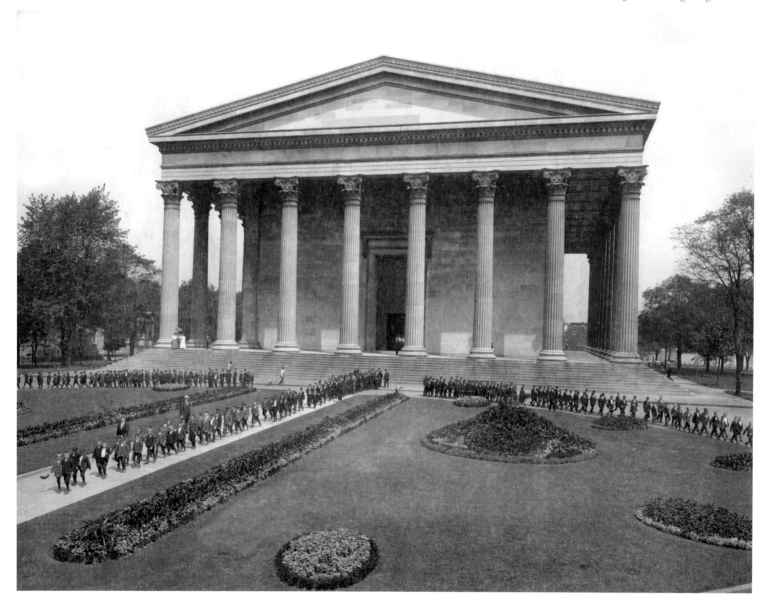

Flood on Delaware Avenue looking north, ca. 1935. The
Delaware River Bridge is visible in the upper right.

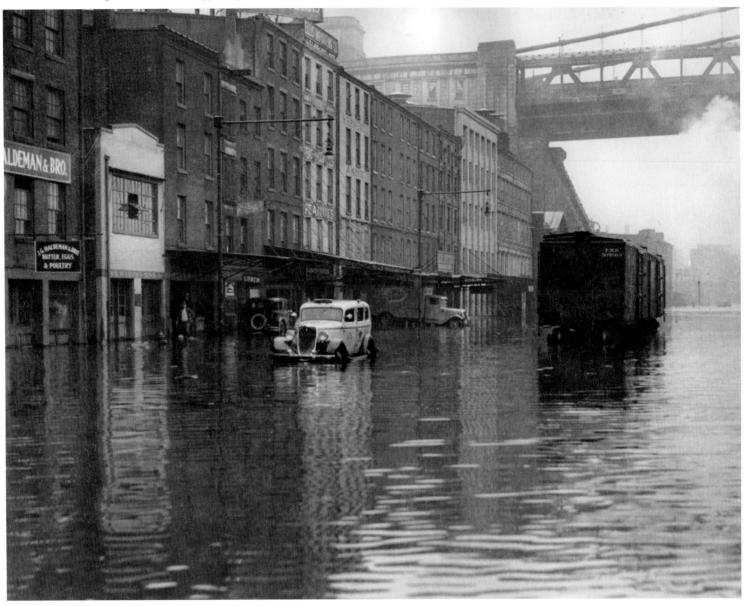

Port Richmond, where the schooner *Calumet* is seen docking ca. 1935, is one of several "river wards" along the Delaware River north of the center of the city. Others include Northern Liberties, Kensington, Frankford, and Bridesburg. They are notable for their long history and role as shipping and industrial centers during the eighteenth, nineteenth, and twentieth centuries. Though many have fared poorly since the loss of major manufacturing in the mid 1900s, efforts are being made to revitalize the neighborhoods today.

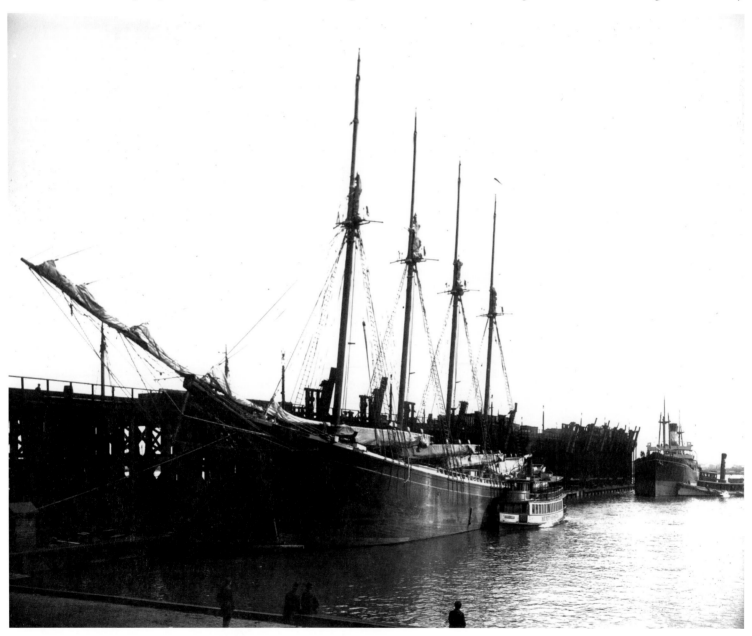

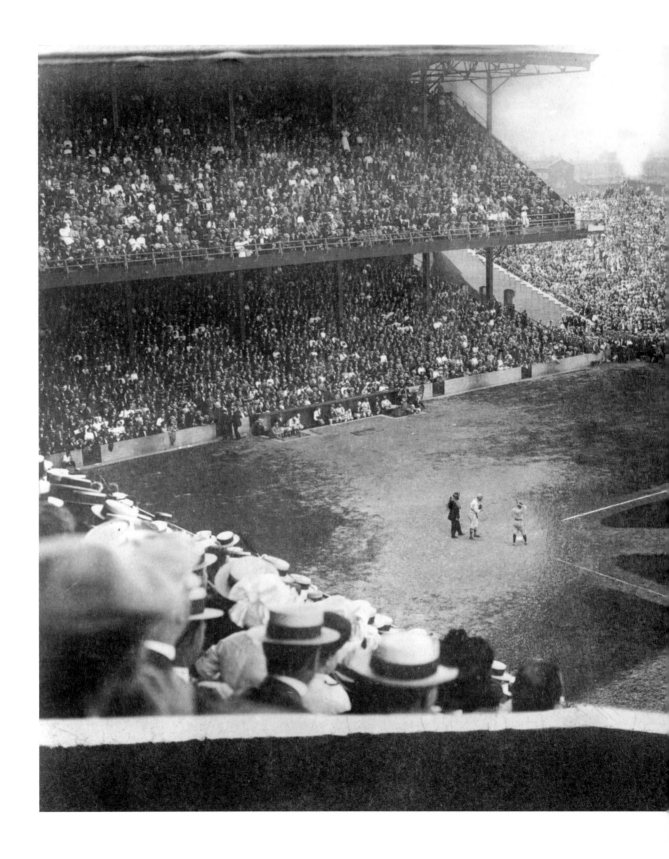

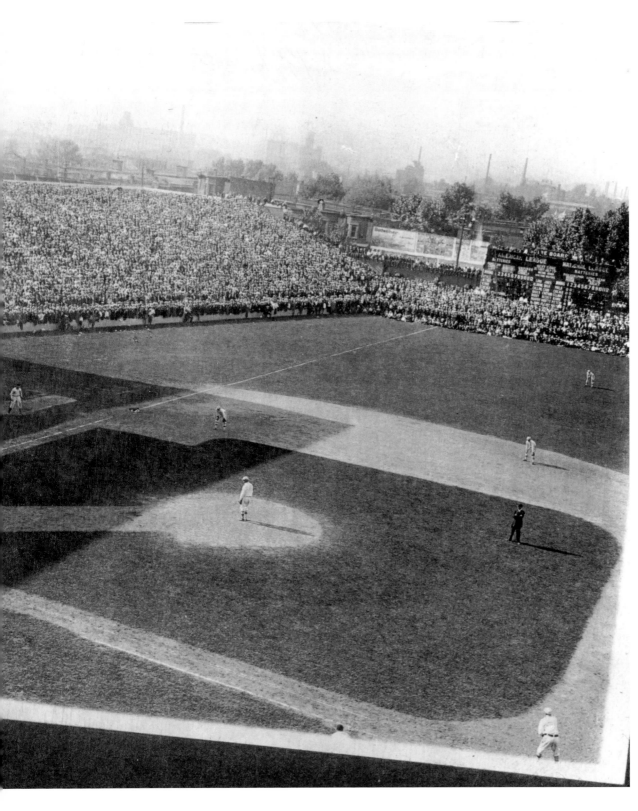

Renamed Connie Mack Stadium in 1953, Shibe Park was home to both the Philadelphia Athletics and the Philadelphia Phillies baseball teams. It was demolished in 1976 after Veterans Stadium was built in South Philadelphia.

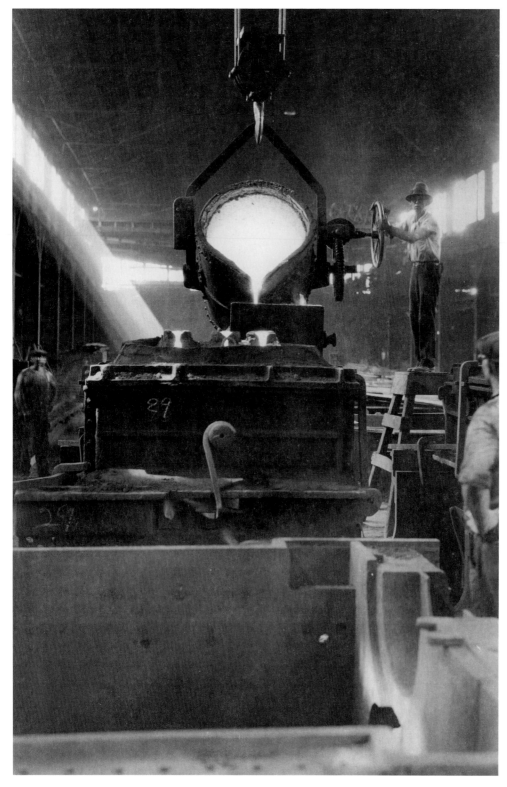

Baldwin Locomotive Works, which dominated the national manufacture of steam, electric, and diesel locomotives and trains for almost 125 years, moved to Eddystone, Pennsylvania in 1928. Production of Baldwin locomotives ended in 1956. In this view, men are pouring from a steel cylinder ca. 1938–1939.

As part of a stunt featured in a transportation parade, this plane landed on the Benjamin Franklin Parkway on July 13, 1937.

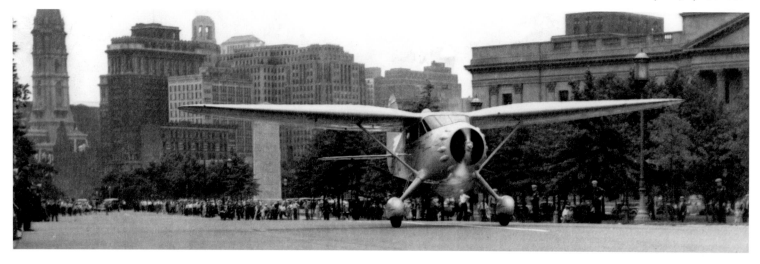

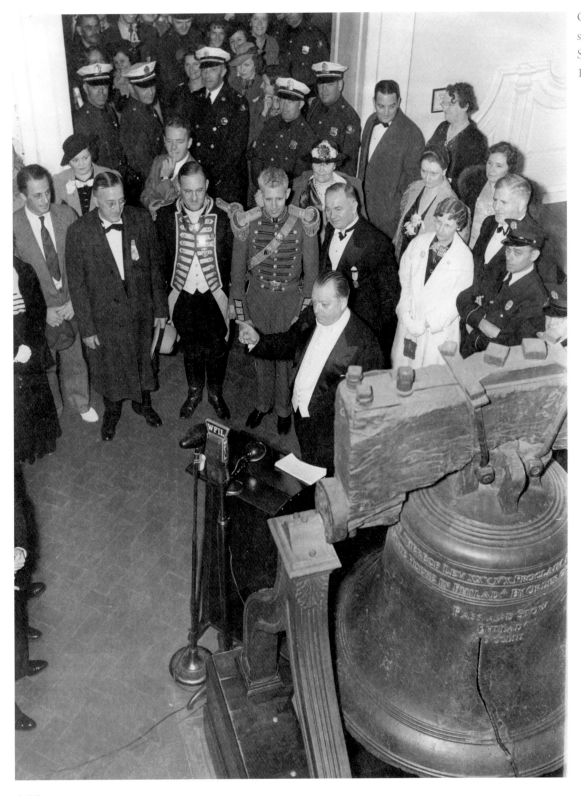

Commemorating the sesquicentennial of the United States Constitution, September 1937

Originally built as part of the Sesquicentennial Celebration of 1926, the Philadelphia Municipal Stadium became known as JFK Stadium in the 1960s. It was a popular sports venue and home to the famed Army-Navy football games for many years. The stadium was demolished in 1992.

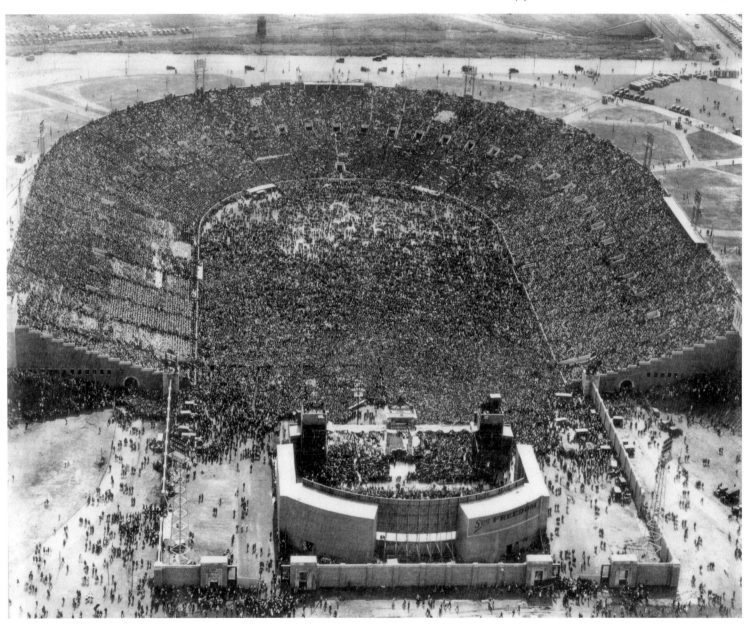

Elderly men on a bench, Norris Park, ca. 1938–1939

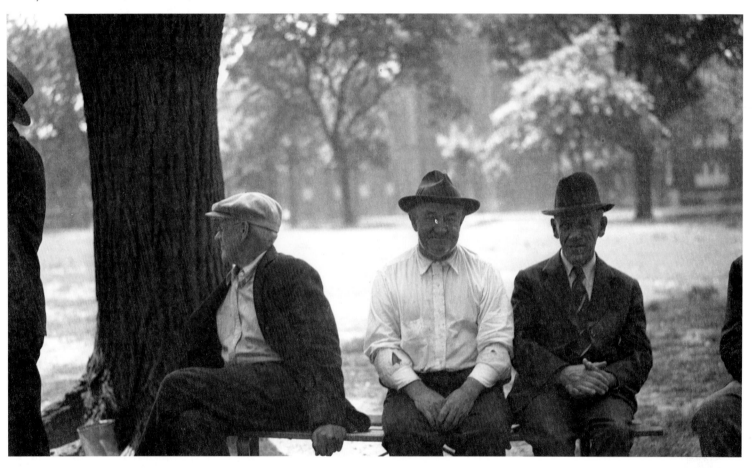

Market Street at night, looking east
from 13th Street, February 3, 1938

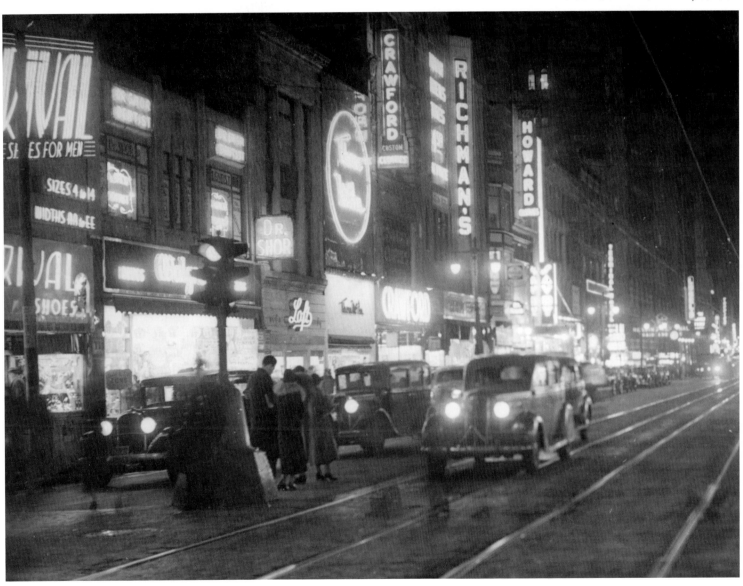

Father Divine, also known as the Reverend General Jealous Divine and seen here in New York City in 1938, was a charismatic spiritual leader based in Philadelphia. Despite facing controversy over his doctrine and cult-like following, he is often credited for his contributions to the Civil Rights movement through his founding of the International Peace Mission movement, which evolved into an international, multiracial church.

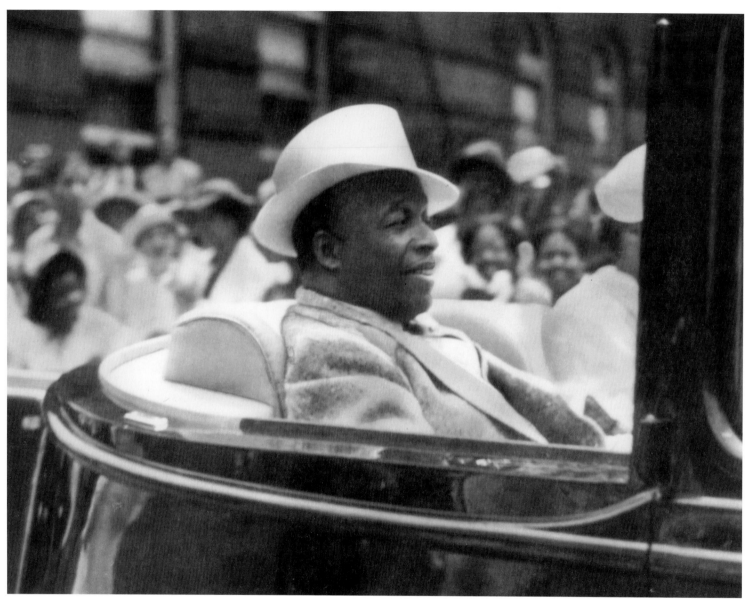

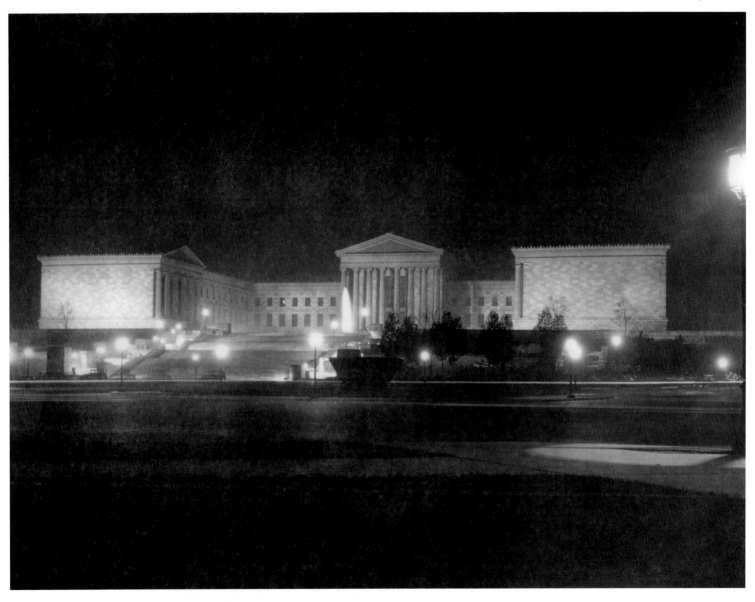

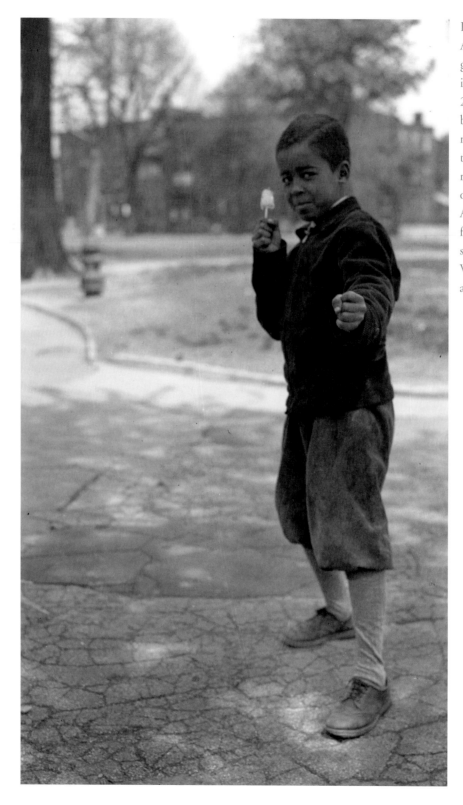

Philadelphia's African American population grew from nearly 85,000 in 1910 to more than 219,000 by 1930. Drawn by the possibility of new manufacturing jobs, the increase was the result of the migration of thousands of African Americans northward from several southern states, among them Virginia, South Carolina, and Georgia.

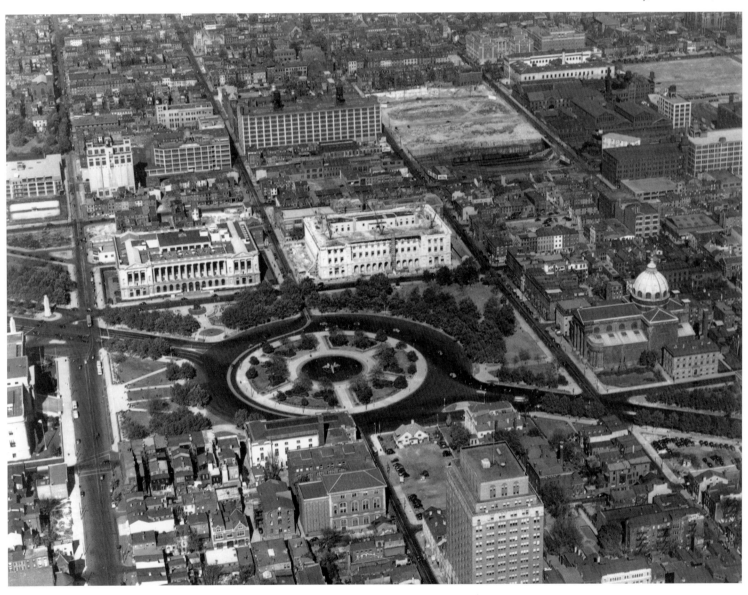

Aerial view of Logan Circle and the
Central Library, October 21, 1939

Boys playing baseball, ca. 1940

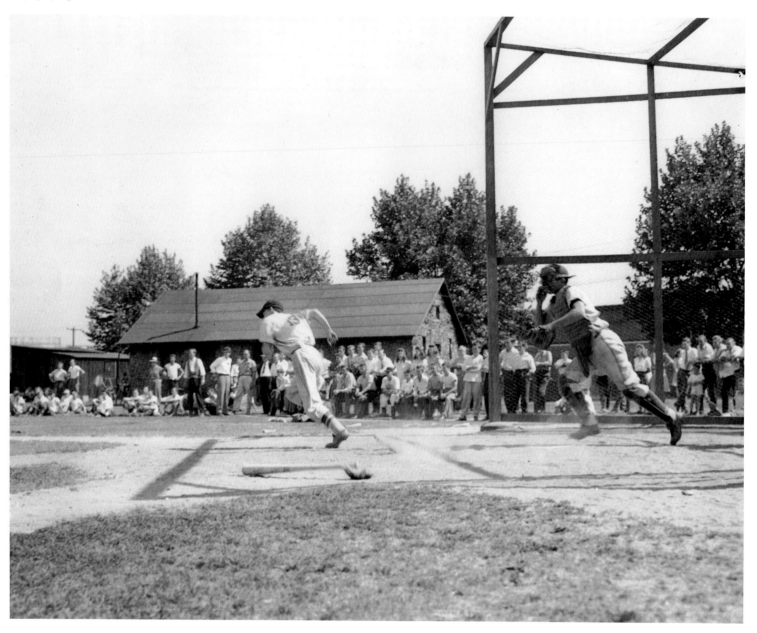

CONFLICT AND THE MATERIALS OF WAR

1940-1959

As the threat of a new world war loomed, Philadelphia set aside many of its local conflicts and prepared to serve the nation as the primary supplier of the materials of war. Industries such as shipbuilding, automobile manufacture, and textiles rose once again to meet the demands of World War II. The dramatic growth in the availability of jobs inspired thousands of African Americans in southern states to migrate north. The lack of manufacturing skills among recent arrivals triggered the development of company-sponsored vocational training programs for the city's immigrant and African American populations, temporarily improving relations among the races. Rationing, bond drives, parades, and other forms of patriotic expression filled the public lives of most Philadelphians.

With the war over and returning servicemen and women seeking jobs and affordable housing, tensions increased once again. Reductions in the demand for products of the manufacturing industry led to the slow decline of Philadelphia's economy and an increase in the unemployment rate as businesses shut down. Some of the city's largest companies, including Brill, Baldwin, and Cramp, all drastically cut their production rate or shut down altogether. In 1944, a strike by employees of the Philadelphia Transportation Company began in response to efforts by the company to hire lower-paid black conductors and motormen. It was one of many strikes that plagued the city as jobs became scarce and competition for them often led to conflict.

Inadequate support of the city's older neighborhoods, as well as growing fears of race and ethnic conflict, drove large numbers of Philadelphians to the new community developments in the northeastern and southern neighborhoods of the city and the suburbs. The neighborhoods closer to downtown were left to the city's poor and unemployed citizens. By the mid-1950s, the aging city was losing its industries and its citizens in what was to be a near-fatal blow to its economic stability.

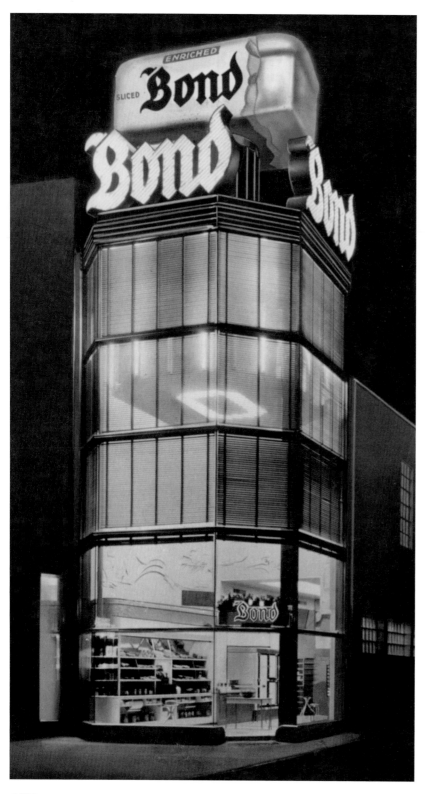

Bond Bakery, 15th Street near Broad Street, 1941

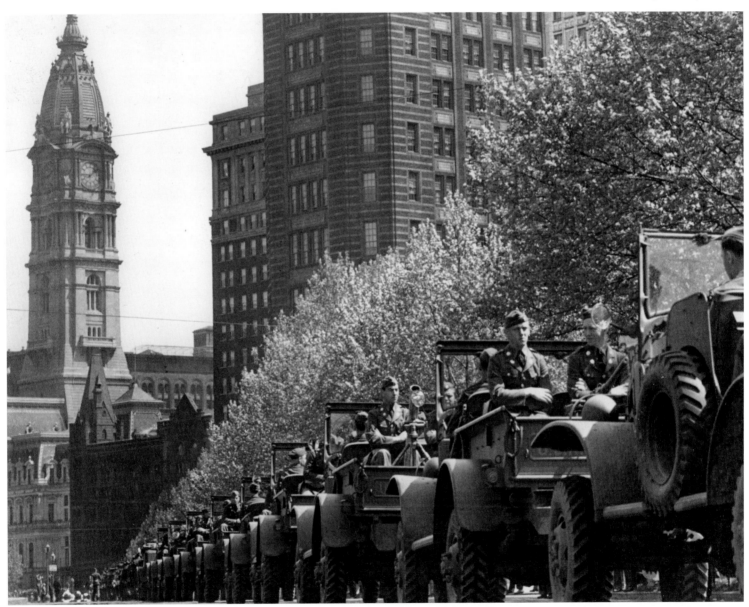

The men pictured are part of the 114th Infantry, Company K mechanics unit, participating in a Veterans of Foreign Wars Parade along the Benjamin Franklin Parkway on May 8, 1941

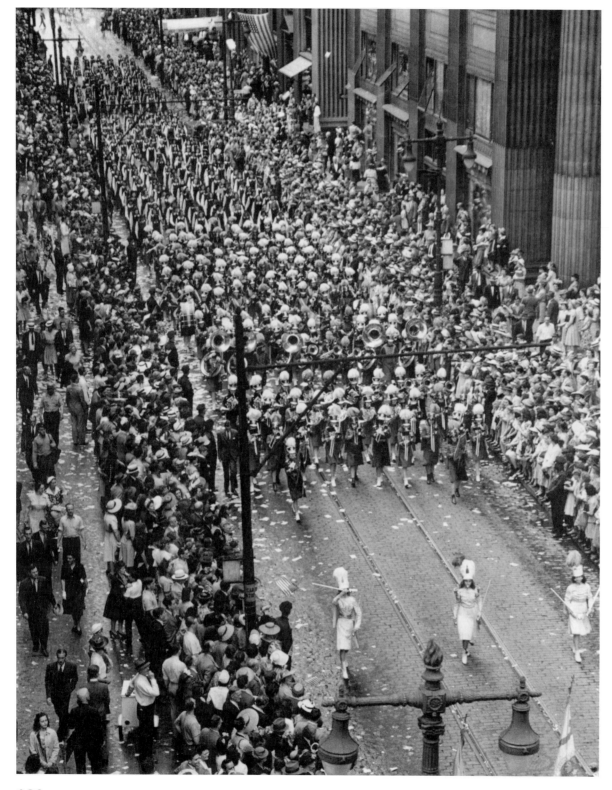

Throughout the war, Philadelphia sponsored dozens of parades and events similar to this Heroes' Parade in an effort to bolster support for the bond drives and improve the general morale of the city. The band pictured is the Combined Catholic Girls High School Band.

Sailors participating in
Americanization Day, Benjamin
Franklin Parkway, May 2, 1942

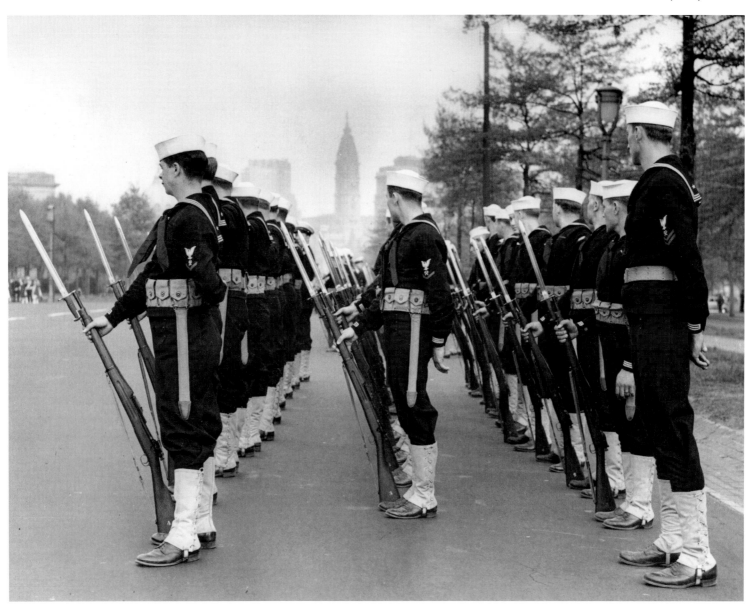

Named for the many small loading docks once found along Dock Creek, Dock Street
was for nearly two centuries the center of Philadelphia's produce and seafood industry.
The creek was filled in at the beginning of the 1800s and Dock Street was born.

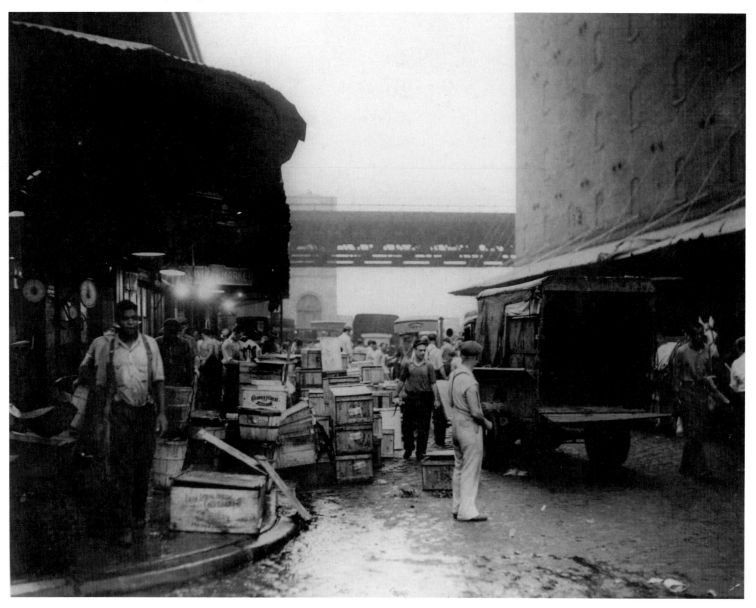

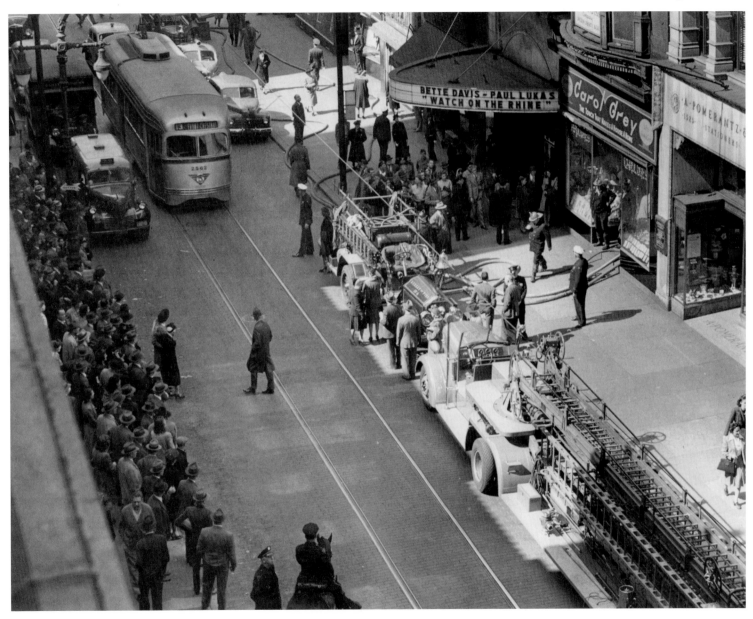

Fire Scene at 1527 Chestnut Street, October 5, 1943.
Note the marquee for the Arcadia Theater, featuring a
film starring Bette Davis.

By the end of World War II, a total of 183,850 citizens of Philadelphia were serving in the armed forces. Additionally, the city served as a point of departure and arrival for countless men and women, many hoping to take advantage of the city's various leisure distractions.

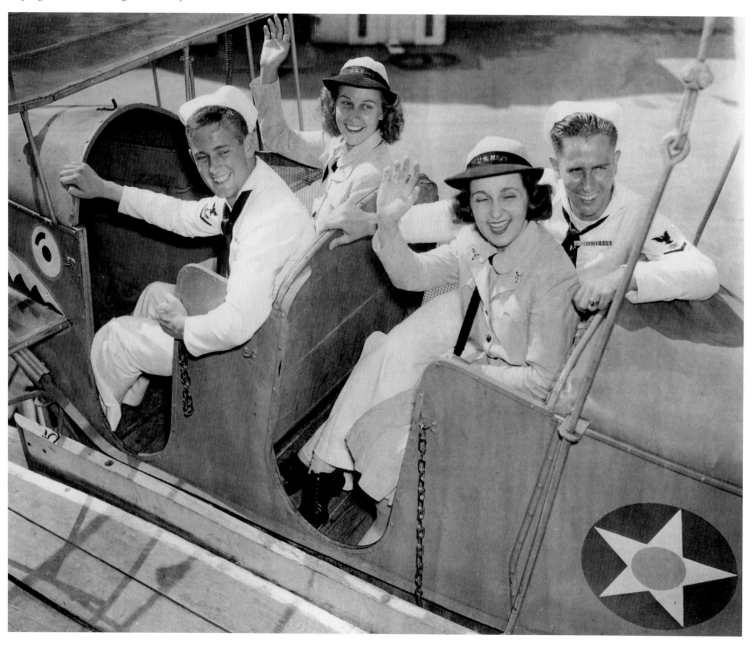

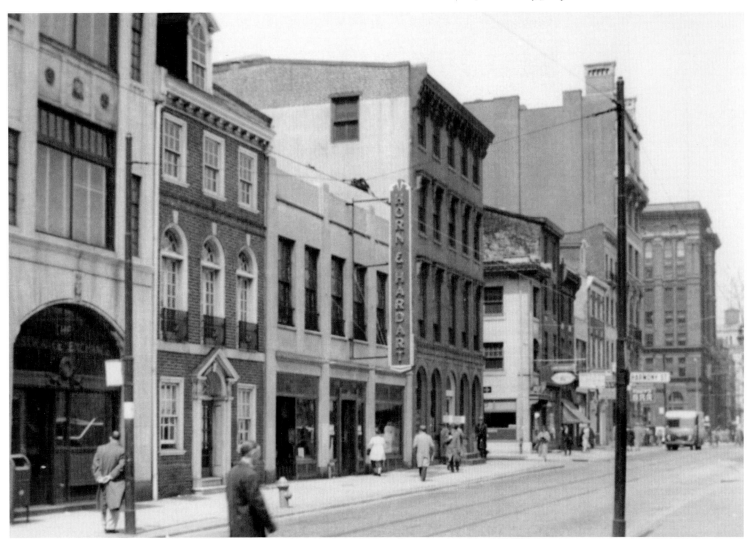

Located at 4th and Walnut streets, this is one of several of Philadelphia's famous self-serve cafeterias, founded by Joseph Horn and Frank Hardart in 1902.

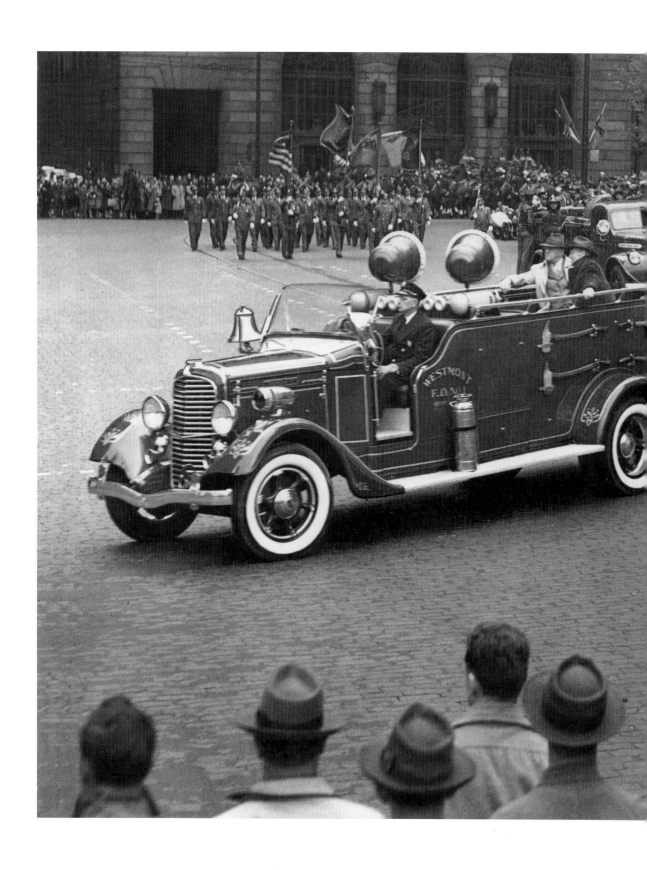

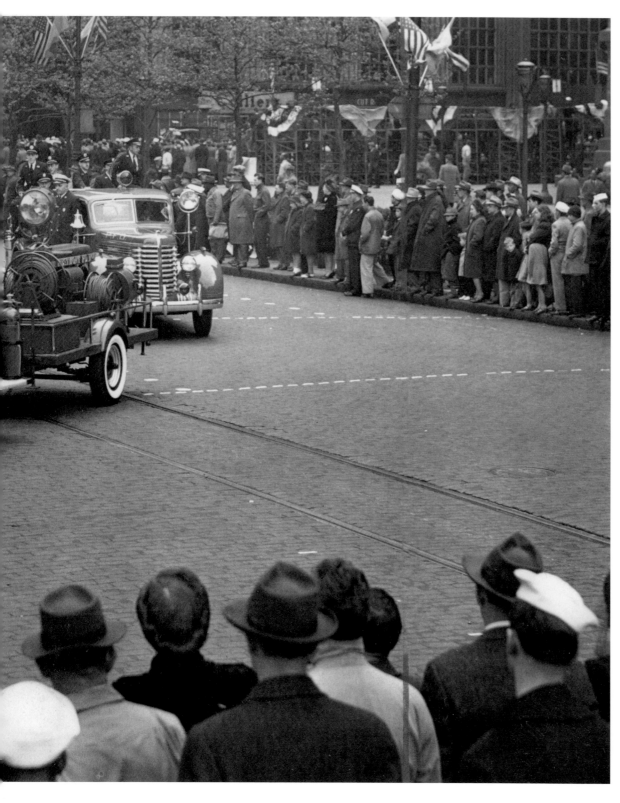

City Hall parade, featuring the Westmont, New Jersey, fire department, April 28, 1946

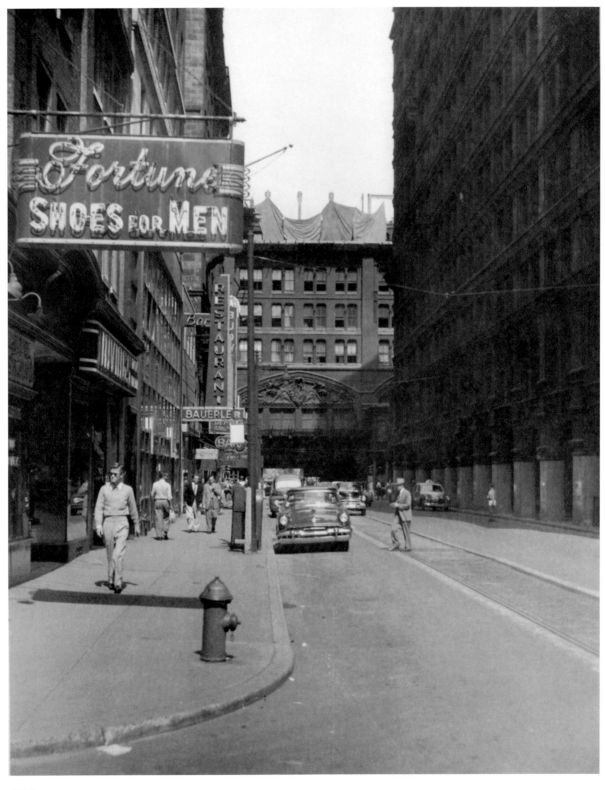

The first home-delivered meal program in the country began in Philadelphia in January 1954. Inspired by similar programs in London during World War II, organizations such as the Lighthouse Community Center began to work toward meeting the nutritional needs of the city's elderly and poor, providing meals on wheels to thousands of Philadelphians.

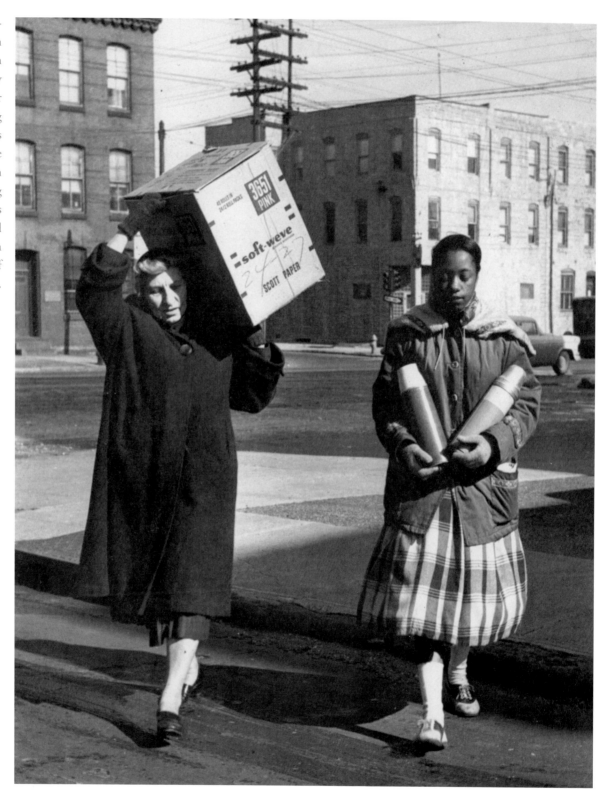

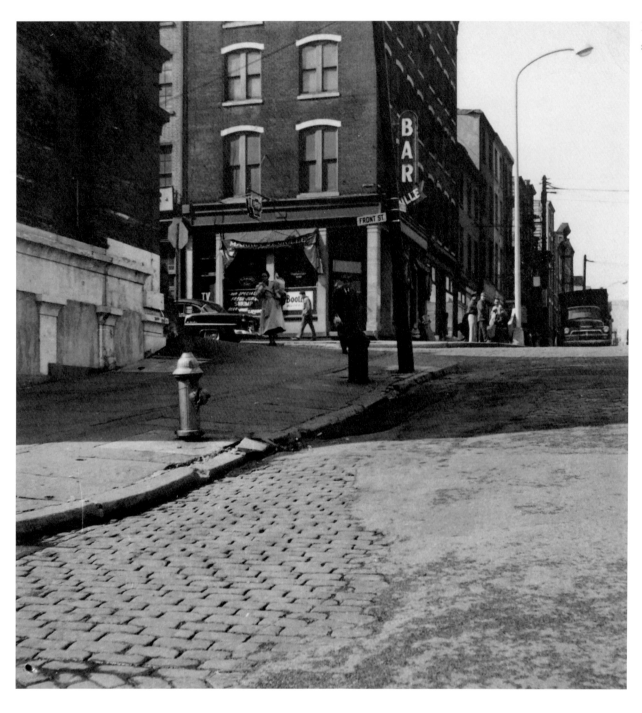

Front and Market
streets, 1956

190

The Snow White Diner, seen here in 1956, still serves Philadelphia's favorite breakfast meat, scrapple, to residents and tourists alike.

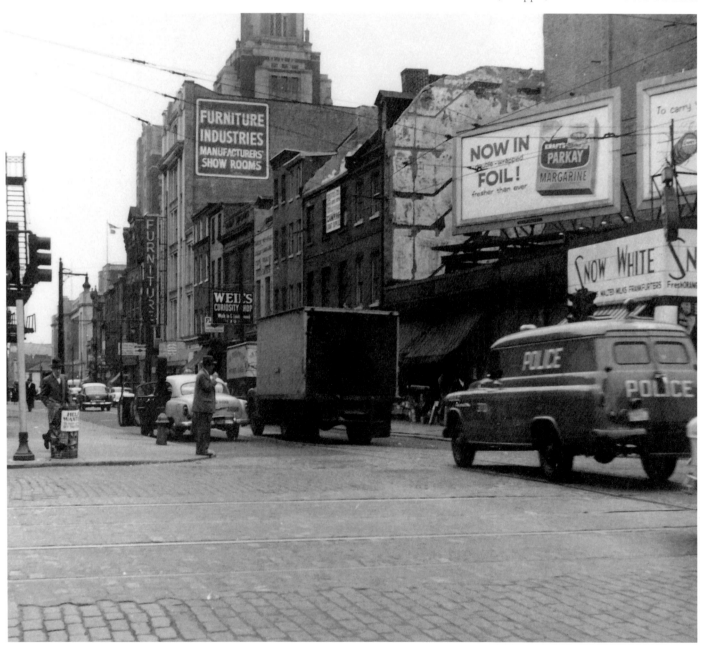

The east side of 4th Street near Walnut Street is one of many blocks partially demolished to make way for Independence National Historical Park in the late 1950s. The luncheonette was once the home of future First Lady Dolley Todd.

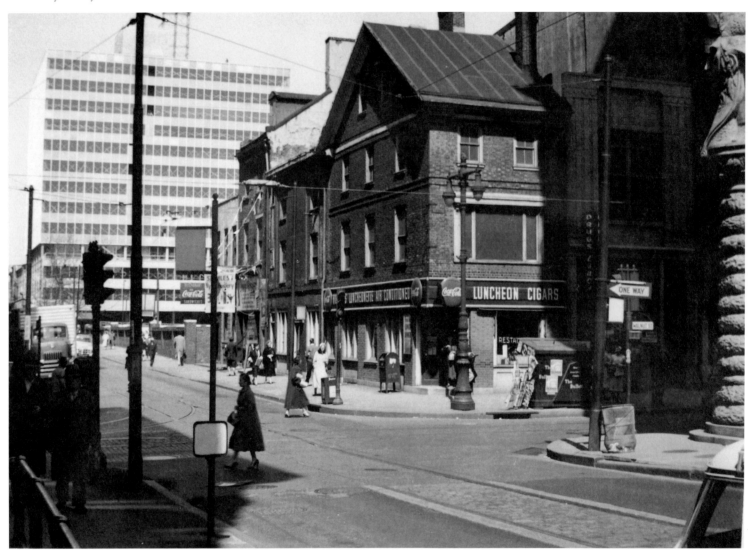

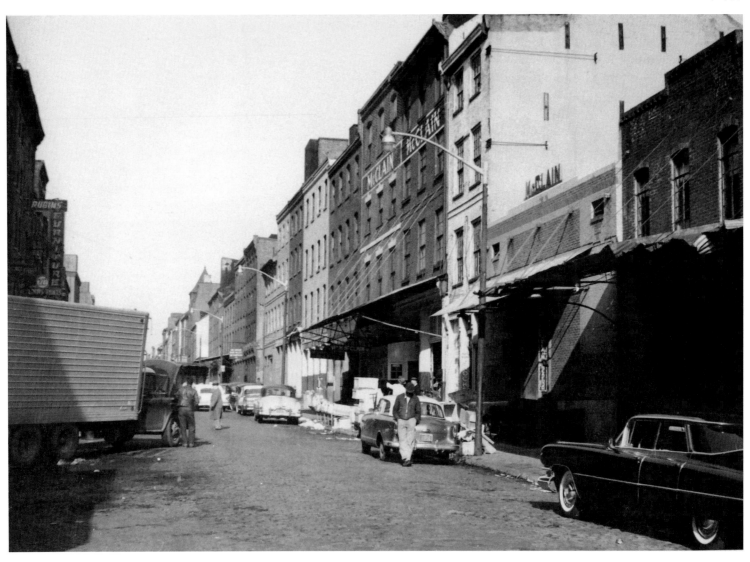

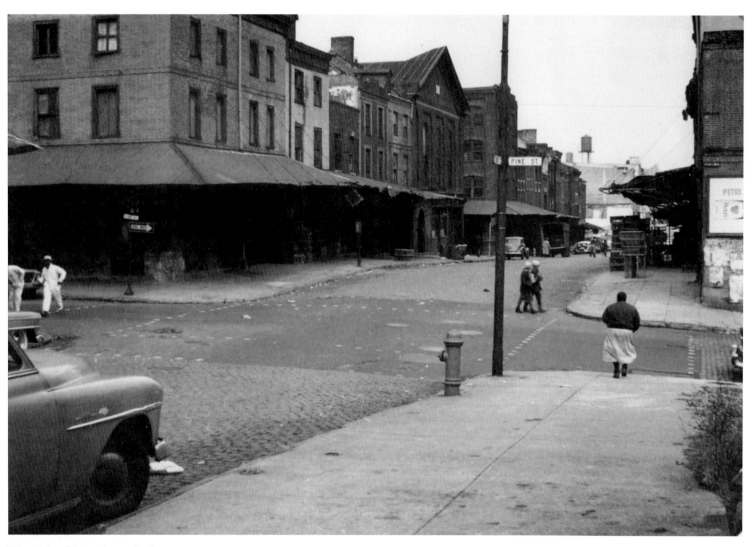

West side of Front Street, looking
north from Pine Street

194

DECLINE AND REBIRTH

1960-1989

With the start of the 1960s Philadelphia entered its most challenging period as riots, ethnic strife, and racial tension overwhelmed the city much as they did most large urban centers at the time. Political corruption, crime, and unemployment all took their toll on the already struggling city. Concerns over ongoing shifts in population and the spread of slums led political leaders to seek answers to revitalizing the city, with little success.

In response to the federal Interstate Highway Act of 1956, the city was approached regarding construction of a major north-south artery along the Delaware River. Against tremendous controversy and the wishes of thousands of Philadelphians, construction on I-95 began in 1965.

Running along the Delaware River through much of the city's oldest neighborhoods and river wards, the highway almost completely severed the city's connection to what had once been the basis of its economy. At the same time, large areas of the city such as Society Hill were claimed by the Philadelphia Redevelopment Authority for renovation and widespread demolition, displacing thousands of families and small businesses. This, in tandem with earlier efforts to create Independence National Historical Park near the Delaware River, changed the look and feel of the once-bustling center of the city.

By the 1970s, Philadelphia had made strides in rehabilitating sections of downtown, but at a great cost to the spirit of the city. Initially praised as an answer to replacing the massive (and abandoned) Broad Street Station near Broad and Market streets, the Penn Center-Suburban Station development soon filled large areas west of City Hall with concrete, glass, and massive plazas. Philadelphia, once known for its ornate Victorian palaces to industry, would now be known for its unadorned and impersonal office blocks. The theaters and shops that once drew thousands lay abandoned and the city grew quiet at night.

In 1987 a single project changed the city's reputation when One Liberty Place was built. Located in the once-sterile area west of Broad Street, the new skyscraper and associated retail shops overcame opposition, initiating a development boom.

In recent years the city has indeed become revitalized, offering a unique blend of old and new. In downtown Center City, private homes, condominiums, office buildings, and businesses stand side by side. Older neighborhoods are being restored and attracting young professionals. Where once massive manufacturing plants employed thousands, educational institutions and hospitals are among the top employers. Vibrant shops and vendors can be found once again in the streets where market sheds and storefront sellers hawked their produce and wares a century ago. Though scarred and a bit frayed at the edges, Philadelphia has regained its place as one of the nation's premier cities and looks forward to a successful and prosperous future.

The overhanging bay window to the right in this view of 8th and Filbert streets is a corner of the cast-iron facade of the Lit Brothers Department Store, seen here in 1961.

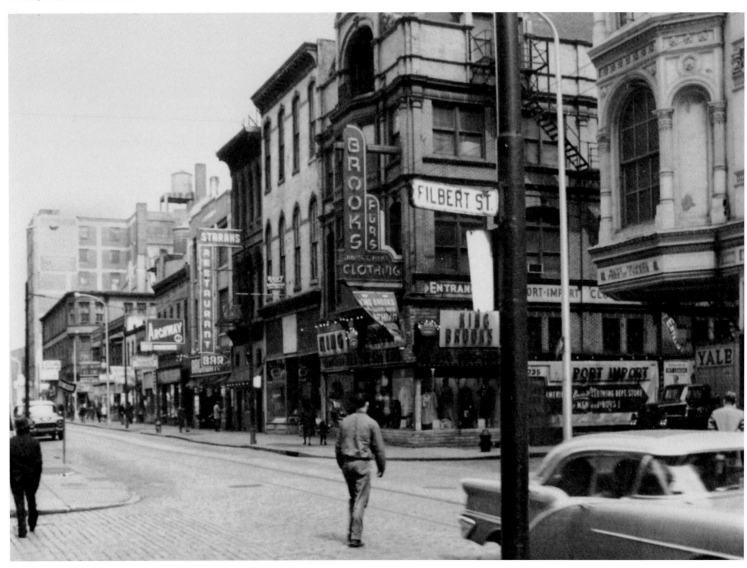

West side of 15th Street at Ranstead
Street, 1962

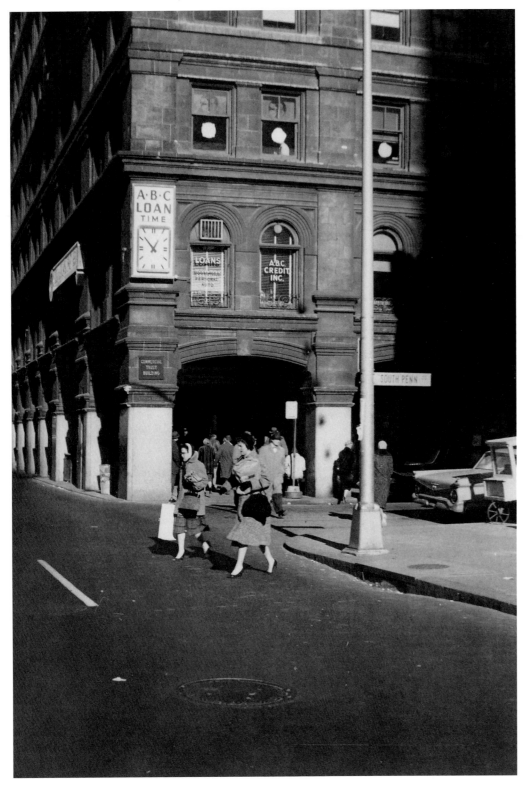

Northeast corner of 15th Street and
Penn Square, the Commercial Trust
Company Building, 1962

North side of Market Street,
March 31, 1971

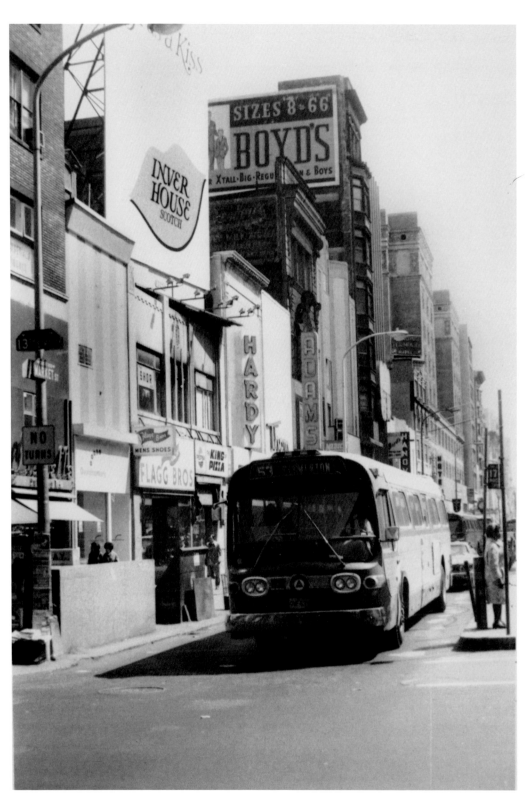

By both tradition and ordinance, no building could be built taller than William Penn's hat atop City Hall. In 1987, after months of debate and controversy, the ordinance was lifted and One Liberty Place was built, and is seen here in 1989.

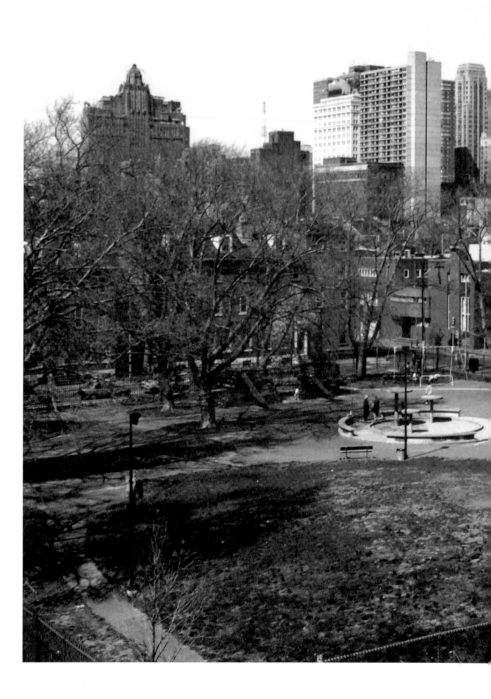

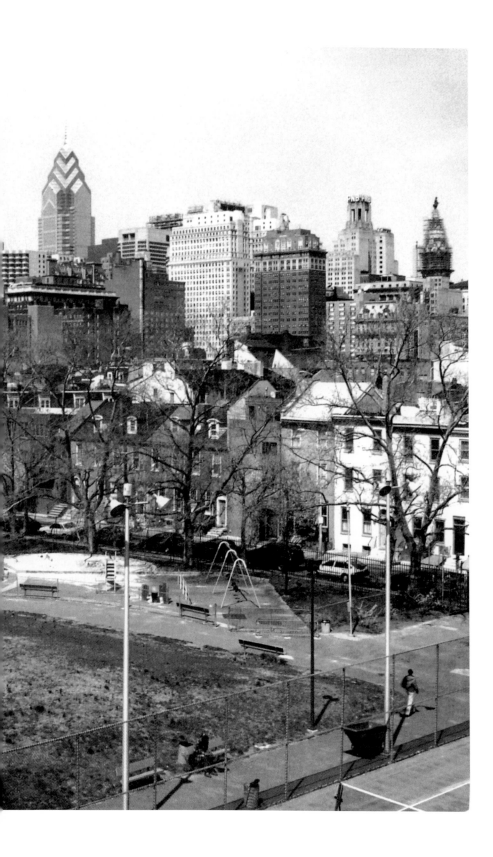

NOTES ON THE PHOTOGRAPHS

These notes, listed by page number, attempt to include all aspects known of the photographs. Each of the photographs is identified by the page number, photograph's title or description, photographer and collection, archive, and call or box number when applicable. Although every attempt was made to collect all available data, in some cases complete data was unavailable due to the age and condition of some of the photographs and records.

II MAIN CENTENNIAL BUILDING
Free Library of Philadelphia
c010946

VI OXFORD STREET
Historical Society of Pennsylvania
Broad from Oxford-Penrose

X WASHINGTON SQUARE
Free Library of Philadelphia
pdcl00057

2 7TH STREET
Free Library of Philadelphia
pdcl00067

3 BULLOCK & CRENSHAW'S
Pennsylvania Historical & Museum Commission
m219003

4 CONGRESS HALL
Free Library of Philadelphia
pdcl00058

5 LOCAL WAREHOUSE
Free Library of Philadelphia
pdcl00036

6 DONNELY'S HOTEL
Free Library of Philadelphia
pdcl00053

7 CHESTNUT HILL
Historical Society of Pennsylvania
6_chestnut hill- Penrose

8 ARCH STREET THEATRE
Free Library of Philadelphia
pdcl01003

9 LAZARETTO
Historical Society of Pennsylvania
8a_lazaretto

10 INDEPENDENCE HALL
Free Library of Philadelphia
pdcl00061

11 US ARMY LABORATORY
Pennsylvania Historical & Museum Commission
m219005

12 LINCOLN FUNERAL
Historical Society of Pennsylvania
11_lincolnfuneral

13 LOCKER'S RESTAURANT
Free Library of Philadelphia
pdcl00107

14 ZION LUTHERAN CHURCH
Free Library of Philadelphia
pdcl00100

15 PHILADELPHIA CIRCUS
Free Library of Philadelphia
pdcl00108

16 PUBLIC LEDGER
Free Library of Philadelphia
pdcl00126

17 TORCH BEARING ARM
Historical Society of Pennsylvania
9_image2025

18 FAIRMOUNT PARK
Free Library of Philadelphia
c030356

20 ACADEMY OF MUSIC
Pennsylvania Historical & Museum Commission
m219052

21 CENTENNIAL GROUNDS
Free Library of Philadelphia
c010923

22 STATE BUILDINGS
Free Library of Philadelphia
c011043

23 MACHINERY HALL
Free Library of Philadelphia
c010552

24 FIRE ENGINE
Pennsylvania Historical & Museum Commission
m219026

26 T. SHAW
Free Library of Philadelphia
pdcl00109

27 FIRST BICYCLE MEET
Historical Society of Pennsylvania
3_bicycle meet

28 STREET CAR
Historical Society of Pennsylvania
db780prt

30 NEW AMERICAN THEATRE
Free Library of Philadelphia
pdcl00103

31 CHESTNUT STREET
Free Library of Philadelphia
pdcl00119

32 BLUE ANCHOR HOTEL
Pennsylvania Historical & Museum Commission
m219029

33 CELEBRATION AT CITY HALL
Historical Society of Pennsylvania
15_dbPRM29

34 PENNSYLVANIA RAIL STATION
Free Library of Philadelphia
pdcl00158

35 MARKET SHEDS
Free Library of Philadelphia
pdcl00043

36 CYPRESS TREE
Historical Society of Pennsylvania
2_cypress tree